LEONARDO DA VINCI

LEONARDO

TEXT BY

JACK WASSERMAN

Professor of Art History, The University of Wisconsin, Milwaukee

THE LIBRARY OF GREAT PAINTERS

HARRY N. ABRAMS, INC., Publishers, NEW YORK

2nd Printing

Library of Congress Cataloguing in Publication Data

Leonardo da Vinci, 1452–1519. Leonardo da Vinci.

(The Library of great painters)
Bibliography: p.
1. Leonardo da Vinci, 1452–1519. I. Wasserman,
Jack, 1921–
ND623.L5W34 759.5 74–13112
ISBN 0-8109-0262-1

Library of Congress Catalogue Card Number: 74–13112

Published by Harry N. Abrams, Incorporated, New York, 1975

All rights reserved. No part of the contents of this book may be reproduced without the written permission of the publishers

Text printed and bound in the Republic of Korea

Illustrations printed in Japan

CONTENTS

Acknowledgments 8

LEONARDO DA VINCI 11

Drawings 57

Biographical Outline 77

Index 177

COLORPLATES

1	BAPTISM OF CHRIST, detail Uffizi, Florence Frontispiece 2
2	BAPTISM OF CHRIST Uffizi, Florence 81
3	BAPTISM OF CHRIST, detail Uffizi, Florence 83
4	ANNUNCIATION Uffizi, Florence 85
5	ANNUNCIATION, detail Uffizi, Florence 87
6	ANNUNCIATION, detail Uffizi, Florence 89
7	GINEVRA DE' BENCI National Gallery of Art, Washington, D.C. 9
8	BENOIS MADONNA Hermitage, Leningrad 93
9	BENOIS MADONNA, detail Hermitage, Leningrad 95
10	ADORATION OF THE MAGI Uffizi, Florence 97
11	ADORATION OF THE MAGI, detail Uffizi, Florence 99
12	ADORATION OF THE MAGI, detail Uffizi, Florence 101
13	ADORATION OF THE MAGI, detail Uffizi, Florence 103
14	ST. JEROME Vatican Museum, Rome 105
15	ST. JEROME, detail Vatican Museum, Rome 107
16	MADONNA OF THE ROCKS Louvre, Paris 109
17	PANELS FOR AN ANCONA National Gallery, London 111

18	MADONNA OF THE ROCKS, detail Louvre, Paris 113
19	MADONNA OF THE ROCKS, detail National Gallery, London 115
20	MADONNA OF THE ROCKS, detail Louvre, Paris 117
21	MADONNA OF THE ROCKS, detail National Gallery, London 119
22	MADONNA OF THE ROCKS, detail Louvre, Paris 121
23	MADONNA OF THE ROCKS, detail Louvre, Paris 123
24	LAST SUPPER Refectory, S. Maria delle Grazie, Milan 125
25	LAST SUPPER, detail Refectory, S. Maria delle Grazie, Milan 127
2 6	LAST SUPPER, detail Refectory, S. Maria delle Grazie, Milan 129
27	LAST SUPPER, detail Refectory, S. Maria delle Grazie, Milan 131
28	LAST SUPPER, detail Refectory, S. Maria delle Grazie, Milan 133
29	LAST SUPPER, detail Refectory, S. Maria delle Grazie, Milan 135
3 0	CECILIA GALLERANI (LADY WITH THE ERMINE) Czartoryski Museum, Cracow 137
31	PORTRAIT OF A MUSICIAN Biblioteca Ambrosiana, Milan 139
32	BURLINGTON HOUSE CARTOON (VIRGIN AND CHILD WITH ST. ANNE) National Gallery, London 141
33	BURLINGTON HOUSE CARTOON (VIRGIN AND CHILD WITH ST. ANNE), detail National Gallery, London 143
34	MONA LISA (LA GIOCONDA) Louvre, Paris 145
35	MONA LISA, detail Louvre, Paris 147
36	MONA LISA, detail Louvre, Paris 149
37	VIRGIN AND CHILD WITH ST. ANNE Louvre, Paris 151
38	VIRGIN AND CHILD WITH ST. ANNE, detail Louvre, Paris 153
39	ST. JOHN THE BAPTIST Louvre, Paris 155
40	ANNUNCIATION Louvre, Paris 157
41	MADONNA DI PIAZZA Cathedral, Pistoia 159
42	MADONNA WITH THE CARNATION (MADONNA WITH THE VASE) Alte Pinakothek, Munich 161
43	National Gallery of Art, Washington, D.C. 163
44	MADONNA LITTA Hermitage, Leningrad 165

- 45 LA BELLE FERRONNIÈRE Louvre, Paris 167
- 46 PORTRAIT OF A WOMAN Biblioteca Ambrosiana, Milan 169
- 47 BATTLE OF ANGHIARI Collection G. Hoffman, Munich 171
- 48 BACCHUS Louvre, Paris 173

Selected Bibliography 175

Photographic Credits 179

ACKNOWLEDGMENTS

The process of writing a book inevitably—and pleasurably—incurs debts to many people and institutions. First among those to whom I am indebted is Professor Frederick Hartt. I deeply cherish his friendship, the important advice he gave me during my researches on Leonardo, and his fundamental help in making this book possible.

Other persons deserve my gratitude also. Hannalore Glasser was gracious enough to allow me to read her excellent forthcoming study of the *Madonna of the Rocks*, and she freely discussed with me the many problems that plague the history of this painting. I benefited greatly from conversations with Ulrich Middeldorf, Ludwig Heydenreich, Carlo Pedretti, and with a former student, Mrs. Biruta Erdmann. Cecil Gould, Michael Levey, and Martin Davies promptly and openly responded to my inquiries and supplied me with invaluable information, for which they have my sincere thanks. I wish to convey special thanks to Professor Horst W. Janson for the many times he has helped and encouraged me.

Thanks are due also to the staffs of three great libraries: those of the Biblioteca Hertziana in Rome, the Kunsthistorisches Institut in Florence, and the American Academy in Rome. Their courtesy and cooperation made summer toil seem agreeable.

I was fortunate to receive a number of research grants from a variety of sources. It is with a deep sense of obligation that I acknowledge the confidence and support of the American Council of Learned Societies, the American Philosophical Society, and the Graduate School and College of Letters and Science of the University of Wisconsin–Milwaukee.

Finally, I owe a special debt of gratitude to the late Milton S. Fox, former Editor-in-Chief of Harry N. Abrams, Inc., for his warmth, humanity, and patience. I am delighted that these virtues are also found in other members of this fine publishing house. I want to praise Mrs. Mary Solimena Kurtz in particular for her superb editing of the manuscript.

LEONARDO DA VINCI

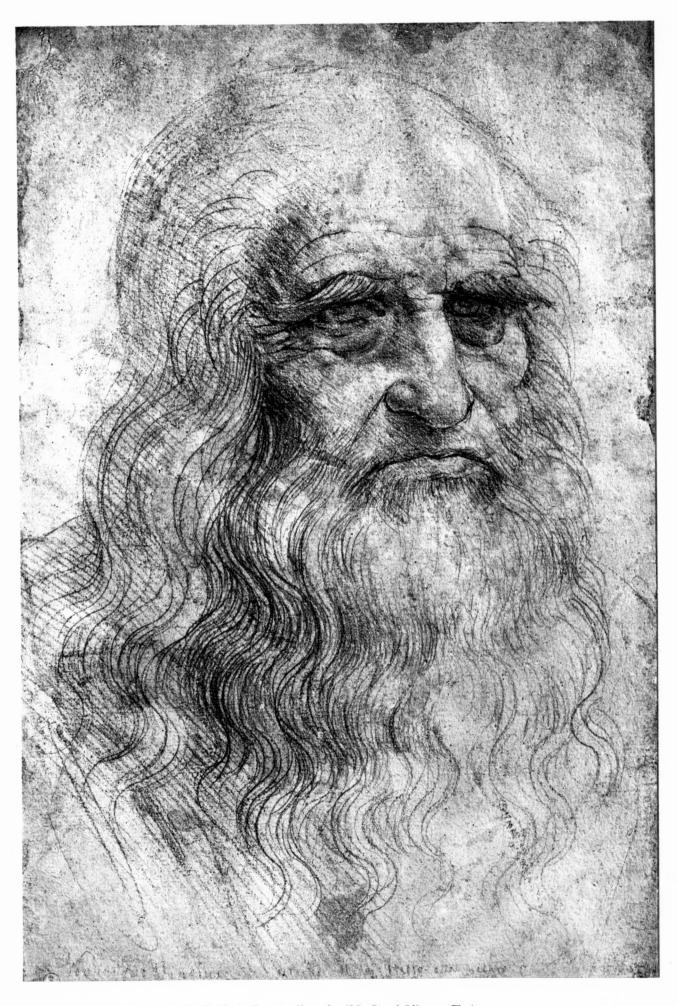

1. SELF-PORTRAIT. c. 1512-15. Red chalk, 13 1/8 × 8 3/8". Royal Library, Turin VASARI, Life of Leonardo: "he wrote . . . using his left hand, and writing from right to left, so that it can be read . . . only in a mirror" (see opposite page)

Leonardo da Vinci: this name has become legendary, a synonym for greatness and for universal genius. And no wonder, for the man who bore it was proficient in almost every area of intellectual and cultural endeavor—in mathematics and geometry; in physics, engineering, anatomy, geology, botany, and geography; in music, sculpture, architecture, and not the least in painting. The list of his personal attributes is equally impressive: he is said to have been handsome and to have had strength, dexterity, brilliance, eloquence, generosity, charm of disposition, and "spirit and courage that were invariably royal and magnanimous," as one of his contemporaries put it.

Therefore, it matters little that Leonardo had a fallible nature. He was called "capricious and fickle," and complaints about his unreliability and dilatoriness were commonplace in his own day. Lodovico Sforza, Duke of Milan, who hired Leonardo to cast a bronze equestrian statue, wrote to Lorenzo de' Medici in Florence asking that Lorenzo send him one or two masters to execute the work, because it did not seem to him that Leonardo would ever finish it. And, years later in Rome, Pope Leo X became so exasperated with Leonardo that he was moved to say: "Alas, this man will do nothing; he

starts by thinking of the end of the work before its beginning."

Leonardo was quick to grumble and to worry about petty things. In careful notes he recorded loans of money he had made, complaints about people who disturbed his privacy, and details about obligations he undertook reluctantly. One senses at times in certain cryptic and paradoxical remarks that he felt persecuted: "The Medici made me, but they also destroyed me"; "When I made a Christ Child you put me in prison; now if I represent Him grown up you will treat me worse."

Leonardo was vain and affected. Take his deliberately abstruse and unconventional manner of writing from right to left, or the eccentric way he dressed: at a time when other men wore long robes of sober color, he wore short doublets and tights made of blue and crimson velvet and silver brocade. Or take his way of presenting himself to the world in the famous Self-Portrait (fig. 1), with a long beard and melancholy demeanor—attributes that in the Renaissance signaled a deep intellect. The late sixteenth-century artist and writer Giampaolo Lomazzo was moved to explain, no doubt when confronted by such a portrait, that "Leonardo used to wear his hair and his beard so long and his eyebrows were so bushy that he

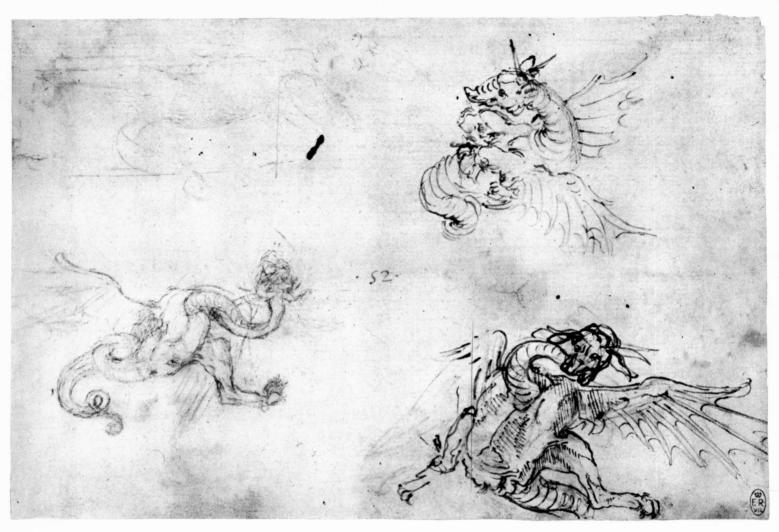

2. DRAGONS. C. 1480. Silverpoint, 6 1/4 \times 9 5/8". Royal Library, Windsor Castle. Reproduced by Gracious Permission of Her Majesty Queen Elizabeth II

3. Giuliano da Sangallo the Younger (attributed). DRAGONS AND OTHER ANIMALS. Second half of 15th century. Pen and wash, 10 $5/8 \times 8$ 5/8''. Whereabouts unknown

4. Anonymous. Nude winged child and an animal. Second half of 15th century. Silverpoint, pen, and bister, 8 1/4 \times 5 7/8". Uffizi, Florence

appeared the very idea of noble wisdom." Did Leonardo fancy himself another Aristotle or Plato? Or, as Lomazzo suggested, did he consider himself the sage Hermes Trismegistus, or perhaps Prometheus, symbol of man's unquenchable thirst for knowledge?

Ultimately, it was the aura of intellectual and personal authority Leonardo exuded that persuaded the great men and women of his age-against all misgivings and despite all of the artist's shortcomings—to seek him out, literally to command and at times even to beg him to paint some small picture for them. It was a high honor in those days for an artist to be so admired and to have the devotion and friendship of no less a personage than the French monarch François I. However, the supreme honor paid Leonardo was the unexpected praise he received posthumously from Giorgio Vasari. Himself an artist and the most famous sixteenth-century chronicler of the lives of the painters, sculptors, and architects, Vasari was an intimate friend of Leonardo's archrival, Michelangelo. Yet so compelling were Leonardo's works and reputation that Vasari was moved to rise above partisanship and to describe him in this fashion: "The heavens often rain down the richest gifts on human beings, but sometimes they bestow with lavish abundance upon a single individual beauty, grace, and ability, so that whatever he does, every action is so divine that he distances all other men, and clearly displays how his greatness is the gift of God and not an acquirement of human art. Men saw this in Leonardo." Men still do.

Leonardo was born in 1452 in the small village of Anchiano (near Vinci), the illegitimate son of the Florentine notary Piero da Vinci and Caterina, a peasant woman. Around 1469, as a youth of seventeen or so, Leonardo accompanied his father and stepmother (Piero had married another woman by then) to Florence. Vasari notes that Leonardo had demonstrated a talent for drawing and design even as a boy. Recognizing these achievements, Piero persuaded his friend Andrea del Verrocchio to accept his son as an apprentice in what was then one of the foremost studios in Italy.

Leonardo's artistic education was the one available to all of Verrocchio's young apprentices: grinding and mixing pigments, learning geometry and the chemistry of colors, preparing panels to receive paintings, the act of painting itself, and working clay and casting bronze into finished sculptures. A standard studio procedure was the use of pattern books, which consisted of collections of drawings to which artists could turn for repeated reference. A noteworthy example of Leonardo's reliance on such books, even after he had left Verrocchio's studio, is found on a page of drawings now at Windsor Castle, showing a variety of sketched dragons (fig. 2). They are so spirited and individual in character that one might be inclined to view them as personal inventions. Yet the

impression cannot be escaped that Leonardo had before him prototypes from late fifteenth-century pattern books, such as the one that has been attributed to Giuliano da Sangallo the Younger (fig. 3). Leonardo's dragons have in common with these a loose-jointed anatomy, scales on a long, sinuous neck, and a spiraling tail. The more dynamic and convincing anatomy of Leonardo's dragons reveals his greater knowledge of the structure and behavior of animals and his superiority as a draftsman.

There is a second example of Leonardo's reliance on pattern book models. His Christ Child in the Louvre version of the Madonna of the Rocks (colorplate 22) appears to depend, with certain modifications, on three pattern book drawings of nearly identical seated children. One of them (fig. 4) is even accompanied on the same page by an animal that in its stylized conception is typical of this genre of drawing (compare fig. 3), thus establishing, by association, the pattern book origins of the child as well. These particular drawings of children were probably known to Leonardo, since they seem to have been part of a pattern book that I believe was in circulation at some time in Verrocchio's studio, probably serving Verrocchio or some assistant as sources for the figures of children on the base of the Forteguerri Cenotaph at Pistoia. Leonardo, however, relied on the live model as well, whose pose he made to conform with that of the children in the pattern book drawings. This was a procedure employed by Renaissance artists who sought to emulate ancient sculpture yet wished to retain the realistic character that only the live model could impart to their work.

Leonardo began his training directly in the major arts of painting and sculpture. In this respect, he was relatively unusual among the artists with whom he was associated during his years of apprenticeship: Domenico Ghirlandaio, Sandro Botticelli, Antonio Pollaiuolo, and Verrocchio himself had had their earliest training in the craft of goldsmithing, whereas Leonardo lacked this background in the minor arts. For this reason, he did not acquire a highly developed sense of art as a mestiere, or trade. Moreover, from the start he displayed an aloofness toward tempera and fresco painting—craft media that, like goldsmithing, were dignified by tradition.

Leonardo's disdain for these media was in each instance differently motivated. He seems, for example, never to have had the opportunity to learn from Verrocchio the use of fresco for wall paintings. Verrocchio himself had received only one commission for a wall painting in his entire life, and this came prior to Leonardo's arrival in his studio. Leonardo in turn did not undertake to paint a mural until middle age, and then he chose a medium of his own invention. On the other hand, as an apprentice he had certainly learned the use of tempera, since it was Verrocchio's exclusive medium in the execution of altarpieces and other paintings on panel. Yet when we first encounter Leonardo as an artist—in the angel he added on the ex-

5. Adoration of the shepherds. c. 1478. Pen, 8 3/8 \times 6". Musée Bonnat, Bayonne

treme left of Verrocchio's *Baptism of Christ* and in his "corrections" elsewhere in the painting (colorplates 1-3)—he was already using some form of oil compound. This is all the more remarkable because Verrocchio had begun the painting in tempera, and Leonardo was then only twenty years old and still under his master's authority. Leonardo's rejection of tempera was, therefore, a considered act, and in choosing oil he revealed a predilection for the effects possible in this medium, first discovered by Flemish artists: transparent and luminous skin surfaces, lustrous jewelry, silken hair, and atmospheric space.

Most of Leonardo's early Florentine years were spent in the comfort and security of Verrocchio's studio. He remained there until at least 1476, although he had joined the painters' guild of St. Luke four years earlier, in 1472. He probably served as Verrocchio's chief assistant, in general charge of the studio's painting section. This may be inferred from an anecdote reported by Vasari, which states that Verrocchio presumably gave up painting entirely when he saw Leonardo's superior achievement in the angel he added to the *Baptism*. Leonardo, he may have decided, was good enough to look after commissions for paintings that came to the studio, permitting Verrocchio to devote himself chiefly to his beloved sculpture.

Leonardo's managerial role in Verrocchio's studio, if such indeed it was, would account for several paintings from the years between 1472 and 1477 that are regularly attributed to Leonardo (although without unanimous agreement): the two versions of the Annunciation, one in the Uffizi (colorplate 4) and the other in the Louvre (colorplate 40); the Ginevra de' Benci (colorplate 7); and the Madonna with the Carnation (colorplate 42). All have general affinities with Verrocchio's style and with that of such assistants as Lorenzo di Credi. However, only the Uffizi Annunciation—in its composition, landscape, and atmospheric effects—and the Ginevra—in her compelling facial expression—come close enough to Leonardo's artistic intentions to permit a strong claim to be made for his direct participation in their execution.

The first independent commission Leonardo is known to have received, in 1478, was for an altarpiece for the chapel of S. Bernardo in the Palazzo Vecchio, the civic palace of Florence. Nothing came of it, although a few drawings for an Adoration of the Shepherds (fig. 5) are sometimes associated with this project. At about the same time, Leonardo painted the charming and youthful Benois Madonna (colorplate 8). His work in these years and in his previous period of apprenticeship is delicate and intimate. Moreover, it reveals the stamp of Verrocchio's influence, notably in the full and boneless physiognomy of the angel he added to the master's Baptism (colorplate 1). One can also detect the influence of the sculptor Desiderio da Settignano, that master of sweet children and Madonnas, of delicately veiled surfaces, and of diffused light (fig. 6). Although they are now lost, we can surmise that

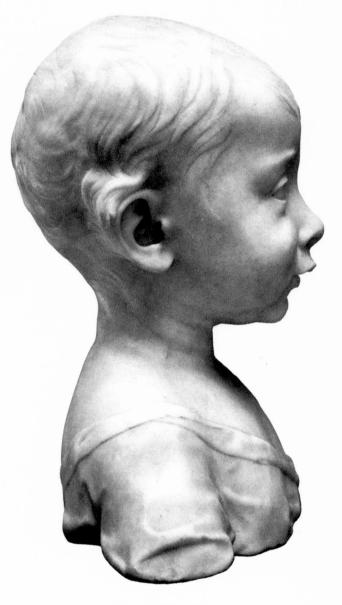

6. Desiderio da Settignano.

BUST OF A LITTLE BOY. c. 1460.

Marble, height 10 3/8".

National Gallery of Art, Washington, D.C.

Andrew W. Mellon Collection

the small clay busts of women and children that Vasari claims Leonardo made as a young man had, as does the *Benois Madonna*, a charm and joviality similar to Desiderio's marble sculptures of the 1450s and early 1460s.

Around the years 1481 and 1482, when Leonardo undertook to paint the Adoration of the Magi (colorplate 10), his largest painting to date, and the penitent St. Jerome (colorplate 14), his mood changed and his emotional range deepened perceptibly and seemingly without warning. He had become intensely responsive to the immense complexities of human nature, to its superficial manifestations, and to the hidden ways the mind functions in moments of great physical and spiritual stress. Both paintings show how well he has understood the anatomy of man and the impassioned and troubled human psyche, bringing them together in reciprocal interaction. Leonardo's interest is in visual truth; it is also in narrative truth, insofar as he attempts, where possible, to return to such primary Christian sources as the Bible and the Apocrypha for his religious themes, in much the same way the humanists were then doing when, as André Chastel says, they attempted "to return to the beginnings, to the Scriptures," in order "to rediscover everything." And so, in the Adoration of the Magi we are witness to an unfolding drama of the acquiescence and humility of three mortal kings to the divine and universal King, and to the awe of all mankind before the spiritual self-revelation of the Son of God. This is the mystical act of the Epiphany that occurred in the biblical Adoration.

This change in Leonardo's mood as revealed in the Adoration and in the St. Jerome was the result of an independent intellectual and spiritual development. Never-

theless, one may detect in these paintings Leonardo's familiarity with the procedures and works of Donatello and Pollaiuolo. From the latter he learned the value of dissection, of the isolation of the human skeleton beneath a taut membrane. However, he painted it with a more consummate understanding of observed reality, for whereas Pollaiuolo and others of his generation almost invariably revised parts of the human anatomy so that they became stylized shapes within a larger decorative pattern, Leonardo chose to lay bare the scientific truth of what he had observed without alteration. Still, he went beyond mere realism and used the emaciated anatomy to convey in the most intense way possible the suffering, self-denial, and spiritual ecstasy of St. Jerome.

The Adoration of the Magi is all drama and action; for this we may, in part, have Donatello to thank. It was in his bronze reliefs for the twin pulpits in the Florentine church of S. Lorenzo that Donatello first succeeded in infusing passionate action into the behavior of intermingling crowds as they react collectively to a miracle or some other religious event. Specific evidence of Leonardo's familiarity with the pulpits may be had by comparing the relationship of the two lateral figures in his Adoration with the comparable treatment of figures in Donatello's relief of the Entombment (fig. 7). In Leonardo's painting and in Donatello's work, the figure on the left is portrayed in deep meditation, while the much younger companion figure on the right looks away from the main action. Yet Leonardo does not so much improve upon the achievement of Donatello as carry his ideas into another realm. He has individualized the mass of writhing and tortured humanity into distinguishable sentiments, emotions, and psychologi-

7. Donatello. ENTOMBMENT. C. 1460-70. Bronze relief on the Gospel Pulpit, 53 7/8 × 110 1/4" (dimensions of entire pulpit). S. Lorenzo, Florence

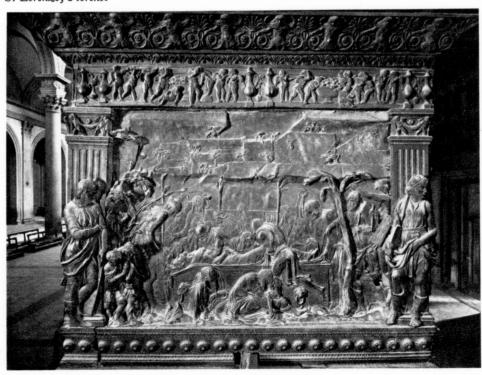

cal states—and, in classical terms, fixed them as types. In so doing he has embodied on a universal plane a large and subtle variety of feelings and attitudes.

At this point, in 1482 or 1483, Leonardo left Florence for Milan, where he remained in self-imposed exile for nearly eighteen years. He thereby exchanged the competitive and upper middle-class society of Florence under the elegant, intellectual, and somewhat patrician leadership of Lorenzo de' Medici for the autocratic and dynastic government of Lodovico Sforza (popularly known as Il Moro, the Moor, because of his swarthy complexion), under whose rule the people of Milan were considered subjects, not citizens. Artistically, Leonardo left an atmosphere that was modern and progressive for one that was peripheral to the mainstream and rather old-fashioned, exchanging the invigorating and exemplary company of Botticelli, Pollaiuolo, and Verrocchio for that of Foppa, Butinone, and Ambrogio de' Predis-artists of good but not commanding talents. In compensation Leonardo entered the very center of Milanese artistic and social life and was accepted at court as a favorite of Il Moro, who gave him an apartment in one of the official residences and later a vineyard.

As court retainer Leonardo assumed a variety of duties and also enlarged his activities as an artist. In Florence he had been essentially a painter; in Milan, although he continued as painter, one of his most important artistic efforts was in sculpture (the Sforza equestrian monument). In addition, he devoted much of his time to military engineering, and designed architectural projects for Milan Cathedral (fig. 8) and for various other churches (fig. 9). Actually, however, he seems to have built nothing. These duties were all within the purview of Leonardo's intellectual, professional, and artistic interests. Others appealed to his sense of fancy and theatricality: he designed sets for theater performances, festivals, marriages, and miscellaneous celebrations. For one of these he made a drawing of a rotating stage (fig. 10). Still other courtly duties distressed him: "It vexes me greatly," he wrote to Il Moro, "that having to earn my living has forced me to attend to small matters."

The immediate circumstances surrounding Leonardo's departure from Florence are not known, but he was in all likelihood prompted essentially by practical considerations. At this time Lodovico Sforza was seeking a sculptor who could cast in bronze an equestrian statue to memorialize his father Francesco. In all of Italy only two studios had developed a high capacity and reputation for bronze casting, those of Pollaiuolo and Verrocchio. Fate contrived to disqualify Pollaiuolo for this task: he had in fact been offered the commission but, according to Vasari, had succeeded in making only two drawings for it. Verrocchio, for his part, was busy at that time designing the Colleoni equestrian monument for the Venetian republic. Only Leonardo, Verrocchio's most gifted pupil, was both

qualified by training and available. On arriving in Milan, however, he may have found Lodovico too absorbed in affairs of state to give much attention to him or to the project for the statue. Conditions in Italy were unstable, and the war Lodovico was waging against Venice was going badly. The war was settled in 1484; but Milan was then struck by a plague that lasted into 1485 and that killed 50,000 people. This was obviously no time to sponsor a costly statue. These factors may explain why when we first hear of Leonardo in Milan he is working on an altarpiece instead of on the Sforza monument. They may also account for the famous letter he wrote to Lodovico, in which he itemized the many ways he could serve him, stressing his talent as a military engineer and concluding with a reference to the equestrian monument, no doubt as a reminder of his purpose in coming to Milan in the first place.

Leonardo probably set to work on the Sforza equestrian monument soon after the plague had subsided in Milan. At first he conceived the horse in the unusual and dynamic rearing position (fig. 11), but later he turned to the traditional striding pose (fig. 12). He then proceeded to make a clay model of the horse that was widely admired for its great size and came to be known, colloquially, as the "colosso." A contemporary account by the mathematician Luca Pacioli records that the model measured approximately twenty-three feet from hoof to mane, or about twice the size of the other equestrian statues of the fifteenth century (Donatello's Gattamelata and Verrocchio's Colleoni, for example, stood eleven and thirteen feet high, respectively, including their riders). Leonardo could not have been motivated by a personal preference when he chose the colossal scale for his monument, since there is nothing in his earlier work that anticipates such great size. We must, therefore, seek the reasons in the statue itself and in the character of the commission. Chief among them no doubt was a desire, or perhaps even a requirement of the contract (which is unfortunately lost), that the statue embody the absolute power and authority of the Sforza dynasty and that it express these qualities by means of a dominant and grandiose image of its founder.

The Sforza equestrian monument was not the first over-lifesize statue of the Renaissance: early in the fifteenth century, Donatello had made a colossal figure of the prophet Joshua, and even before that, in 1394, Jacopo della Quercia had erected a large equestrian statue of the Sienese condottiere Gian Tedesco. But Donatello's work was modeled in terra cotta and Della Quercia's was constructed in wood, straw, tow, hemp, and clay; both were painted to simulate marble. It was not until Michelangelo's David that a statue of colossal proportions, measuring over thirteen feet, was carved in marble. Leonardo might have anticipated Michelangelo in producing a colossal statue in permanent materials had he actually finished

8. dome studies for milan cathedral. 1487–88. Pen, 6 1/2 \times 4 5/8". Codex Atlanticus. Biblioteca Ambrosiana, Milan

9. PLANS AND PERSPECTIVE VIEWS OF DOMED CHURCHES. C. 1490. Pen and ink, 9 \times 6 1/2". Bibliothèque Nationale, Paris

10. ROTATING STAGE. 1490. Pen, 7 1/2 \times 4 7/8" (size of codex). Codex Arundel. British Museum, London

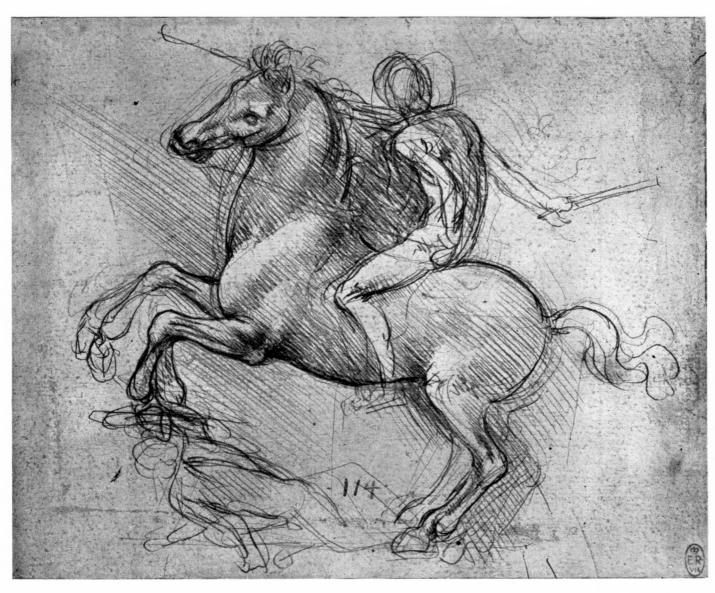

11. STUDY FOR THE SFORZA EQUESTRIAN MONUMENT. c. 1485. Silverpoint on greenish ground, 6×7 1/4". Royal Library, Windsor Castle. Reproduced by Gracious Permission of Her Majesty Queen Elizabeth II

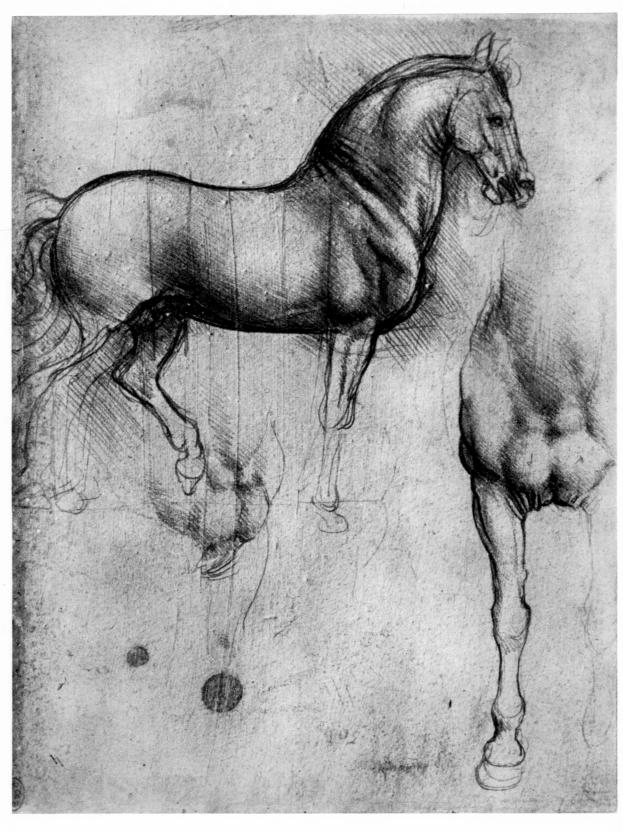

12. STUDY FOR THE SFORZA EQUESTRIAN MONUMENT. C. 1490–91. Silverpoint, 8 $7/16 \times 6$ 5/16''. Royal Library, Windsor Castle. Reproduced by Gracious Permission of Her Majesty Queen Elizabeth II

the Sforza monument. His task, which was to cast a gigantic group using many tons of bronze, was a formidable one in those days. It is impossible to say whether he would have been successful, since the project was abandoned and it seems that Lodovico sent the bronze to his brother-in-law Ercole d'Este in Ferrara in 1494 to make cannons for war. The clay model of the "colosso" was soon seriously damaged by French military archers, who used it as a target. Later still, it was entirely destroyed, probably through decay and neglect.

The "colosso" was the only major work of sculpture known to occupy Leonardo during these Milanese years. For the rest, he was busy with commissions for buildings and especially for paintings, practically all of the latter carried out under court patronage. The most famous painting, of course, is the Last Supper (colorplate 24), still miraculously preserved after centuries of decay and near destruction during World War II. Leonardo also executed portraits of Lodovico Sforza, his wife, and two mistresses. Only one of the latter, the Cecilia Gallerani (colorplate 30), has survived. Also of this period is the Portrait of a Musician (colorplate 31), attributed by many critics to Leonardo, whose provenance and identity are unknown (the sitter may have been a member of Lodovico's court). Finally, Leonardo decorated two rooms in the Castello Sforzesco; only the so-called Sala delle Asse still faintly reveals its former splendor, with a trompe-l'oeil canopy of intertwined tree branches covering its walls and ceiling.

The first work Leonardo executed in Milan is the version of the Madonna of the Rocks today in the Louvre (colorplate 16), which was commissioned by the Confraternity of the Immaculate Conception. It is in many ways a pivotal painting, especially in the treatment of light and nature: one is not prepared for the tense equilibrium of serrated and stalagmitic boulders that compose the grotto in the background or for the intrusion of vaporous mists that inundate it. The light that illuminates the four figures is no longer the relatively shadowless one that was so popular in fifteenth-century Florence, but the one Leonardo himself recommended to artists after he arrived in Milan. It enters the painting from the side at a fortyfive-degree angle and is softened into an evening glow that seems to become a positive force, dispelling the dimness of the cave's interior to reveal a scene of devotional enchantment.

There is a second version of this painting in London's National Gallery (colorplate 17). In its initial conception, it was based on designs by Leonardo, but it was probably executed by Ambrogio de' Predis. Leonardo's style is here changed. The ethereal mood and fragility of the figures of the earlier painting are gone, replaced by an increase in scale and by monumental forms. The change, occurring in all probability between 1485 and 1490, could have been brought on by Leonardo's concurrent work on the colossal Sforza equestrian monument.

Leonardo's career in Milan took a turn away from the visual arts when he began his lifelong habit of recording his odyssean search for knowledge in notebooks. It is appropriate at this point to interrupt our discussion of his strictly artistic evolution and to examine this aspect of Leonardo's career, because in so doing we may better understand certain of the changes in his art after he arrived in Milan.

The notebooks contain extensive notes on a large variety of subjects, including those relating to science and engineering, to which Leonardo was to devote considerable energy for the rest of his life, even at the expense of his activities as an artist. "He is entirely occupied with geometry and has no patience for painting," wrote an eyewitness to his activities in 1501. Leonardo's notebooks reveal a mind in which naturalism and the rule of reason predominate. "All true sciences are the result of experience which has passed through our senses," he wrote, adding that "the eye is the universal judge of all objects." However, he sensibly qualifies this stress on observation: "It seems to me that those sciences are vain and full of error which do not spring from experiment, the source of all certainty." The key words in Leonardo's vocabulary are "science," "eye," "experience," "experimentation." He adds mathematics to this pantheon of intellectual and empirical methodology when he admonishes: "Let no man who is not a mathematician read the elements of my work."

Leonardo fared well as an engineer, since the times were quite propitious for the development and application of this aspect of his talent. Accelerating geographic explorations, industrial and commercial expansion, and increasingly frequent wars all required new and improved navigational devices, machinery of various kinds, military fortifications, and weapons. Leonardo exploited the climate of the times on a typically universal scale by drawing plans to improve health and transportation in cities (fig. 13) and by making sketches of war machines. His talent in these areas did not go unnoticed, and he received as many commissions for works of engineering as he did for works of art. At one point, we hear that Leonardo is actually casting bronze cannons in Milan. In 1502, he served the ruthless and ambitious Cesare Borgia for nearly a year as military engineer, inspecting fortifications for him in northern Italy. Finally, in 1503, Leonardo was able to persuade the Florentine government to engage him for the improbable—and what was for that age surely the impossible—task of diverting the flow of the Arno River in order to cut off access to the sea by Pisa, with which Florence was then at war.

Leonardo's drawings of military and industrial machines, some four hundred in all, are of incalculable importance because they form the most extensive corpus of this sort of mechanical technology to come down to us from the Renaissance. They are also among the most accurate drawings of machines in this period: perspective

14. LENS GRINDER. c. 1490. Pen, height 20". Codex Atlanticus. Biblioteca Ambrosiana, Milan

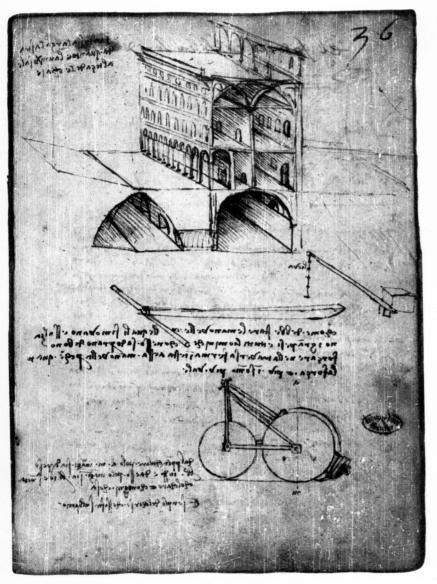

13. STUDY OF A BUILDING. C. 1490. Pen, 9 \times 6 1/2". Codex B. Bibliothèque Nationale, Paris

15. Anonymous. Unidentified war machine. Early 16th century. Pen and ink and wash, $12 \times 9''$. Codex Vaticano Greco 219. Vatican Library, Rome

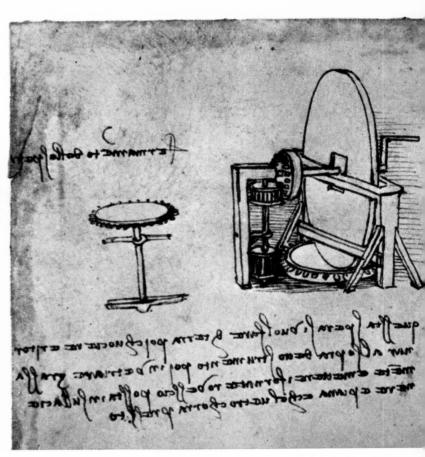

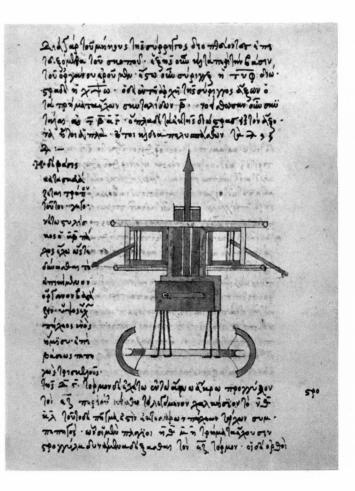

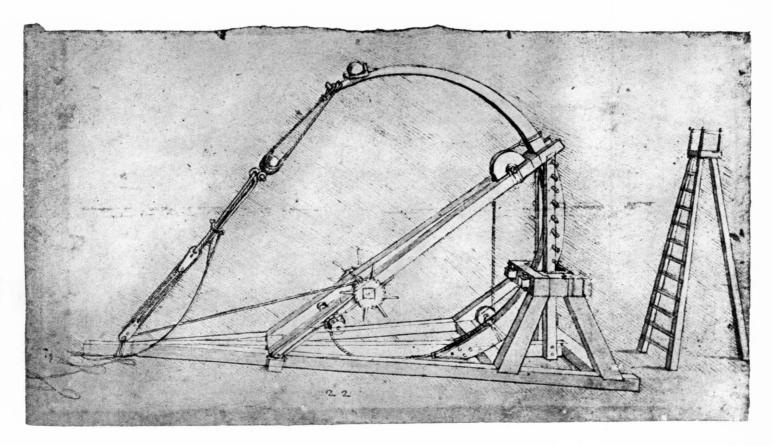

16. CATAPULT. C. 1490. Pen, 4 7/8 × 8 1/2". Codex Atlanticus. Biblioteca Ambrosiana, Milan

and chiaroscuro are employed to give the images naturalistic form and to make their mechanisms explicit enough so that they could be reconstructed and actually manufactured. Compare, for example, the drawing of a lens grinder (fig. 14) by Leonardo with an early sixteenth-century drawing of an unidentified war machine (fig. 15), so abstractly conceived as to be thoroughly indecipherable; or compare his sketch of a catapult (fig. 16) with one by the thirteenth-century architect Villard de Honnecourt (fig. 17).

To what extent were Leonardo's designs for machines original? It cannot be substantiated that he actually invented any of those we find drawn in his notebooks. Nor can we take his famous letter to Lodovico Sforza, in which he boasted about all the war machines he could make, as evidence of his originality. The fact is that there already existed on Leonardo's arrival in Milan more than a thousand such contraptions in the courtyard of the Castello Sforzesco. We would like to think that the famous flying machines he drew (fig. 18) were his own inventions, yet Giovanni Battista Danti of Perugia had already tested a flying machine with movable wings a generation before.

The general belief among specialists is that Leonardo copied machines he saw in factories, in armories, and in manuscripts by other engineers and artists as part of his usual learning process, and that in so doing he refined and

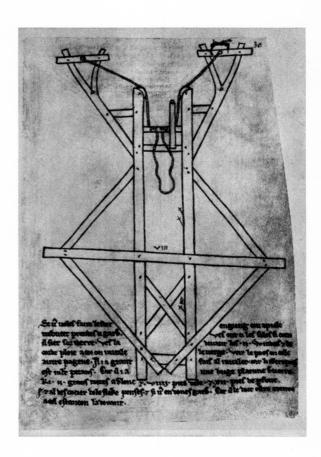

17. Villard de Honnecourt. CATAPULT. 13th century. Pen (?), 9 × 6 3/8". Bibliothèque Nationale, Paris

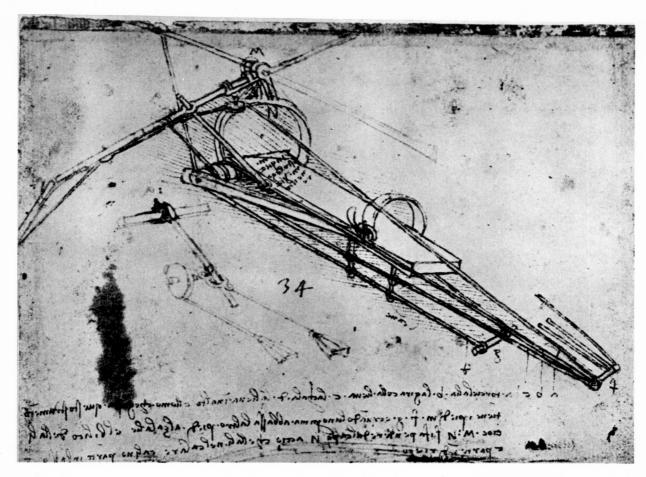

18. FLYING MACHINE. c. 1490. Pen, height 7 1/4". Codex Atlanticus. Biblioteca Ambrosiana, Milan

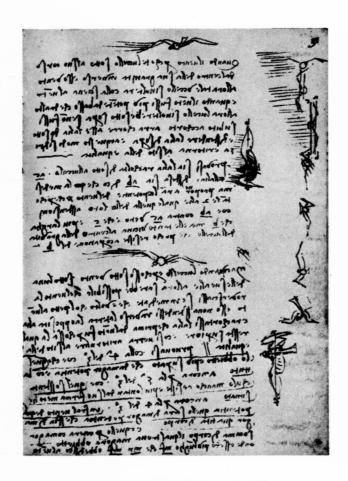

19. birds in flight. Pen, 8 1/2 \times 6 1/8" (size of codex). Royal Library, Turin

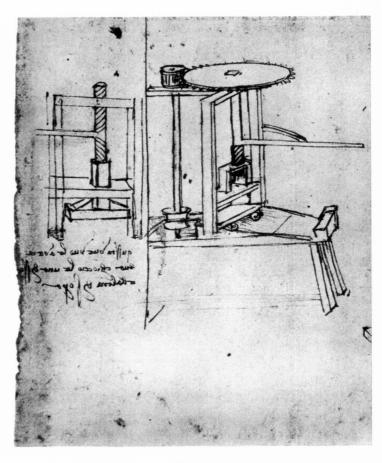

20. PRINTING PRESS. C. 1490. Pen, height 3 3/8". Codex Atlanticus. Biblioteca Ambrosiana, Milan

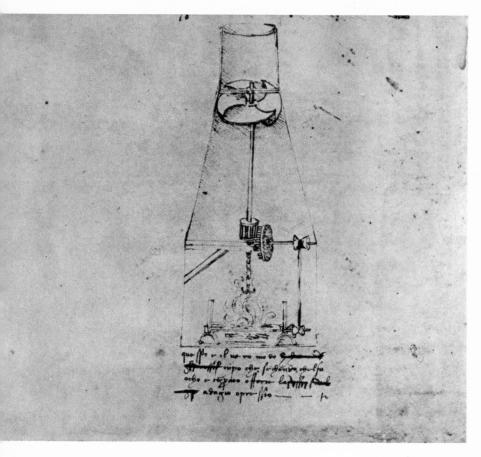

21. TURNSPIT. c. 1490. Pen, 4 7/8 × 2". Codex Atlanticus. Biblioteca Ambrosiana, Milan

There is a marvelous sense of modernity in Leonardo's approach to machinery. Efficiency and practicability, as well as a concern for ways to save time, labor, and space, were among his primary considerations. Leonardo's drawing of a printing press (fig. 20) shows how he intended to improve upon the movable type press developed by Gutenberg in the mid-fifteenth century. His desire was to reduce the number of steps and, consequently, the number of workers needed to operate the machine (from

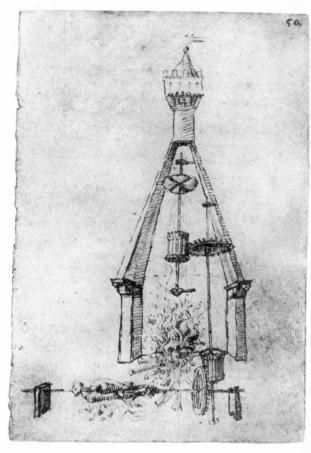

22. Giuliano da Sangallo the Younger. TURNSPIT. Late 15th century. Pen, $7 \times 4 3/4''$ (10 $1/4 \times 4 3/4''$, size of sketchbook page). Biblioteca Comunale degli Intronati, Siena

two to one) by using a single lever that, when turned, would simultaneously lower the platen and pull under it the type bed with its sheet of paper ready to receive the printed impression. His solution was not to be incorporated in printing presses for a century.

Leonardo's drawing of a turnspit (fig. 21) is equally innovative. His contemporaries Francesco di Giorgio and Giuliano da Sangallo the Younger (fig. 22) made drawings of turnspits that were exactly alike in their use of two fires. The function of one fire was to create the updraft needed to activate the flue's blades, which in turn would start the skewer rotating; the other fire, some distance forward, was meant to roast the bird as it rotated on the skewer. Leonardo's turnspit, on the other hand, depends on one fire that serves both functions simultaneously, and is thus a much more compact affair.

Leonardo considered science to be so all-encompassing that for him it even subsumed painting. The artist, he maintained, had to use the methods of science, the scientist the tools of art. A scientist who was unable to draw was, he believed, deficient in a basic means of demonstration, while an artist without a command of geometry could not construct a perspective system (fig. 23) or establish the proportions of men (fig. 24) and animals,

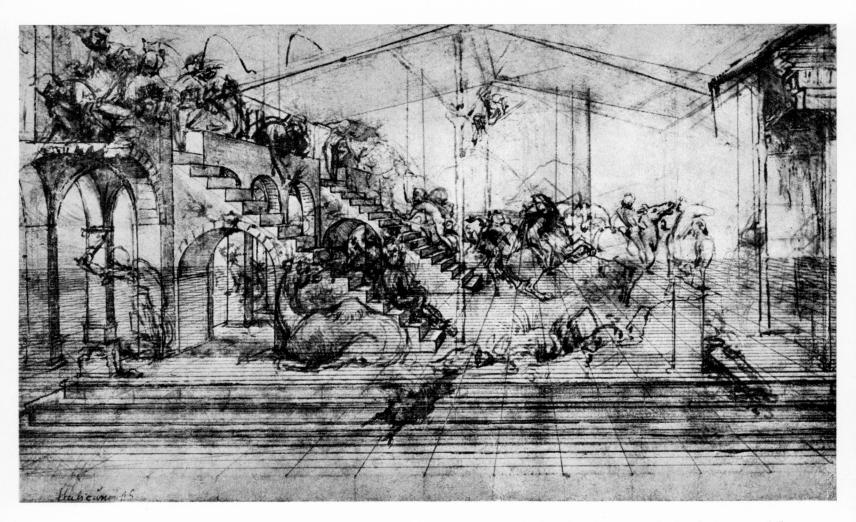

23. Perspective background for the adoration of the magi. 1481–82. Pen and ink and wash over metalpoint, 6 1/2 \times 11 1/2". Gabinetto dei Disegni e Stampe, Uffizi, Florence

24. MALE HEAD SQUARED FOR PROPORTIONS. c. 1488. Pen and ink over silverpoint, $8\ 3/8 \times 6''$. Royal Library, Windsor Castle. Reproduced by Gracious Permission of Her Majesty Queen Elizabeth II

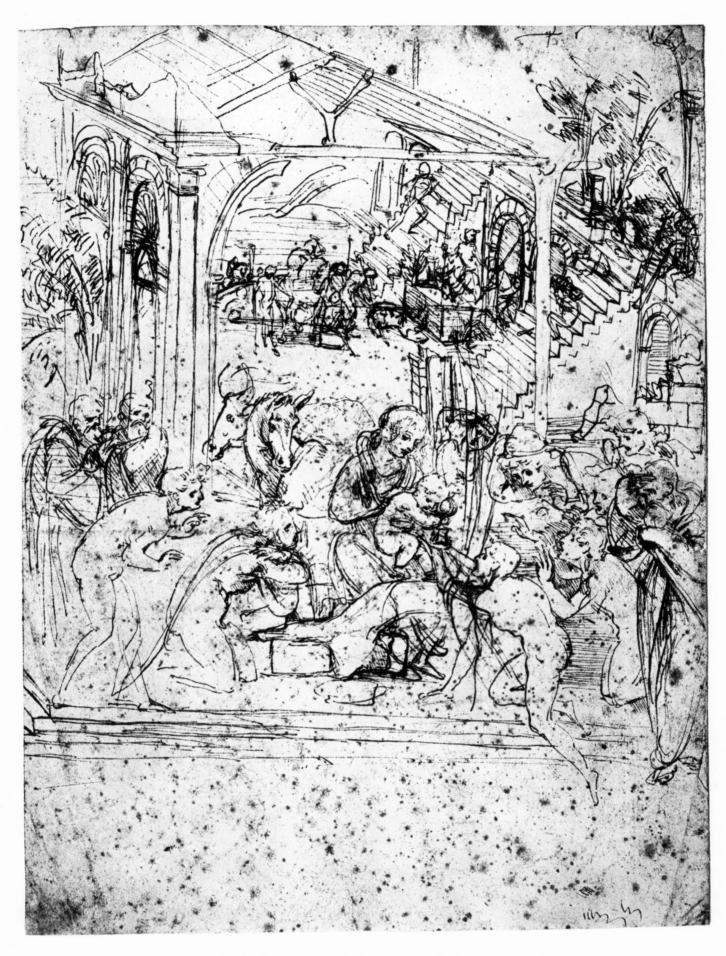

25. Adoration of the magi. 1481–82. Pen over metalpoint, 11 $1/4 \times 8$ 1/2''. Louvre, Paris

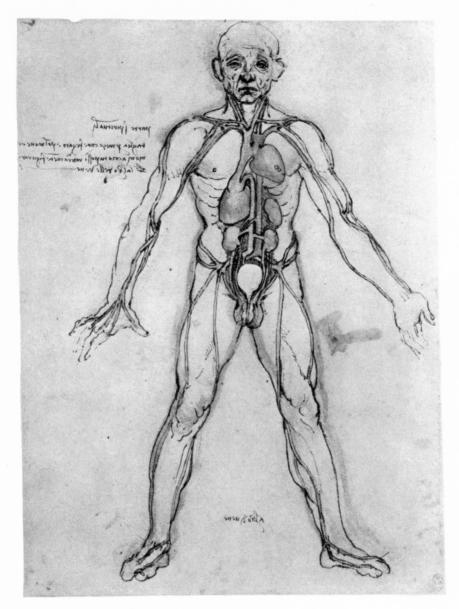

26. ANATOMICAL FIGURE. C. 1490–1500. Pen and ink over black chalk and green wash, 11 1/8 × 7 7/8". Royal Library, Windsor Castle. Reproduced by Gracious Permission of Her Majesty Queen Elizabeth II

which for Leonardo were basic to a work of art. He maintained, furthermore, that the aims of science and art were one and the same in their search for knowledge. However, Leonardo went beyond the simple equation of art with science. "Among the sciences painting comes first," he declared. He called upon artists to enlarge the range of their experiences: "Do you not perceive how many and various notions are performed by man only, how many different animals there are, as well as trees, plants, flowers, with many mountainous regions and plains, springs and rivers, cities with public and private buildings; machines, too, fit for the purposes of man, divers costumes, decorations and arts? And all these things ought to be regarded as of equal importance and value by the man who can be termed a good painter."

When Leonardo—while still in Florence—began to study geometry, anatomy, botany, and the other sciences, he thought of them essentially as the handmaidens of painting and utilized them in traditional ways. For example,

from the early years of the fifteenth century the idea prevailed that the human body had to be understood scientifically before it could be represented artistically. Leon Battista Alberti, the fifteenth-century theoretician and architect, turned this into a precept when he wrote in 1435: "Before dressing a man one first draws him nude, after which we enfold him in draperies; in painting the nude, we put down first his bones and his muscles, which we then cover with his flesh, so that it will not be difficult to understand the place of each muscle beneath the flesh." Leonardo accepted this premise in the series of sketches he executed for the Adoration of the Magi (fig. 25; colorplate 10): he drew various figures in the nude before he clothed them, so that he could understand their anatomies and movements. And for the St. Jerome (colorplate 14), Leonardo's study of the skeleton before he enclosed it in a membrane of flesh is obvious (fig. 26). But there is already in these examples an extreme precision and a curiosity about the objects themselves that go beyond what

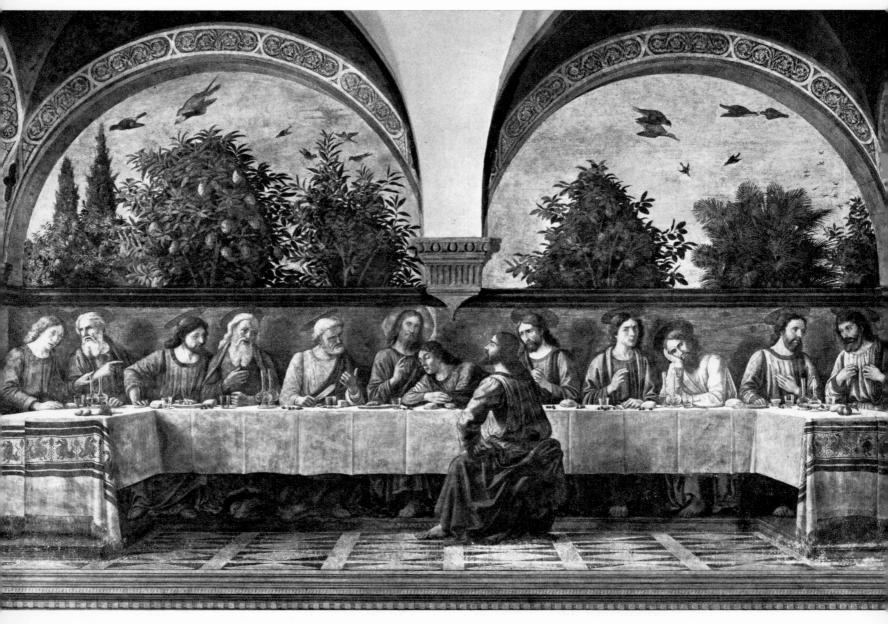

27. Domenico Ghirlandaio. THE LAST SUPPER. 1480. Fresco. Refectory, Ognissanti, Florence

his contemporaries sought and sometimes even beyond the requirements of art.

In Milan, Leonardo's study of nature and his scientific investigations generally seem to have become more formal and theoretical; the natural and physical sciences were becoming for him disciplines to be pursued for their own sakes, and this he did increasingly until his death. During the Milanese years, his paintings, which he considered the summation of knowledge, took on certain of the characteristics of scientific demonstrations. The Last Supper of 1495–97 (colorplate 24) is a striking example of this: no composition could be more orderly or more logical, and the principles of geometry and of a rigorously rational artistic process are everywhere in view. This is in marked contrast to Ghirlandaio's Last Supper of 1480

(fig. 27). Both artists have set out to represent the biblical story of the final supper before the betrayal and crucifixion of Christ. It was then, according to the Gospel of St. Matthew, that Christ said to his followers: "Verily, I say unto you that one of you shall betray me." And He then proceeded to identify his betrayer: "He that dippeth his hand with me in the dish, the same shall betray me."

Never before Leonardo's fresco had this narrative been portrayed with such clarity, with such concern for the unity of time, place, and action, and with such attention to the precise representation of the very moment of the revelation of the betrayal to come. Nor had the individuality of the apostles—at least some of them—ever before been so exactly depicted or their behavior so

systematically characterized, in conformity with psychological and biblical truth: Judas, his sinister attitude announcing his guilt; St. James the Greater, thrusting out his arms in an impetuous gesture; St. Peter, asking the youthful St. John to inquire of Christ the identity of the betrayer; St. Thomas, his finger raised in doubt. And never before had so rigorous and complex a geometric control been applied to a composition: the overall perspective system, the symmetry, the strict arrangement of the figures in groups of three, the geometric shapes of all the sections and details of the painting, including windows, wall hangings, ceiling coffers, and table. Implicit in this geometricization of the religious world may be the idea of its sanctity and universality, an extension of the concept commonly held in the Renaissance that spiritual values inhere in geometric forms. Leonardo has here transferred that concept from the realm of architecture (fig. 9) to painting. Even Leonardo's specific interest in the design of machinery may have had its effect on the painting of the Last Supper. One need only recall his prerequisite for the good painter—that he encompass a wide range of knowledge, including a familiarity with the machine. Thus, for the first time in his painting, groups

of figures have been intricately and systematically interlocked.

This new attitude in regard to the representation of groups of figures may also be seen in the beautiful Burlington House Cartoon of the Virgin and Child with St. Anne (colorplate 32), which Leonardo began a few years after the Last Supper. In contrast to the much earlier Madonna of the Rocks (colorplate 16), we find in the cartoon a rigorous compression in which the figures have been so concentrated that the bodies, glances, movements, and gestures all perpetually interconnect, interweave, and conjoin like the parts of a machine (fig. 14). Of course, Leonardo was not literally translating the function of machines into the creation of a work of art; but his experience in designing machines, and more generally, in thinking in larger scientific terms created in him a frame of mind and a way of seeing that conditioned nearly everything he did and that led him to equate painting with science.

Due to Lodovico Sforza's defeat by the French in 1499, Leonardo departed from Milan in December of that year and spent the early months of the following year in other cities of northern Italy—at the Este court

28. VERSO OF THE PORTRAIT OF GINEVRA DE' BENCI. C. 1474. Oil on panel, 15 $1/8 \times 14 1/2''$. National Gallery of Art, Washington, D.C. Ailsa Mellon Bruce Fund

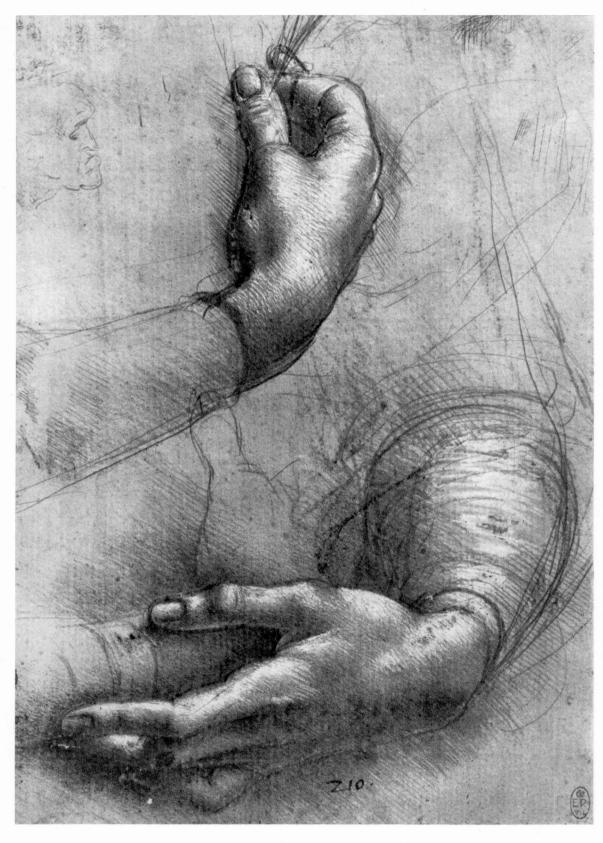

29. STUDY OF HANDS. C. 1485. Silverpoint, 8 $1/2 \times 57/8''$. Royal Library, Windsor Castle. Reproduced by Gracious Permission of Her Majesty Queen Elizabeth II

in Mantua, then in Venice, and finally at Vaprio (near Milan)—before returning to Florence in late April of 1500. He had left this city nearly eighteen years before, still a young man with his reputation unformed; he returned the great and famous creator of the Last Supper and the "colosso," and with a distinguished reputation as an engineer as well. The Florence to which he now returned was vastly changed. The Augustan deportment that had radiated from the person of Lorenzo de' Medici and that had lent a certain courtly nuance to Florentine society had succumbed to a more active republicanism and a more broadly conceived democratic government. Popular rule was channeled through a Great Council, an assembly of 3,000 male citizens whose responsibility it was to legislate and to elect officials. The new regime had been brought on by the revolution of 1494, two years after Lorenzo's death. The atmosphere in Florence when Leonardo returned was tense and anxious. The city was engaged in an interminable war with Pisa that sapped her resources and isolated her from her Italian neighbors. Yet Leonardo had at least

missed the period immediately following the revolution, when Fra Savonarola's highly inflammatory leadership was at its most influential. The friar's violent and compulsive condemnation of vanity and profanity, in art as in life, were no longer to be heard in Florence after his execution in 1498, and no longer were paintings burned at his instigation or created to conform to his parochial standards of taste and morality.

The first three years after Leonardo returned to Florence were for him without artistic focus or marked interest in painting. He did request and receive a commission for an altarpiece for the church of the SS. Annunziata, although nothing came of it. During this time too he worked, I believe for Louis XII, King of France, on the Burlington House Cartoon of the Virgin and Child with St. Anne (colorplate 32) and on the lost Madonna with the Yarnwinder for Florimond Robertet. The last-named painting is mentioned in a letter that a certain Fra Pietro da Novellara sent to his correspondent in Mantua, Isabella d'Este, in April of 1501. Leonardo also began a second cartoon of the Virgin and Child with St. Anne in about 1501. This

cartoon is known only through a description in another letter Fra Pietro wrote to Isabella a few days earlier. According to Fra Pietro, Leonardo seems to have agreed to paint several panels for Isabella, including her portrait, but it is doubtful that he ever intended to honor these commitments. There is also mention of one or two unidentified portraits that were then being painted by pupils under his indifferent supervision. Otherwise, Leonardo's thoughts were almost entirely devoted to geometry. Moreover, for nearly a year, in 1502, he was away in northern Italy inspecting military fortifications for Cesare Borgia. When he returned to Florence the next year, he again picked up the major strands of his artistic career, yet without abandoning his abiding involvement in science and engineering.

The new phase of Leonardo's career opens with the Battle of Anghiari, an uncompleted mural he prepared for the recently built Hall of the Great Council in the Palazzo Vecchio. The Hall was to serve as the meeting place for the citizens' legislative council, and Leonardo's painting was to form a pair with Michelangelo's Battle of Cascina (fig. 31) on either side of a centrally located dais that included seats for the head of state and eight magistrates. Leonardo's

mural was to occupy the right wall. A chapel was erected against the wall facing the dais, and it was to have had an altarpiece by Filippino Lippi. Sometime after the latter's death in 1504, the commission was given to Fra Bartolommeo, who painted a Virgin and Child with St. Anne that includes a variety of other saints (fig. 32). It is safe to assume that this subject was the one that had been required of Lippi as well. The Hall of the Great Council was thoroughly changed when Vasari remodeled it in the 1550s, and there is no remaining visual evidence of its original appearance. However, using records of payments to the painters and craftsmen who decorated and furnished the Hall, Johannes Wilde has given us a believable reconstruction of the interior (fig. 33) as it would have looked in the early years of the sixteenth century had Michelangelo and Leonardo completed their murals.

The Battle of Anghiari, the Battle of Cascina, and the Virgin and Child with St. Anne were part of a unified program that was intended to expand upon the central meaning of the Hall itself, which in the minds of the Florentines embodied democratic and republican values. It is easy to imagine the ideological implications inherent in paintings of battles in which the Florentines had been vic-

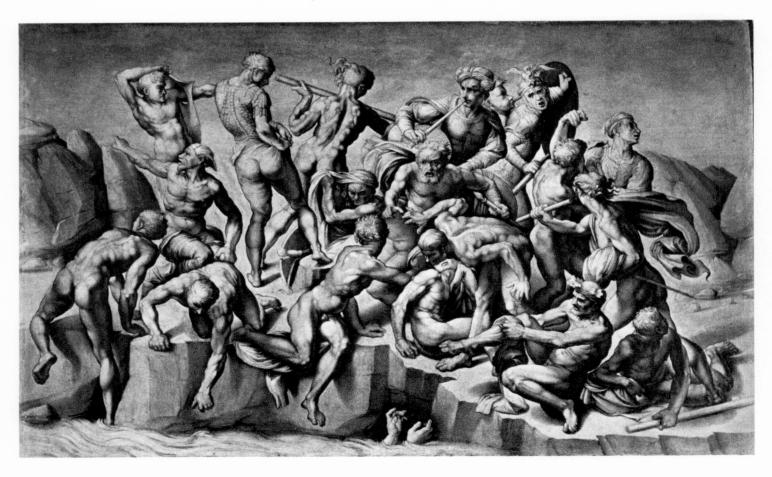

31. Aristotile da Sangallo (attributed). COPY OF CENTRAL SECTION OF MICHELANGELO'S CARTOON FOR THE BATTLE OF CASCINA. Early sixteenth century. Grisaille on paper, 30 × 52". Collection Lord Leicester, Holkham Estate, Norfolk

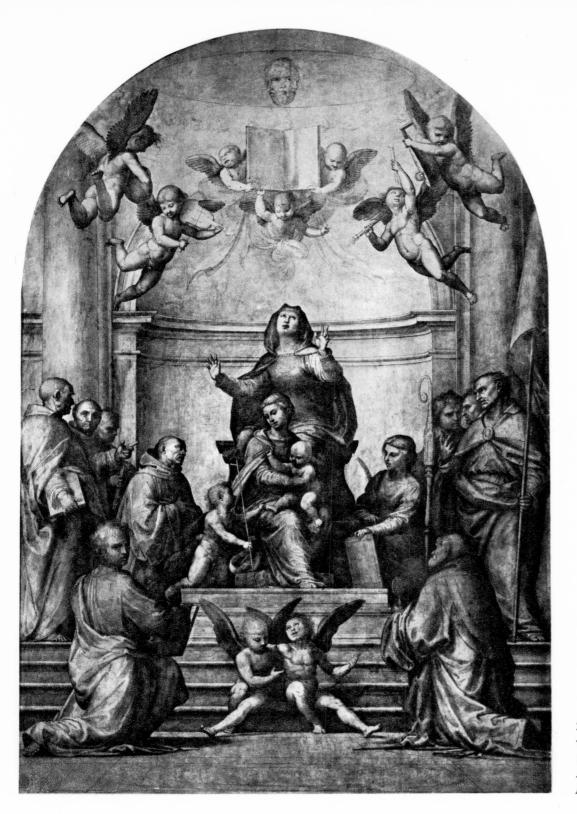

32. Fra Bartolommeo. VIRGIN AND CHILD WITH ST. ANNE. 1510. Oil on panel, 47 $1/4 \times 303/4''$. Museo di S. Marco, Florence

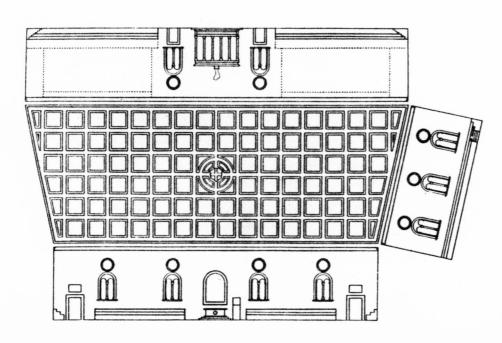

33. RECONSTRUCTION OF THE HALL OF THE GREAT COUNCIL, FLORENCE. Original structure built before 1512. From J. Wilde, Journal of the Warburg and Courtauld Institutes, VII, 1944

torious against threats to their republic: the first with the Pisans at Cascina in 1365, and the second with the Milanese at Anghiari in 1440, twelve years before Leonardo was born. The war that Florence was currently waging against its old rival Pisa (whose strongest support was coming from Milan, Florence's other traditional enemy) obviously played a part in the selection of these particular military engagements from the past as subjects for the frescoes in the Hall.

The role of Fra Bartolommeo's Virgin and Child with St. Anne in the ideological program of the Hall's decoration would be difficult to ascertain were it not for Vasari, who noted that the painting included the figures of the protectors of Florence and those on whose feast days the city had won its victories. We have Wilde to thank again, this time for corroborating Vasari's division of the saints into these two categories and for identifying four saints: Victor, on whose feast day the battle against Pisa was fought at Cascina; and John the Baptist, Bernard, and Zenobius, patron saints of Florence. Wilde might also

have noted the importance of St. Anne in this iconographic scheme, since it was on her feast day—July 26, 1343—that a revolt broke out against the tyrant Gualtiere di Brien, the so-called Duke of Athens, which led to the restoration of democratic government in Florence.

The decorative program of the Hall of the Great Council may have had several levels of political and rhetorical meaning, but prominent among them must have been the themes of freedom and divine protection. The altarpiece establishes the intervention of God and the saints in the efforts of Florence to retain her liberty and her democratic traditions against both internal and external threat. The battle scenes may be interpreted as secular pictorializations of those efforts and as reminders to the Florentines of the greatness and courage of their ancestors, who had fought repeatedly to preserve those traditions. These paintings of men and horses were to be monumental in size, and the concepts they embodied likewise grew with them to a scale that was larger than life—an appropriate enough way for government to en-

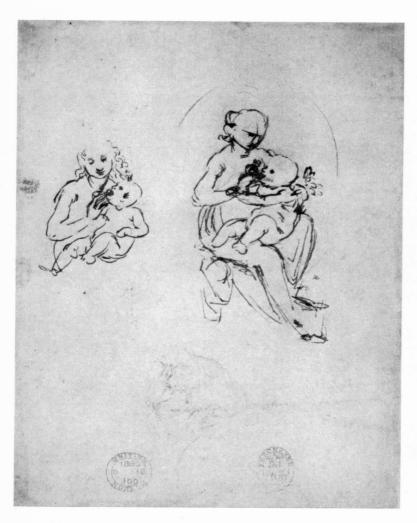

34. STUDIES FOR THE BENOIS MADONNA. c. 1478. Pen and leadpoint, 7 $3/4 \times 5 7/8''$. British Museum, London

35. Lorenzo di Credi (attributed). COPY OF THE BENOIS MADONNA. Late 15th century. Panel, 18 $7/8 \times 12 5/8''$. Galleria Colonna, Rome

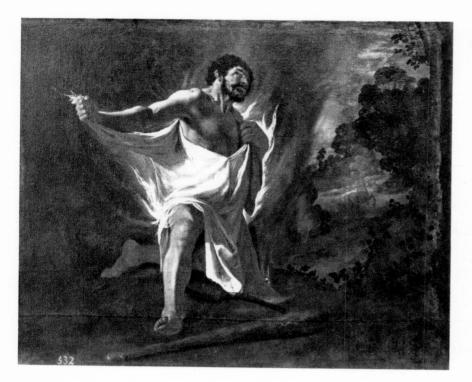

36. Francisco de Zurbarán. HERCULES SEARED BY THE POISONED CLOAK. 1634. Oil on canvas, 53 $1/2 \times 65 3/4''$. Prado, Madrid

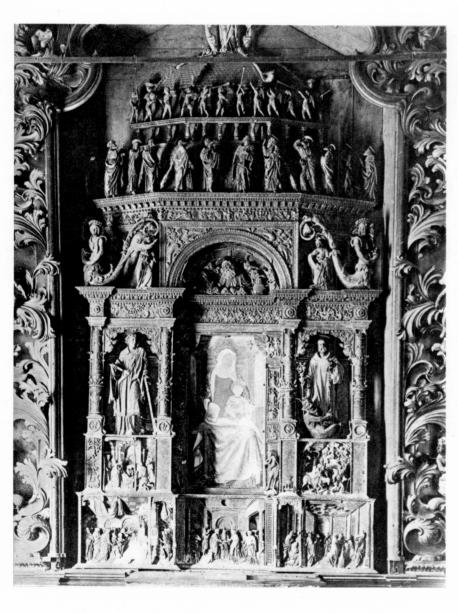

38. Anonymous.

PERSONIFICATION OF GEOMETRY. C. 1500.

Woodcut, 6 5/8 × 4 5/8".

Frontispiece of the

Antiquarie Prospettiche Romane.

Biblioteca Casanatense, Rome

37. Angelo del Maino. MORBEGNO ALTARPIECE. Begun 1516. Wood, 196 7/8 × 118 1/8". S. Lorenzo, Morbegno, Italy

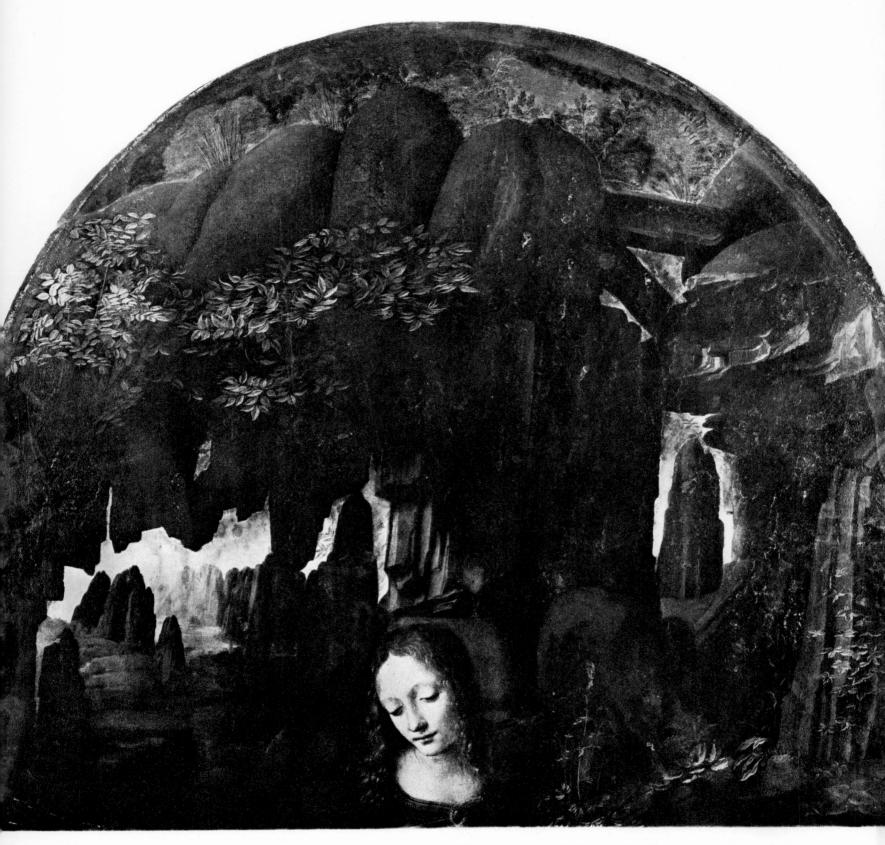

39. MADONNA OF THE ROCKS (detail, infra-red photo). 1482-83. Oil on canvas (originally panel), 78 × 48 1/2". Louvre, Paris

noble and universalize its highest principles, as Leonardo had previously done in the Sforza equestrian monument. Here again, Leonardo lent his artistic talents to political and propagandistic purposes.

The episodes Leonardo and Michelangelo were assigned to paint for the Hall could not have been more congenial to their artistic temperaments. Michelangelo found in his an opportunity to portray his beloved human figure in a great variety of poses and as if he were creating a relief in marble. Leonardo, who from his earliest years had been fascinated by the horse and its potential for conveying dynamic force and movement, now again had a chance to explore that subject. Furthermore, he could continue his study of man under conditions of physical and mental stress and elaborate on the entanglement of forms and figures he had introduced in the Last Supper and developed in the Burlington House Cartoon. But I wonder if he might not have felt alternate moments of excitement and despair as he tried unsuccessfully to recapture, in paint this time, the grandeur and power of expression he had attempted in his only other civic commission, the Sforza equestrian monument. I wonder also which of the conflicting principles of government that underlay these two projects, authoritarian rule or popular governance, he found most attractive: his personality, his

actions, and his associations suggest a loyalty to neither and an indifference to both.

Leonardo began the fascinating Mona Lisa (colorplate 34) in 1503, the same year he began the cartoon for the Battle of Anghiari, and the republican character of Florence at the time seems also to have conditioned his approach to this portrait. Mona Lisa, probably the wife of a wealthy merchant, betrays her upper middle-class status by a rather matronly and calm attitude. This is in imitation of the type of portraiture that had been practiced by Jan van Eyck and other Flemish artists of the early fifteenth century, and that had already been adopted by Italian portrait painters of the generation preceding Leonardo's. Mona Lisa vaunts her provocative personality by turning on the beholder a frank and bemused glance and an ineffable smile. She presents a marked contrast to Cecilia Gallerani, the mistress of Lodovico Sforza, whose portrait (colorplate 30) Leonardo had painted in Milan a few years earlier. Cecilia's complicated pose is studied and slightly mannered, and thus helps hide her thoughts and feelings, for she turns her head to the side, away from the beholder, gazing aimlessly into a distant void. Her figure is set against a neutral background so that the beholder is forced to admire the beautiful and elegant outline of her face, her fashionable dress and hairdo, and the ermine

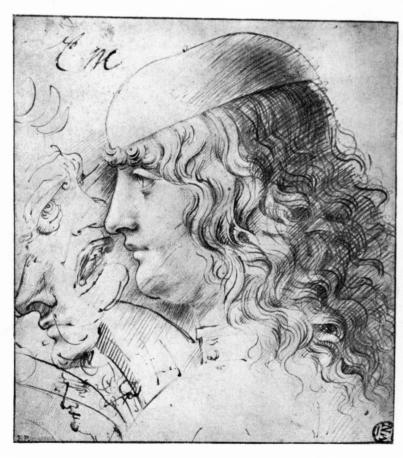

40. Ambrogio de' Predis (attributed). STUDIES OF HEADS. C. 1490. Pen, 7 1/8 × 6 1/8". Louvre, Paris

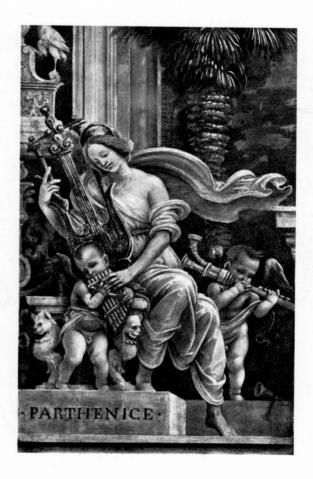

41. Filippino Lippi. PARTHENICE. 1501-2. Fresco.
Strozzi Chapel, S. Maria Novella, Florence

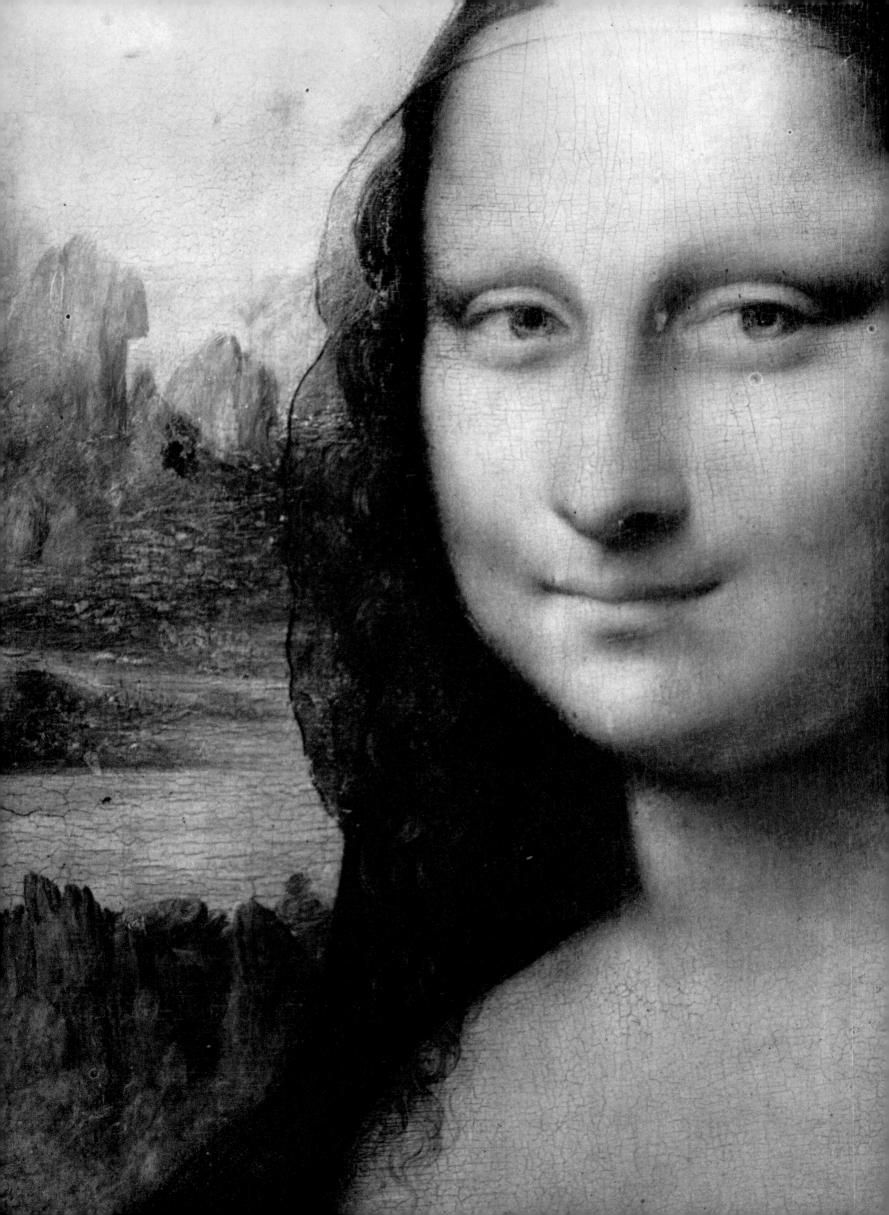

43. Lorenzo di Credi (attributed). A MIRACLE OF S. DONATO OF AREZZO AND THE TAX COLLECTOR. C. 1479. Tempera on panel, 6 $1/2 \times 13$ 11/16''. Worcester Art Museum, Worcester, Mass. Theodore T. and Mary G. Ellis Collection

■ 42. MONA LISA (detail, infra-red photo). 1503-7. Oil on panel, 30 1/4 × 20 7/8". Louvre, Paris

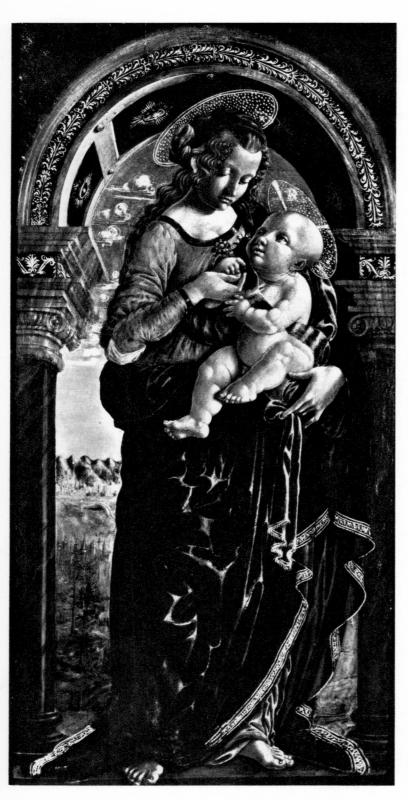

45. Anonymous (follower of Bernardo Butinone). VIRGIN AND CHILD. 1490s. Oil on panel, $36\ 5/8\ \times\ 18\ 7/8''$. Pushkin Museum, Moscow

in her arms (an attribute of the highest society). The Cecilia Gallerani is a courtly portrait; to find anything comparable to the Mona Lisa in Leonardo's earlier work, we have to revert from these Milanese years to the first Florentine period, when the Ginevra de' Benci was painted. To be sure, the Mona Lisa is a more profound and mature portrait, but directness of manner and the impact of personality are already vigorously in evidence in the sullen and coldly aloof expression of Ginevra.

The remainder of Leonardo's life was spent primarily in Milan, Rome, and at Cloux in France. He made two relatively brief visits to Milan in 1506 and 1507, first for nearly a year and then for one month. In 1508, he again returned to Milan, this time for an extended stay of five years, and served as court painter to Louis XII. This was the culmination of persistent attempts in the previous two years by the French monarch to entice Leonardo to paint several pictures for him, among them "two Madonnas." It is not unlikely that the Virgin and Child with St. Anne now in the Louvre was one of them (colorplate 37). However, the only work Leonardo is known for certain to have begun in Milan at this time (and of which we have a visual record) is a bronze equestrian statue of Gian Giacomo Trivulzio, general of the French army. Unlike the Sforza equestrian monument, this one was to be a private funerary monument for the family chapel in the church of S. Nazaro in Broglio. Since the new statue was to have natural dimensions, the problems of statics, support, and casting that Leonardo had faced in the Sforza monument were considerably lessened. This may have encouraged Leonardo once again to attempt a dramatic rendering of the horse, rearing on its hind legs, rather than striding forward (fig. 47). However, he abandoned this solution for the more dignified pose-probably mainly for reasons of decorum (fig. 48). Leonardo's drawings show his several attempts to design the mausoleum structure upon which the horse was to rest, the basic elements of which are a classical architectural form, nude male figures bound to columns, and an interior space for the coffin of the deceased. The remarkable similarity of the mausoleum to the Tomb of Pope Julius II that Michelangelo had begun to design in Rome in 1505 has been endlessly commented upon and reveals the crosscurrents of ideas that existed between these two great contemporaries, despite their overt mutual hostility. The Trivulzio monument never came to fruition, being another doomed attempt in Leonardo's career as a sculptor.

Leonardo may have painted the now-lost Leda and the Swan while in Milan, apparently after two attempts to do so in Florence between 1503 and 1506. The fact that it was executed in Milan around 1508 and that it was seen at Fontainebleau much later, in 1625, makes it possible that Leonardo had been pressed to finish the painting, not by his original patron—whoever he may have been—but by Louis XII or some member of his court.

A copy in the Borghese Gallery (fig. 50) of the original painting reproduces the spiraling figure of Leonardo's Leda and gives some idea of her fleshy qualities. Leonardo's earliest drawings for the *Leda*, of 1503–4, show the figure kneeling in a bold, tension-filled pose (fig. 49). In this, the *Leda* compares with the figures in a coeval painting, the *Battle of Anghiari* (colorplate 47), although the posture in the former is more arbitrarily conceived. In the final painted *Leda* Leonardo eased up on the serpentine twist, but he made the body more gently sinuous and mannered. Its outline and movement were painted with a feeling for the decorative continuity of spiraling form, which replaces the natural articulation of anatomy and posture; its willowy elegance recalls the languid grace

of a Botticelli Venus (fig. 51), but with the body thicker, softer to the touch, and emitting a distinct aura of eroticism.

In 1513, Leonardo went to Rome at the invitation of Giuliano de' Medici. We learn from Vasari that he was engaged by Pope Leo X (Giovanni de' Medici), Giuliano's cousin. It was an unpleasant and difficult time for him in some ways: he met with rebukes from the Pope, who was annoyed by Leonardo's dilatoriness in completing a painting for him and for illegally using corpses in making anatomical studies; there were also petty difficulties with local craftsmen. It was in Rome that he may have begun the St. John the Baptist today in the Louvre (colorplate 39). A study of this work indicates that Leonardo's

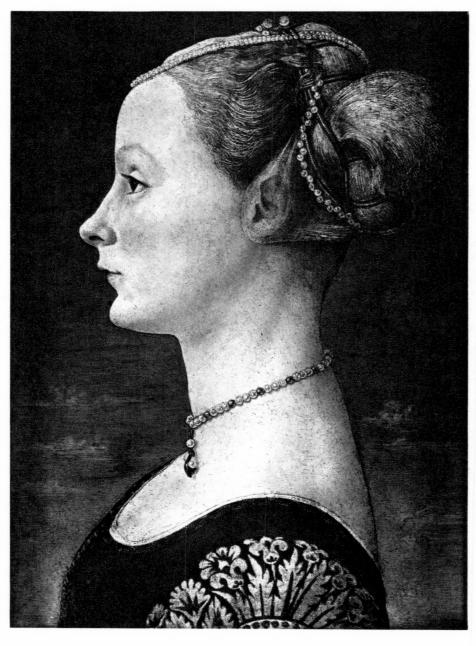

46. Antonio Pollaiuolo. Portrait of a woman. c. 1470. Tempera on panel, 18 $1/8 \times 13 \ 3/8''$. Poldi-Pezzoli Museum, Milan

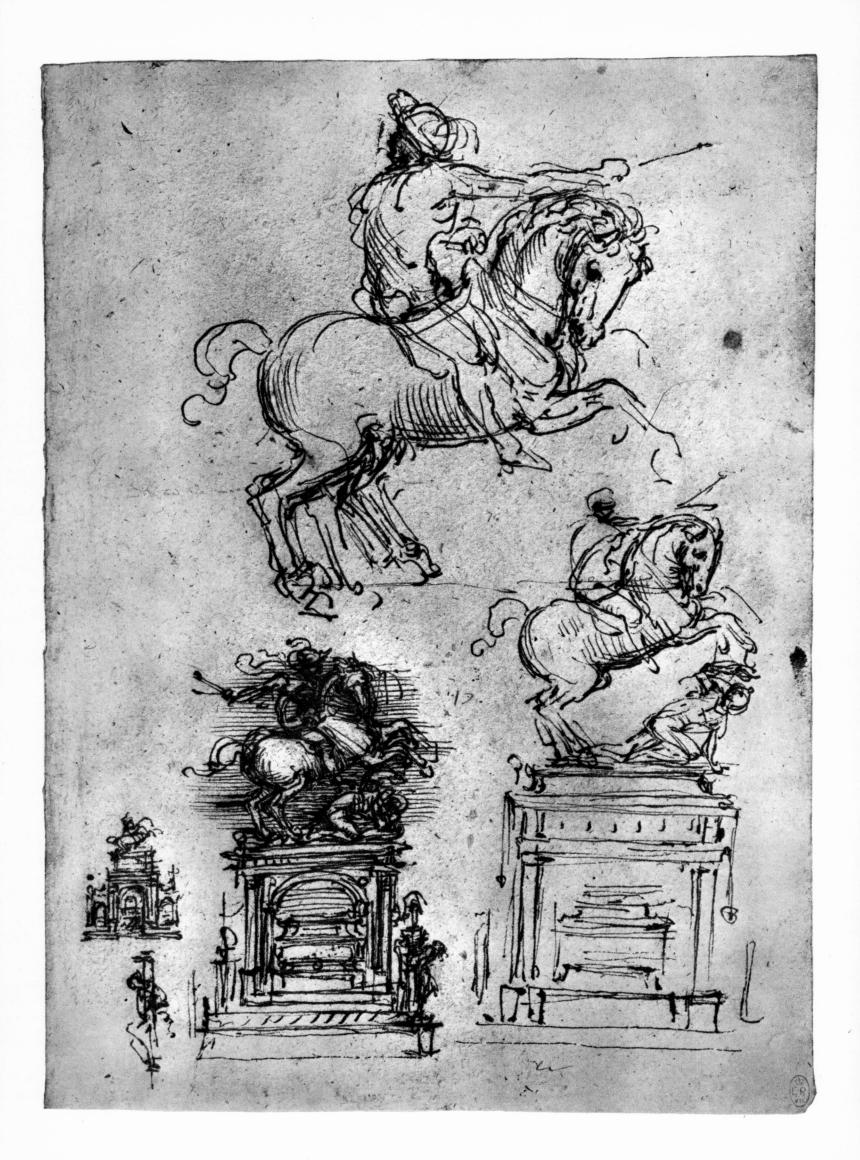

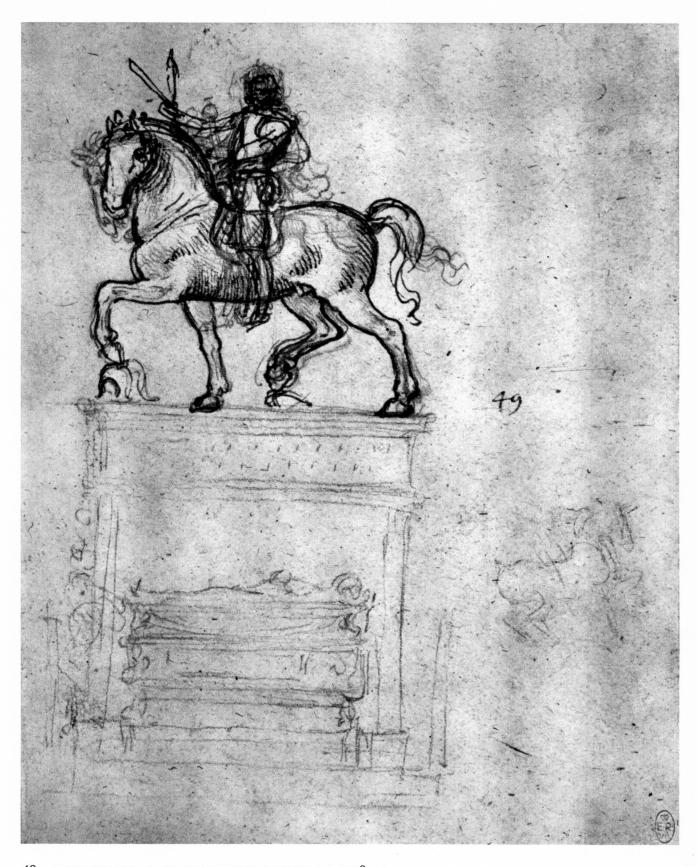

48. STUDY FOR THE TRIVULZIO EQUESTRIAN MONUMENT. 1508–11. Pen and red chalk, $8\,5/8\times6\,7/8''$. Royal Library, Windsor Castle. Reproduced by Gracious Permission of Her Majesty Queen Elizabeth II

■ 47. STUDY FOR THE TRIVULZIO EQUESTRIAN MONUMENT. c. 1508–11. Pen and bister, 11 × 7 7/8". Royal Library, Windsor Castle. Reproduced by Gracious Permission of Her Majesty Queen Elizabeth II

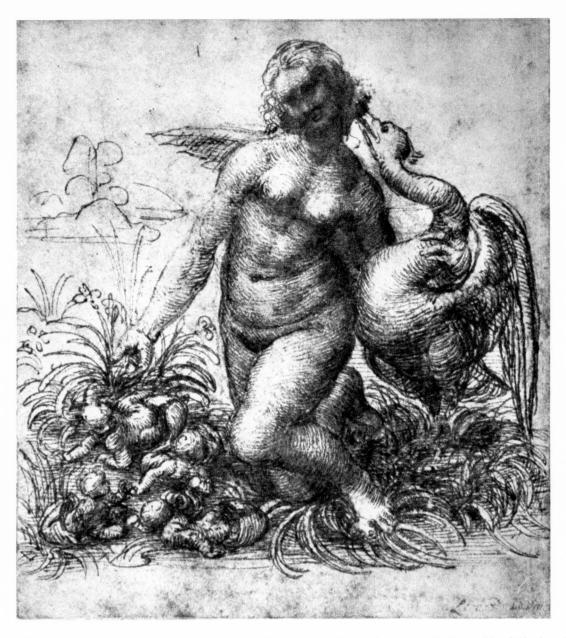

49. STUDY FOR A KNEELING LEDA. 1503-4. Pen over wash, 6 $1/4 \times 5 1/2''$. Devonshire Collection, Chatsworth. By courtesy of the Trustees of the Chatsworth Settlement

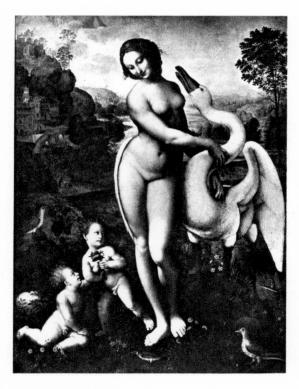

50. Anonymous. Copy of Leonardo's Leda and the swan. Early 16th century. Panel, $44\ 1/4 \times 33\ 7/8''$. Borghese Gallery, Rome

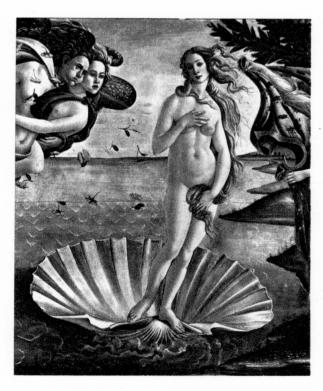

51. Sandro Botticelli. The birth of venus (detail). After 1482. Tempera on canvas, 5' 9" \times 9' 2". Uffizi, Florence

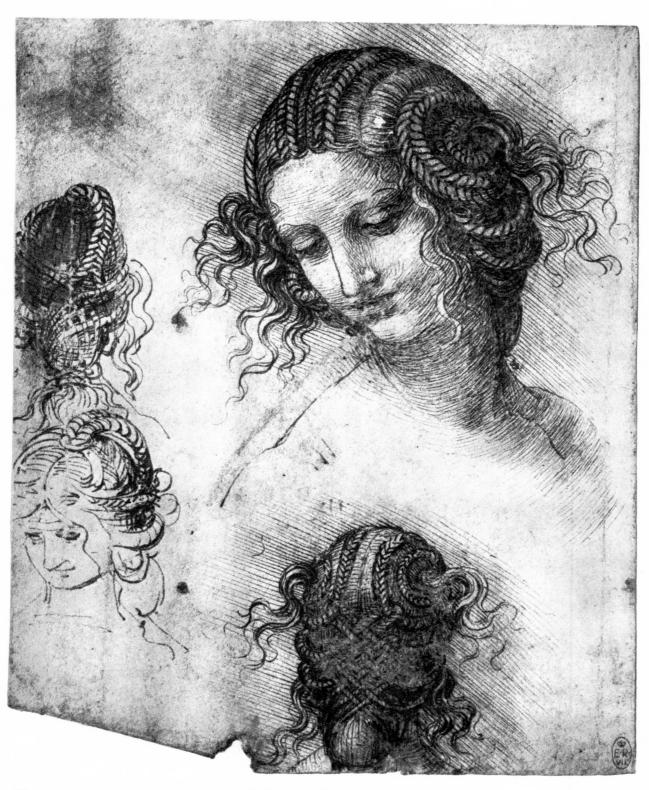

52. STUDIES FOR THE HEAD OF LEDA. 1508. Pen over black chalk, 7 7/8 \times 6 3/8". Royal Library, Windsor Castle. Reproduced by Gracious Permission of Her Majesty Queen Elizabeth II

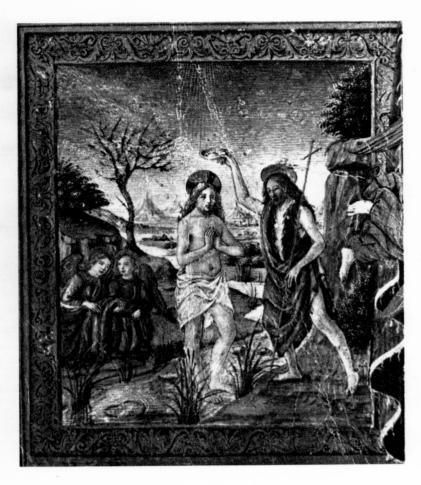

53. Migliore Attavante. BAPTISM OF CHRIST. 1483–85. Parchment, 1 3/8 × 3/4". Miniature detached from the Missal Romanum, illuminated for the Bishop of Dol. Musée des Beaux-Arts du Havre, Le Havre

artistic mood has again clearly changed. Observable nature has been excluded, and definable psychological characterization such as we saw in nearly all his previous works is no longer his primary concern. Such characterization had already been largely stripped away in the Louvre version of the Virgin and Child with St. Anne and in the painted Leda. We see this too in his sketches for the Leda (fig. 52), where the facial expression and the forms of nature had become equivocal and rarefied. What is emerging in the St. John to displace the more strictly geometric configurations of composition is an abstract language of figural representation, setting, and atmosphere that is invoked less to bolster the narrative aspect of the subject than to express its underlying mystical qualities. This parallels developments in Leonardo's scientific thinking that more and more concern themselves with abstract questions, with the underlying and invisible aspects of reality, with gravity, weight, force, and with generative processes. He has left us evidence of some of this: visually in the form of drawings of the act of copulation, of embryos (fig. 55), of the movement of water and wind as manifested by abstract, two-dimensional patterns of swirling designs (figs. 56, 57); descrip-

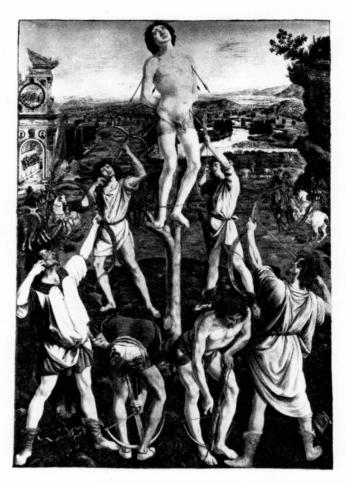

54. Antonio Pollaiuolo. MARTYRDOM OF ST. SEBASTIAN. C. 1473. Tempera on panel, 153 $1/4 \times 78 \ 3/4''$. National Gallery, London

tively in explanations of how erosion and the fossils of remote geological times contribute to the formation and transformation of river beds and land masses.

St. John the Baptist is Leonardo's final statement. This spiritual emissary, like an apparition, is bathed in a light that enters from an unseen source. The pervasiveness of shadows blacks out all visible references to a circumscribed and familiar world, and the saint is made to appear what he is-a heavenly being who exists in a cosmic and spiritual realm beyond that of physical reality. St. John's role, as the last of the old and the first of the new prophets who foretell the coming of Christ, is to admonish man on his uncertain fate and arouse in him fear and concern for his salvation. For all Leonardo's presumed atheism and unrelieved commitment to pure science, a conception such as we find in this painting could not be anything but the expression of a deeply felt and personal religious faith. We are of necessity led to this conclusion by Leonardo's unique definition of a work of art as the summation of knowledge, which is to say, the revelation of personal knowledge and experience acquired by the artist who has observed the world of man and nature. Leonardo may have pressed this function of art

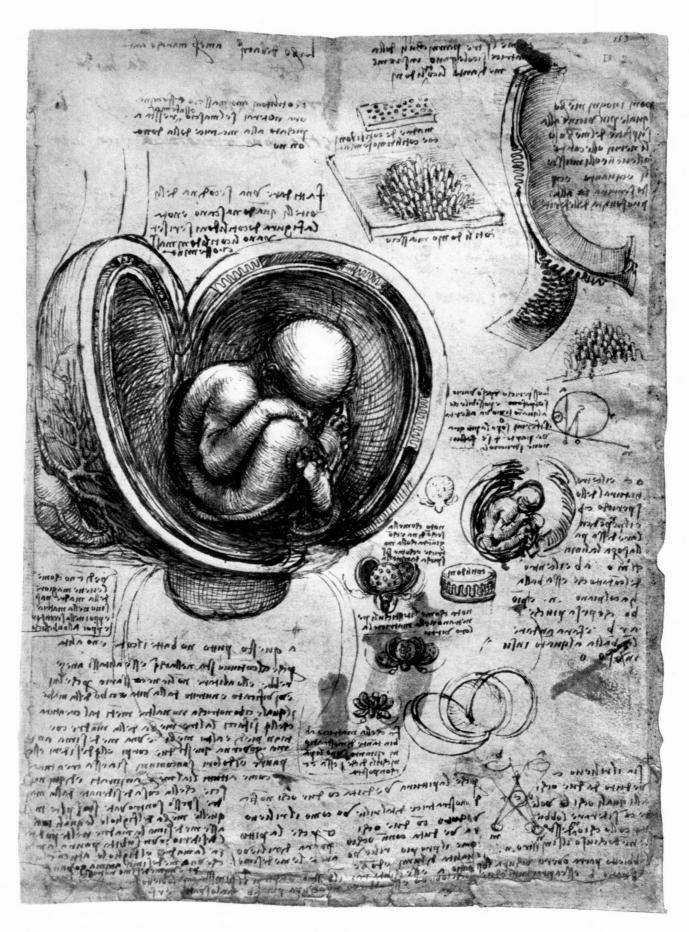

55. STUDIES OF EMBRYOS. C. 1510–13. Pen over red chalk, 11 $7/8 \times 8$ 3/8''. Royal Library, Windsor Castle. Reproduced by Gracious Permission of Her Majesty Queen Elizabeth II

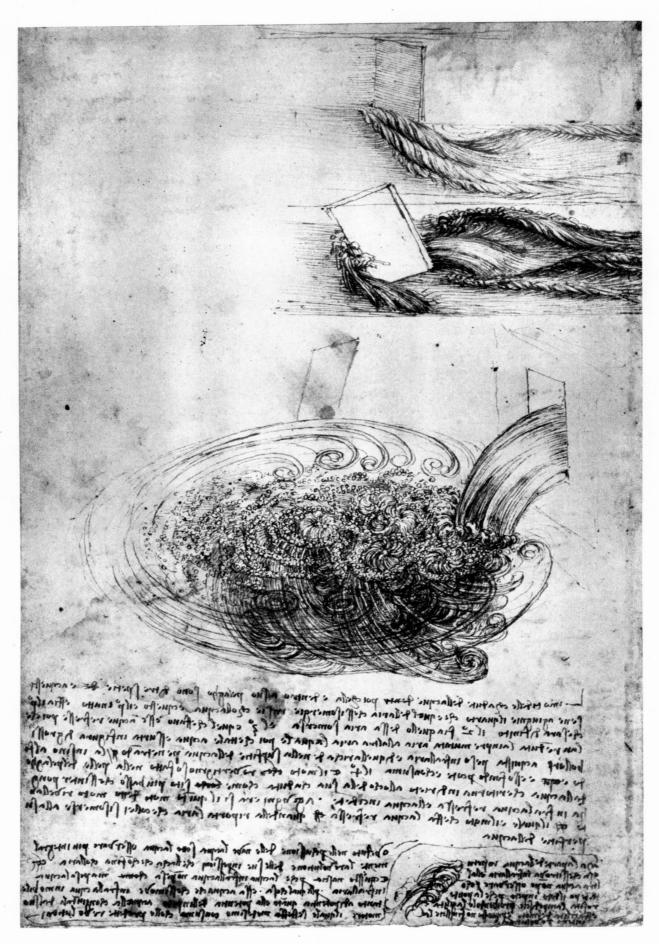

56. STUDIES OF WATER MOVEMENTS. C. 1508. Pen and ink, 11 3/8 × 8".

Royal Library, Windsor Castle. Reproduced by Gracious Permission of Her Majesty Queen Elizabeth II

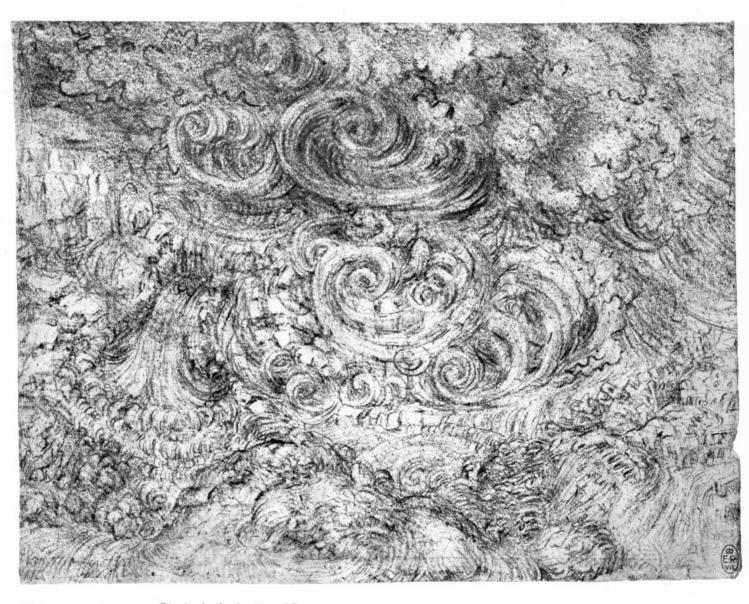

57. A DELUGE. C. 1515. Black chalk, 6 $3/8 \times 8''$. Royal Library, Windsor Castle. Reproduced by Gracious Permission of Her Majesty Queen Elizabeth II

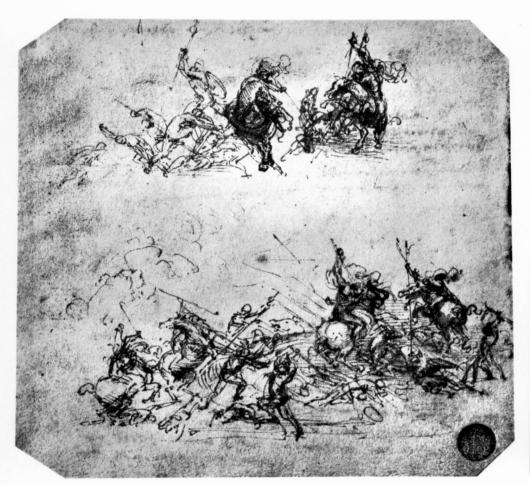

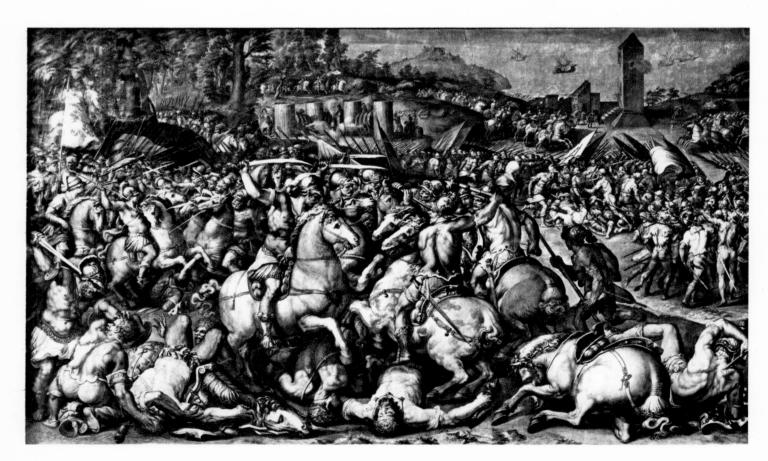

59. Giorgio Vasari. BATTLE OF S. VINCENZO. 1557. Fresco, 24' 6" × 42' 6". Palazzo Vecchio, Florence

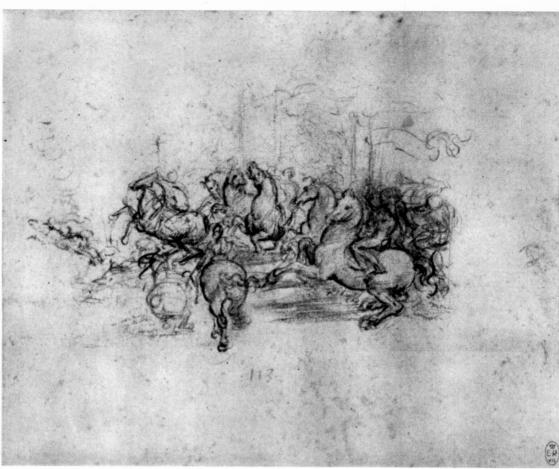

58. STUDIES FOR THE BATTLE OF ANGHIARI (Neufeld reconstruction). 1503-5.
a): Pen, 6 1/4 × 6 1/8". Accademia, Venice.
b): Pen, 4 × 5 1/4". Accademia, Venice.
c): Black chalk, 6 1/4 × 7 3/4".
Royal Library, Windsor Castle. Reproduced by Gracious Permission of Her Majesty Queen Elizabeth II

to a new level of self-expression in the St. John, permitting it to convey the artist's apprehensions and anticipations, his profoundest feelings and beliefs—in this instance, religious expression as another aspect of human reality.

In 1514 and 1516, respectively, two of Leonardo's most important patrons—Louis XII and Giuliano de' Medici—died. Fortune intervened, however, in the figure of François I, Louis XII's successor to the throne of France. He became Leonardo's patron, great friend, and protector in the artist's last years. In 1516, Leonardo set out for France at the new monarch's invitation and was given lodgings in the castle at Cloux. There he died on May 2, 1519. Only shortly before, on April 23, he had providentially made his last will and testament, no doubt because of his rapidly failing health. We may guess that he had suffered a series of strokes, since two years earlier—in an eyewitness report—Antonio de' Beatis noted that Leonardo had lost the use of an arm.

The French period was, from an artistic point of view, the least fruitful of Leonardo's entire career. He seems to have made designs for the royal castle of Romorantin (fig. 61), which, typically, did not go beyond the

planning stage. To our knowledge, he began no new paintings or statues at this time, although François I did request a panel of the *Virgin and Child with St. Anne*. These last years seem to have been given over primarily to his scientific studies and to entertaining the King, who greatly admired his mind and his gift for brilliant conversation.

Leonardo now found the peace, the solitude, and the admiration he had longed for most of his adult life. He had few fixed responsibilities, no conflicts with competitors or intrusions from the curious and the envious; no rebukes, no criticism; failure had become a word without meaning for him. In short, he enjoyed and indulged his new-found intellectual freedom and his role as royal retainer. As far as François I was concerned, Leonardo himself seemed a work of art by the mere fact that he existed, perfect and eminently successful. We concur with him today, for Leonardo has come to epitomize the intellectual and creative grandeur to which all men can aspire. Leonardo exemplifies the words of the Renaissance humanist Pico della Mirandola: "We [God is speaking] have given you, Oh Adam, no visage proper to yourself, nor

60. Anonymous. STUDY OF A HEAD. c. 1473. Pen, brown ink, and brown wash, 6 15/16 \times 6 7/16". Pierpont Morgan Library, New York

61. STUDY FOR ROMORANTIN CASTLE. c. 1518. Black chalk, 7 1/8 × 9 5/8".

Royal Library, Windsor Castle. Reproduced by Gracious Permission of Her Majesty Queen Elizabeth II

any endowment properly your own, in order that whatever place, whatever form, whatever gifts you may, with premeditation, select, these same you may have and possess through your own judgment and decision. The nature of all other creatures is defined and restricted within laws which We have laid down; you, by contrast, impeded by no such restrictions, may, by your own free will, to whose custody We have assigned you, trace for yourself the lineaments of your own nature. I have placed you at the very center of the world, so that from that

vantage point you may with greater ease glance round about you on all that the world contains. We have made you a creature neither of heaven nor of earth, neither mortal nor immortal, in order that you may, as the free and proud shaper of your own being, fashion yourself in the form you may prefer. It will be in your power to descend to the lower, brutish forms of life; you will be able, through your own decision, to rise again to the superior orders whose life is divine."

DRAWINGS

It is staggering to note that more than 1,500 of Leonardo's drawings have vanished, probably forever. Therefore, we should be thankful for the circumstances that have allowed more than 600 of them to survive today in a number of institutions, notably the Royal Library at Windsor Castle, although it is not entirely clear what these circumstances were. Leonardo's penchant for keeping his drawings, in order to refer back to them while at work on some great painting, obviously contributed to their preservation. Another factor in their preservation was Leonardo's foresight in leaving his artistic effects to his faithful friend and assistant, Francesco Melzi, in whose possession they remained until his death in 1570. Fortune then intervened to keep the drawings together still longer: they were purchased from Melzi's heir, who seemed insensitive to them, by the sculptor Pompeo Leoni, probably between 1582 and 1590. Leoni bound them together in several volumes, and they remained intact until the end of the century or until his death in 1608. After that date, the history of the drawings becomes uncertain and their fate precarious. Thanks to the new spirit of collecting, one group of 600 drawings had entered England's Royal Collection by the late seventeenth century. The rest have nearly all been lost-many during the artist's own lifetime, due partly to the workshop practice of passing drawings on from one artist to another for study and use.

Without the drawings of Leonardo at Windsor and a few others elsewhere, we would be denied pages of great beauty and a meaningful understanding of the man himself, of his artistic achievement, of his creative processes, and of his intellectual and emotional range. They contain, for example, all we know of his two most famous efforts as a sculptor: the Sforza and the Trivulzio equestrian monuments. The Sforza statue, executed by Leonardo as a full-scale model in clay, was later wantonly destroyed. The drawings alone reveal to us Leonardo's extraordinary creativity as an architect (as seen in several intricate plans and elevations of churches and projects for urban designs), as an anatomist (an area of study he helped elevate to a science by means of his precise anatomical drawings), and as an engineer (evident in his marvelous drawings of machines, precious manifestations

of a bygone world of engineering in the fifteenth and sixteenth centuries).

But that is not all. The drawings convey Leonardo's enchantment with the by-products and curiosities of human thought and feeling, as registered in his tantalizing and mysterious allegories, in his graceful masquerade figures, in those imaginary creatures that take on fantastic shapes, and in sketches of grotesques and deformed old men and women, some of them perhaps dwarfs at the court of his patron, Lodovico Sforza, in Milan. The powerful *Deluge* series, with its brooding evocations of the cosmic destruction of the world, reflects the morbid and pensive mood of his later life. And a valuable record of his facial features remains in the famous red-chalk *Self-Portrait* in Turin, impressive in its Aristotelian grandeur and intense intellectualism.

Observation was for Leonardo the basis of all art. and images had first to be set down on paper, he believed, before they could be conceived in monumental form. And so, using a variety of instruments-silverpoint, pen, sanguine, black chalk, the brush—he drew everything he saw. Men and women, the young and the old, children, animals of all sorts, mechanical objects, trees, flowers, rocks and mountain ranges, flowing water, even the unseen wind came within the range of his vision and interests. Drawings, therefore, had two basically inseparable functions for Leonardo. First, they served as miscellaneous and conscientious records of visual reality, made with the purpose of understanding animate and inanimate nature, its form, structure, movement, dynamics, individual character, and force-and, where man was concerned, expression. Second, they became classifiable elements of experience and knowledge that he could use for his scientific and engineering investigations and as ideas to group into a variety of combinations forming the many preliminary studies and projects he made for specific paintings. In the final analysis, however, Leonardo viewed both proces es as one, because what he learned from nature as an observer, what he learned at the dissecting table as a scientist, and what he learned in practice as an engineer he intended ultimately to place at the service of art, which was for him the summation of knowledge. Drawings were the means to this end.

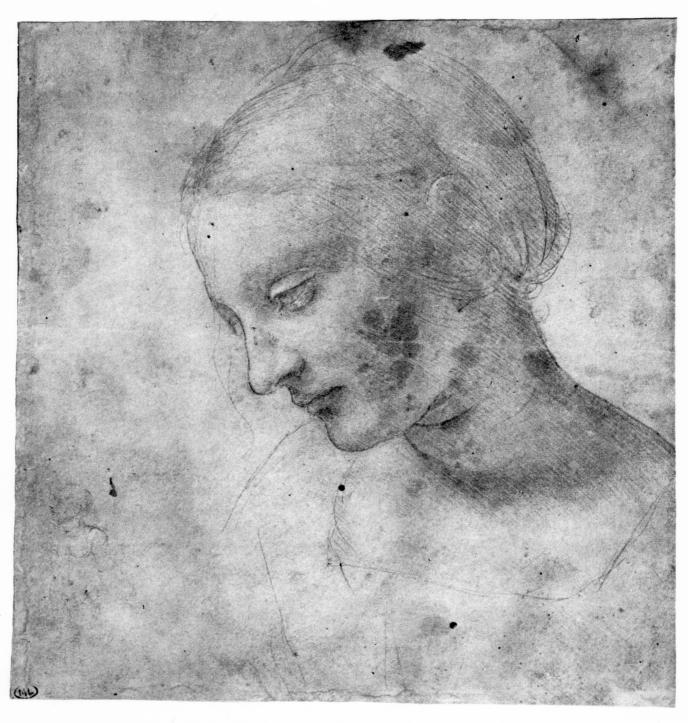

62. Head of a woman. c. 1490. Silverpoint, 7 1/8 \times 6 5/8". Louvre, Paris

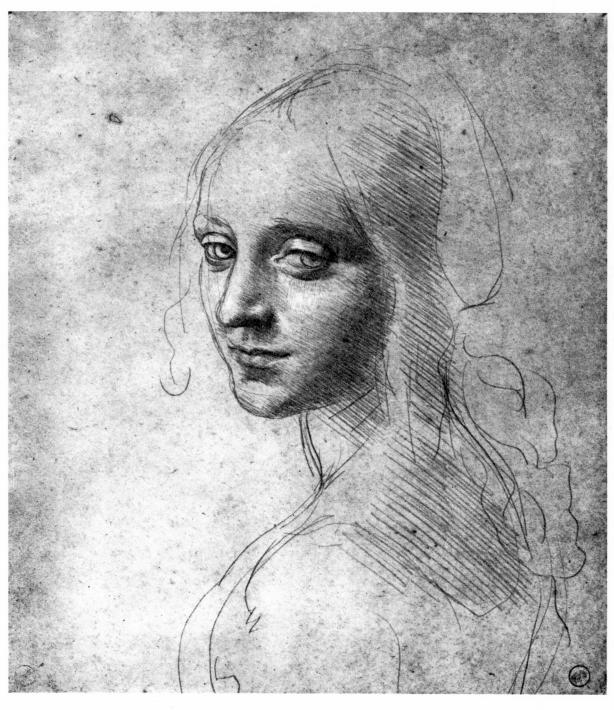

63. Head of a girl. c. 1486–90. Silverpoint and white on rose-colored paper 7 1/8 \times 6 1/4". Royal Library, Turin

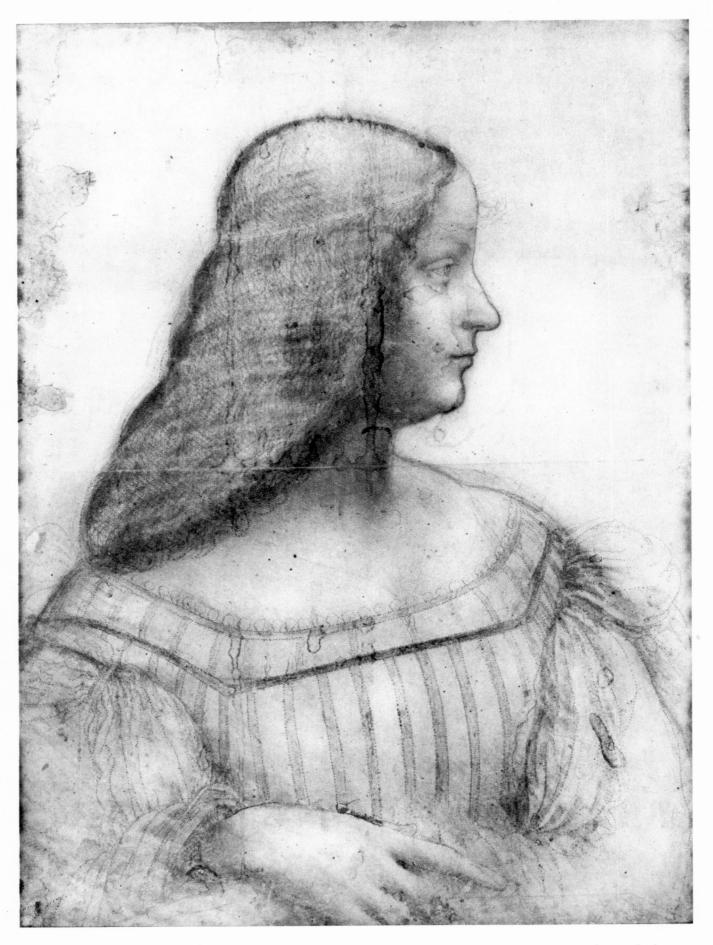

64. PORTRAIT OF ISABELLA D'ESTE. 1500. Black chalk with charcoal with pastel, 24 7/8 × 18 1/8". Louvre, Paris

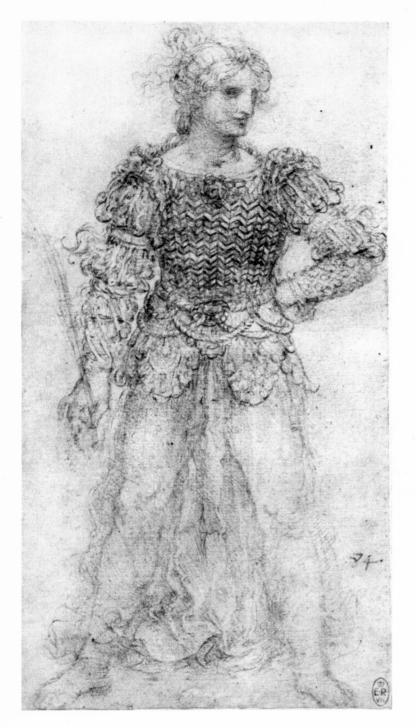

65. FIGURE IN A MASQUERADE COSTUME. C. 1513. Black chalk, 8 1/2 × 4 7/8".

Royal Library, Windsor Castle.

Reproduced by Gracious Permission of Her Majesty Queen Elizabeth II

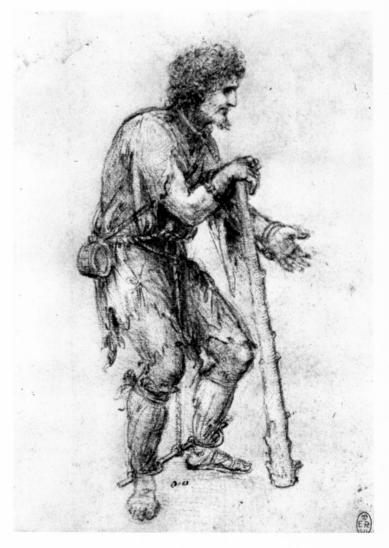

66. SHACKLED PRISONER. C. 1512.
Black chalk, 7 1/4 × 5".
Royal Library, Windsor Castle.
Reproduced by Gracious Permission of
Her Majesty Queen Elizabeth II

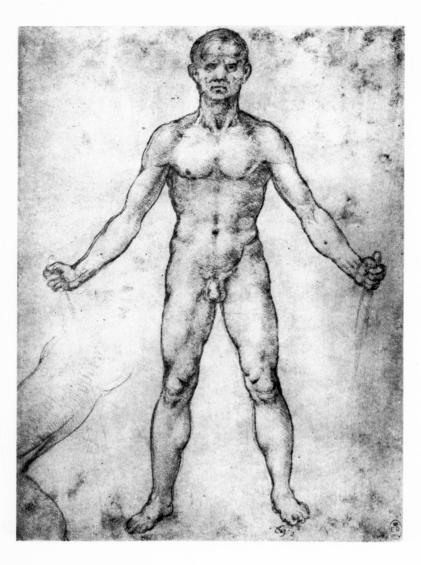

67. MALE NUDE. C. 1503-7. Red chalk, 10 3/4 × 6 1/4". Royal Library, Windsor Caslte. Reproduced by Gracious Permission of Her Majesty Queen Elizabeth II

68. STUDY OF HORSES. C. 1478.

Pen and ink over leadpoint, 4 1/4 × 7 1/4".

Royal Library, Windsor Castle.

Reproduced by Gracious Permission of

Her Majesty Queen Elizabeth II

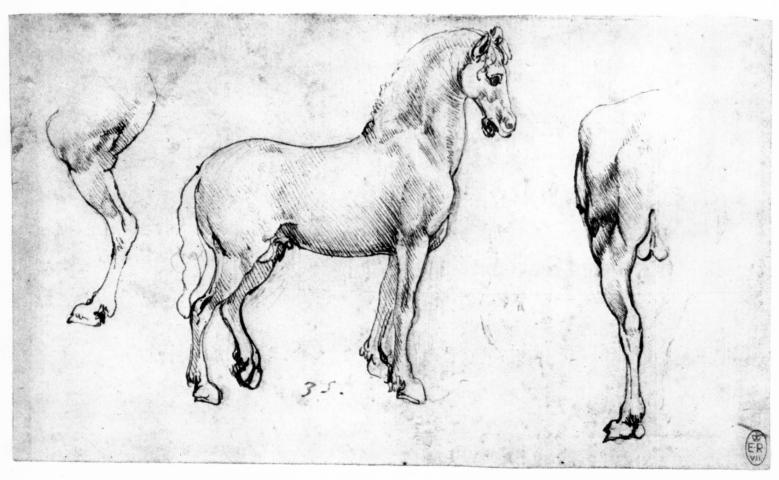

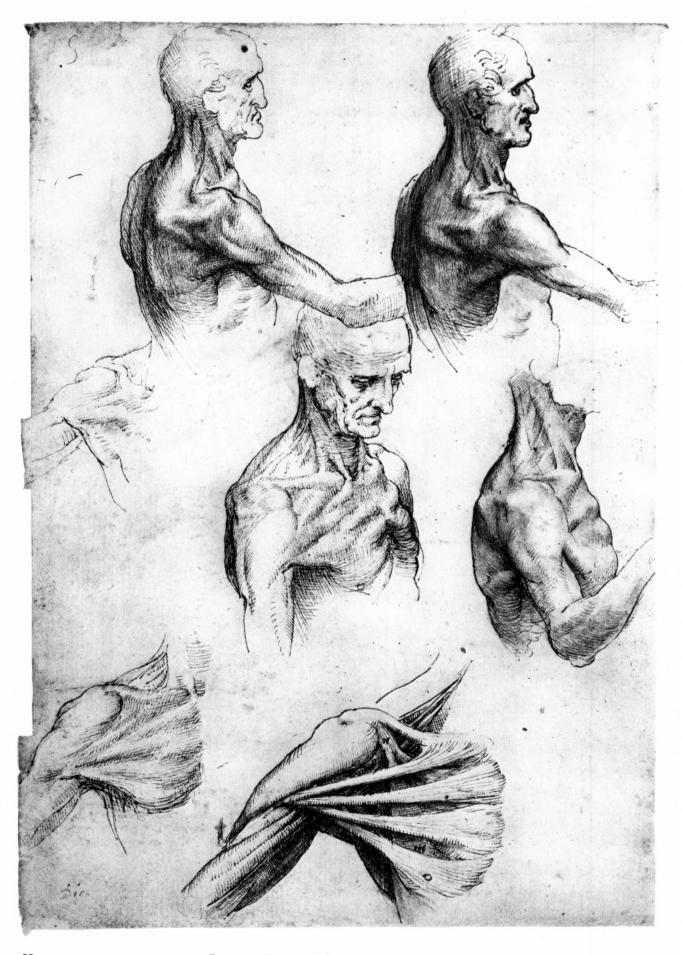

69. Anatomical studies. 1510. Pen, 11 $3/8 \times 7 \ 3/4''$. Royal Library, Windsor Castle. Reproduced by Gracious Permission of Her Majesty Queen Elizabeth II

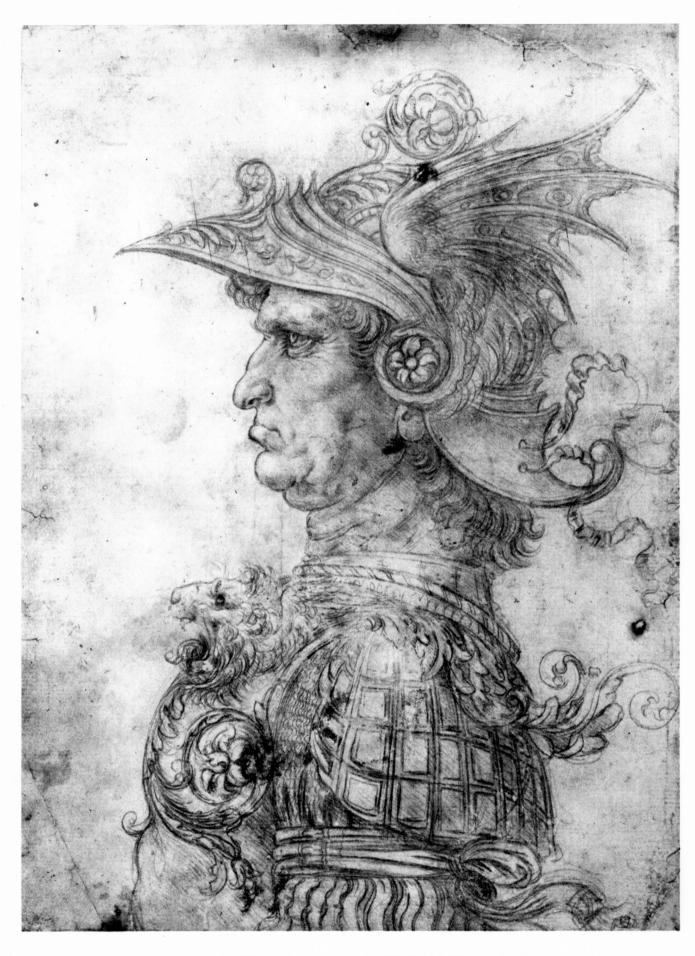

70. Man wearing a helmet. c. 1480. Silverpoint, 11 $1/4 \times 8$ 1/8". British Museum, London

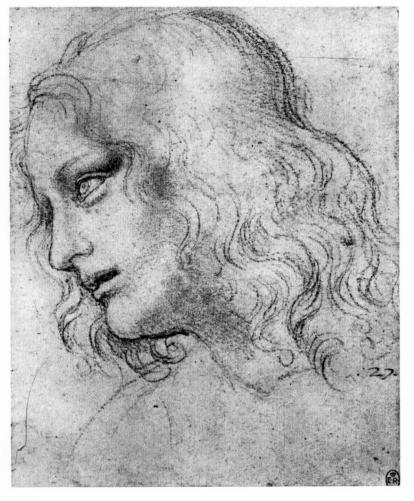

71. STUDY OF THE HEAD OF ST. PHILIP FOR THE LAST SUPPER. 1495. Black chalk, 7 $1/2 \times 5 7/8''$. Royal Library, Windsor Castle. Reproduced by Gracious Permission of Her Majesty Queen Elizabeth II

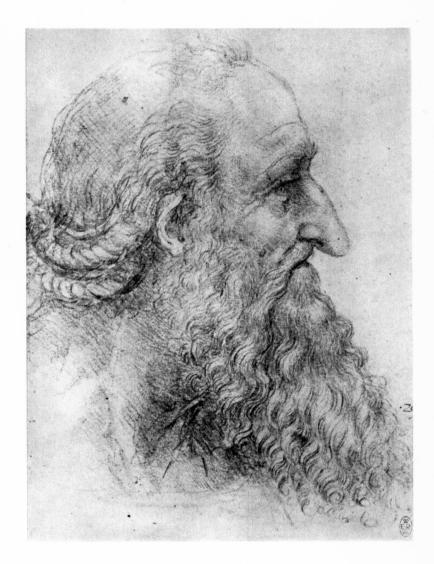

72. HEAD OF AN OLD MAN. C. 1511–12.
Black chalk, 11 3/8 × 6 1/8".
Royal Library, Windsor Castle. Reproduced by
Gracious Permission of Her Majesty Queen Elizabeth II

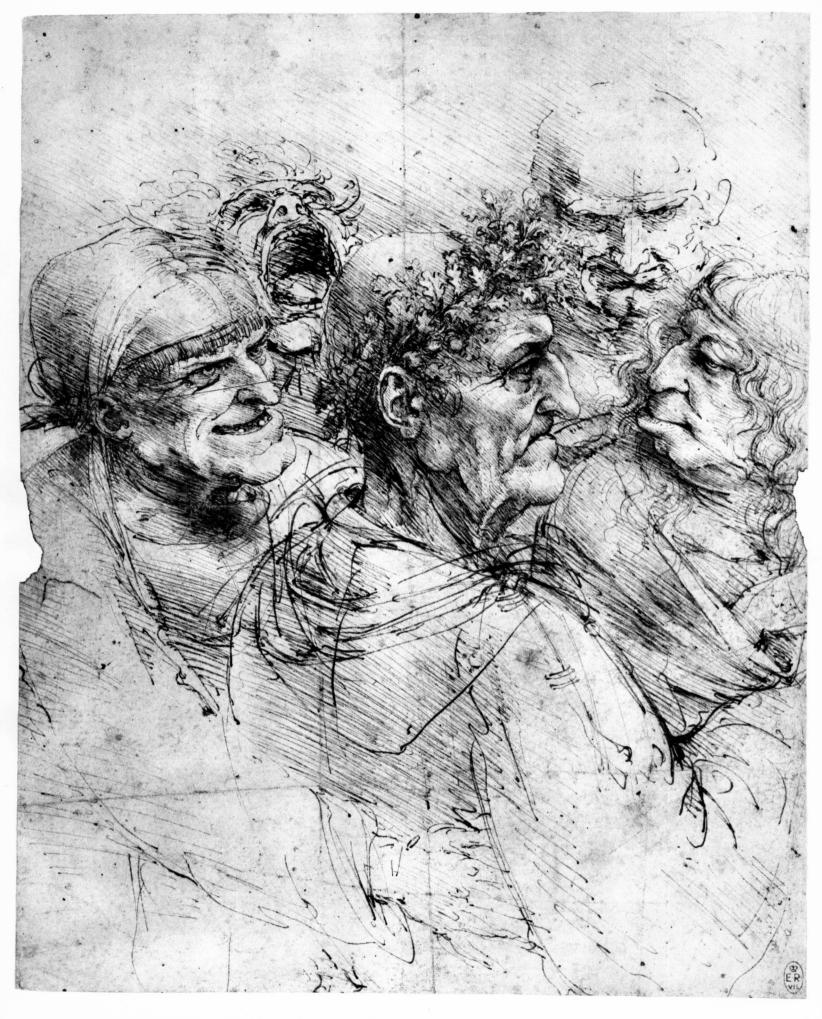

73. GROTESQUE HEADS. C. 1490. Pen, 10 $1/4 \times 8$ 1/8''. Royal Library, Windsor Castle. Reproduced by Gracious Permission of Her Majesty Queen Elizabeth II

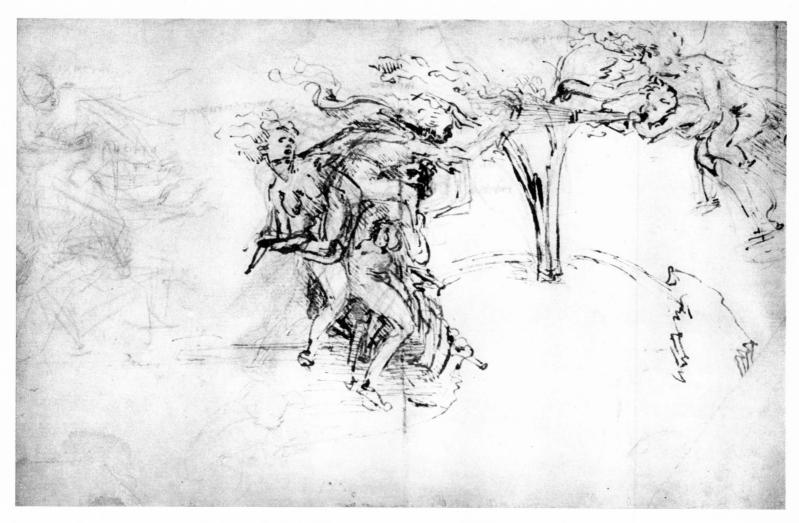

74. Allegorical subject. c. 1481. Pen and ink and silverpoint, 6 3/8 × 10 1/4". British Museum, London

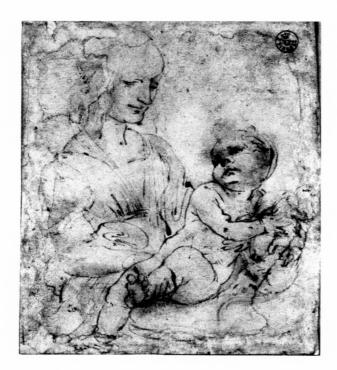

75. VIRGIN AND CHILD WITH A CAT. 1470s. Pen and ink and wash, 5×4 1/8". Gabinetto dei Disegni e Stampe, Uffizi, Florence

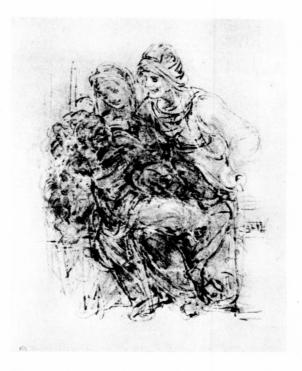

76. VIRGIN AND CHILD WITH ST. ANNE. C. 1503–4. Pen and ink over black chalk, 4 $3/4 \times 4''$. Louvre, Paris

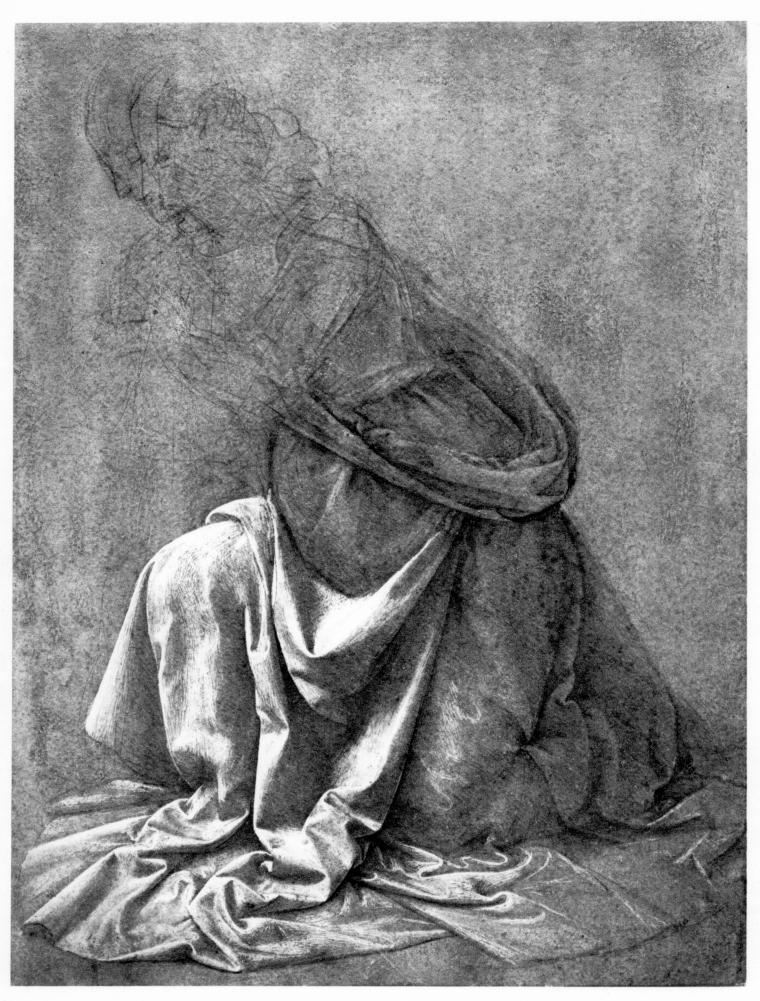

77. STUDY OF DRAPERY FOR A KNEELING FIGURE. c. 1478. Silverpoint, ink, wash, and white on red prepared paper, 10 1/8 \times 7 3/4". Galleria Nazionale, Rome

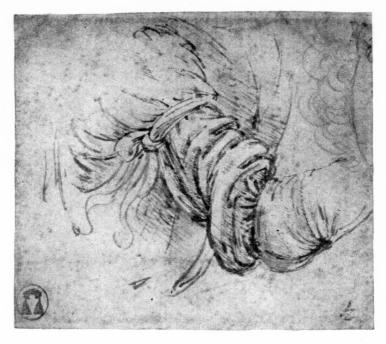

78. STUDY OF A SLEEVE. c. 1473. Pen, 3 1/8 \times 3 5/8". Christ Church, Oxford

79. STUDY OF DRAPERY. c. 1473. Brush on linen, heightened with white, 7 $3/8 \times 9$ 1/4''. Louvre, Paris

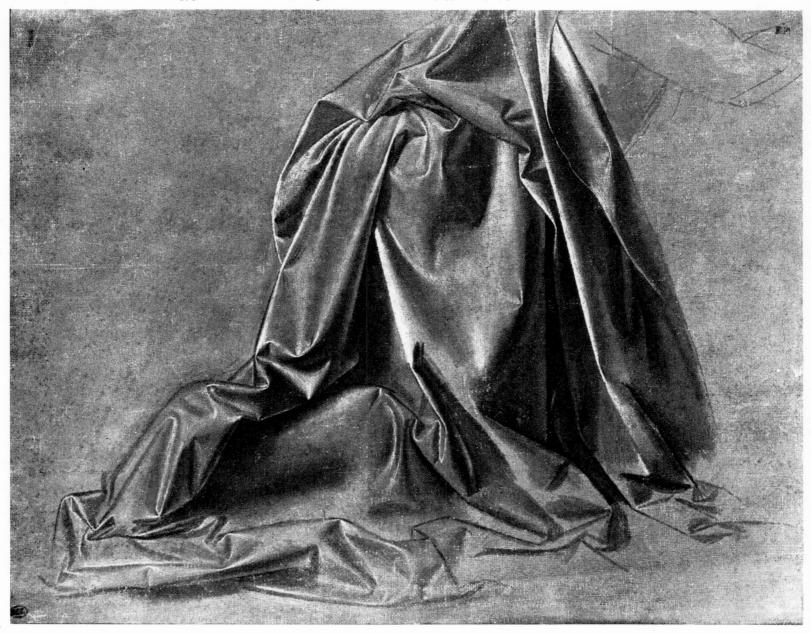

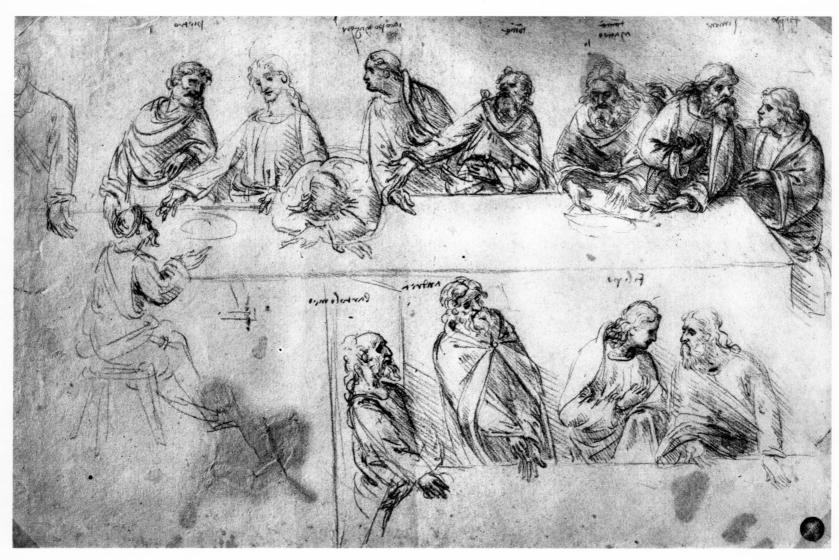

80. Anonymous. Copy of Leonardo's composition study for the last supper. c. 1495–97. Red chalk, 10 1/4 \times 15 3/8". Accademia, Venice

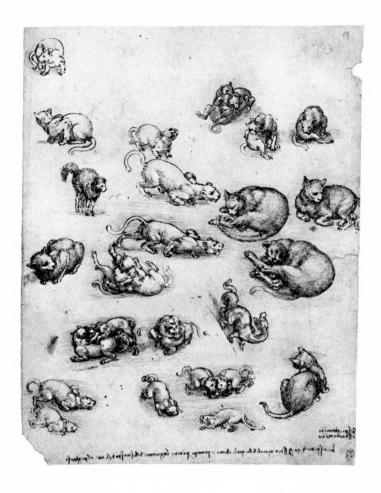

81. STUDIES OF CATS AND DRAGONS. C. 1513-14.

Pen and ink and wash over black chalk, 10 5/8 × 8 1/4".

Royal Library, Windsor Castle.

Reproduced by Gracious Permission of

Her Majesty Queen Elizabeth II

82. NEPTUNE GUIDING THE SEAHORSES. C. 1503-4.

Black chalk, 9 7/8 × 15 1/2".

Royal Library, Windsor Castle.

Reproduced by Gracious Permission of

Her Majesty Queen Elizabeth II

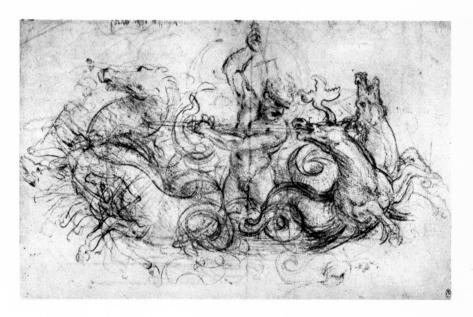

83. DRAGON. After 1513.
Pen and black chalk, 7 3/8 × 10 5/8".

Royal Library, Windsor Castle.

Reproduced by Gracious Permission of

Her Majesty Queen Elizabeth II

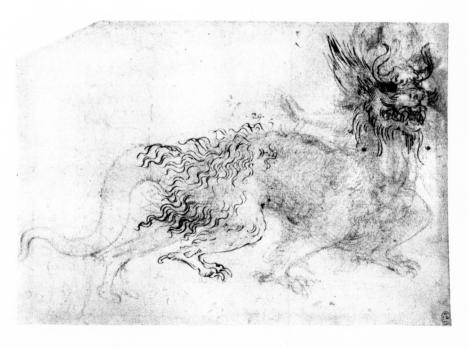

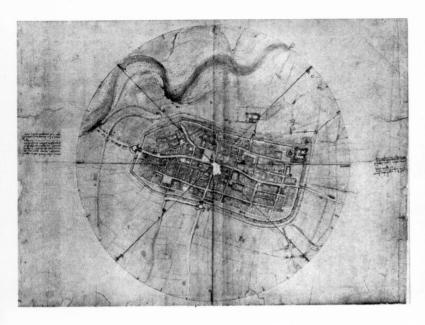

84. PLAN OF IMOLA. 1502.
Pen and ink over watercolor, 17 3/8 × 23 3/4".
Royal Library, Windsor Castle.
Reproduced by Gracious Permission of
Her Majesty Queen Elizabeth II

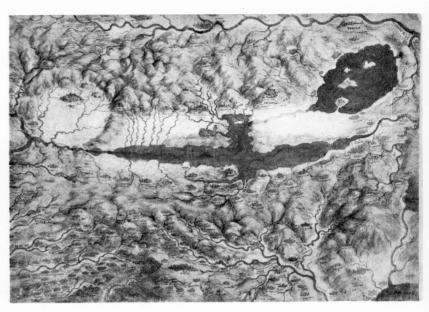

85. AERIAL VIEW OF THE CHIANA VALLEY, SHOWING AREZZO, CORTONA, VOLTERRA, PERUGIA, AND SIENA. C. 1502-3. Pen and ink and watercolor, 13 1/4 × 19 1/4". Royal Library, Windsor Castle. Reproduced by Gracious Permission of Her Majesty Queen Elizabeth II

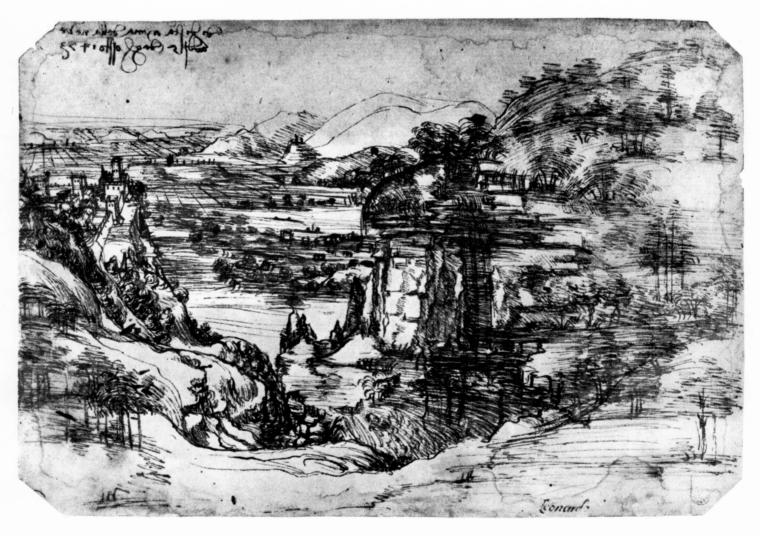

86. LANDSCAPE. 1473. Pen, 7 1/2 × 11 1/4". Gabinetto dei Disegni e Stampe, Uffizi, Florence

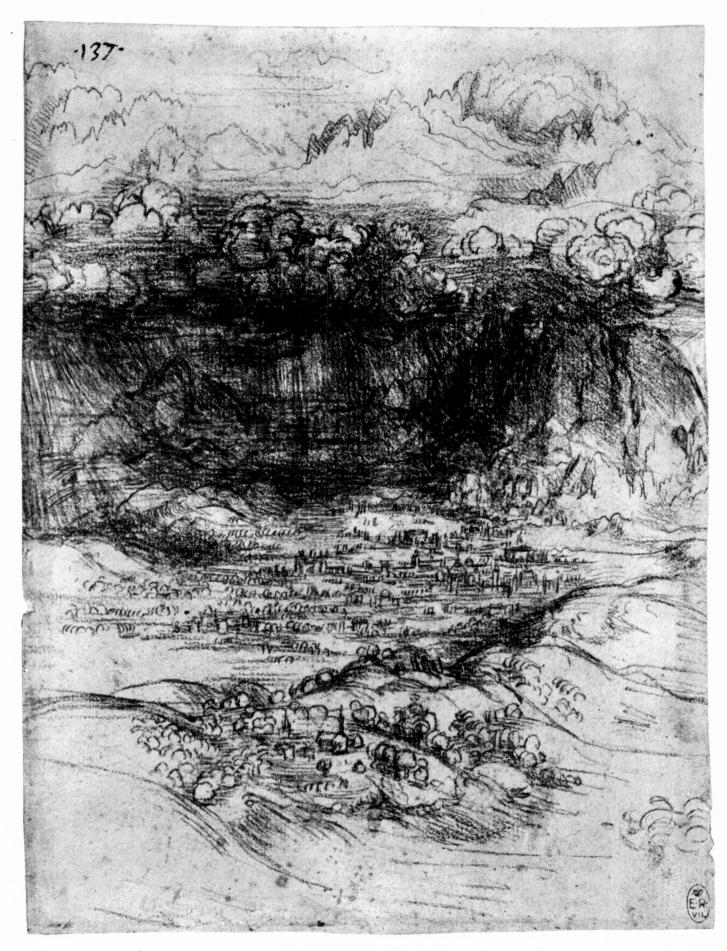

87. Storm Breaking over a valley. c. 1499. Red chalk on white paper, 11 $1/2 \times 5$ 7/8''. Royal Library, Windsor Castle. Reproduced by Gracious Permission of Her Majesty Queen Elizabeth II

88. RANGE OF MOUNTAIN PEAKS. 1511.
Red chalk heightened with white, 4×6 1/4".
Royal Library, Windsor Castle. Reproduced
by Gracious Permission of
Her Majesty Queen Elizabeth II

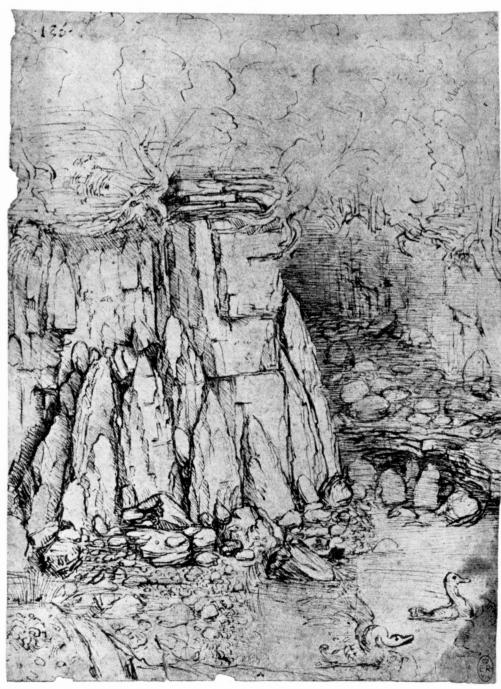

89. A CAVERN. C. 1494.

Pen, 8 5/8 × 6 1/4".

Royal Library, Windsor Castle.

Reproduced by Gracious Permission of

Her Majesty Queen Elizabeth II

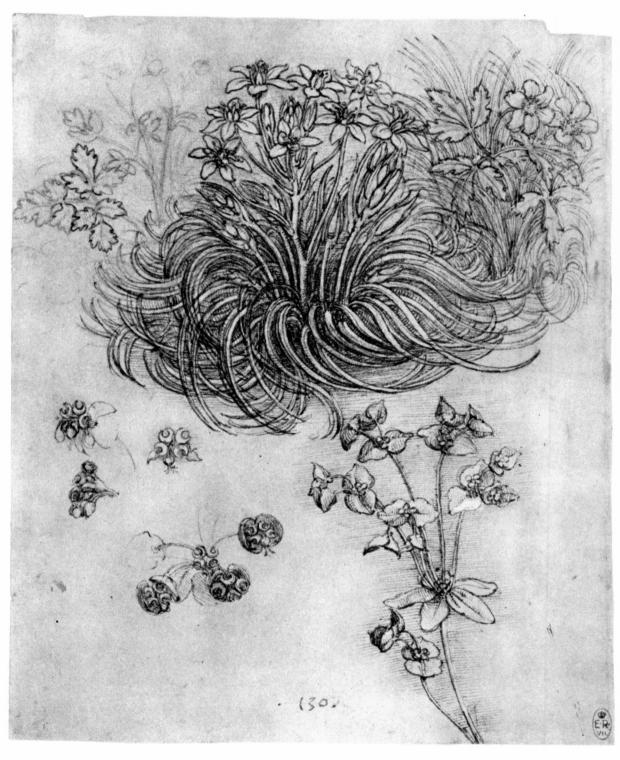

90. Star of Bethlehem and other plants. c. 1505–8. Red chalk and pen, 7 5/8 \times 6 3/8". Royal Library, Windsor Castle. Reproduced by Gracious Permission of Her Majesty Queen Elizabeth II

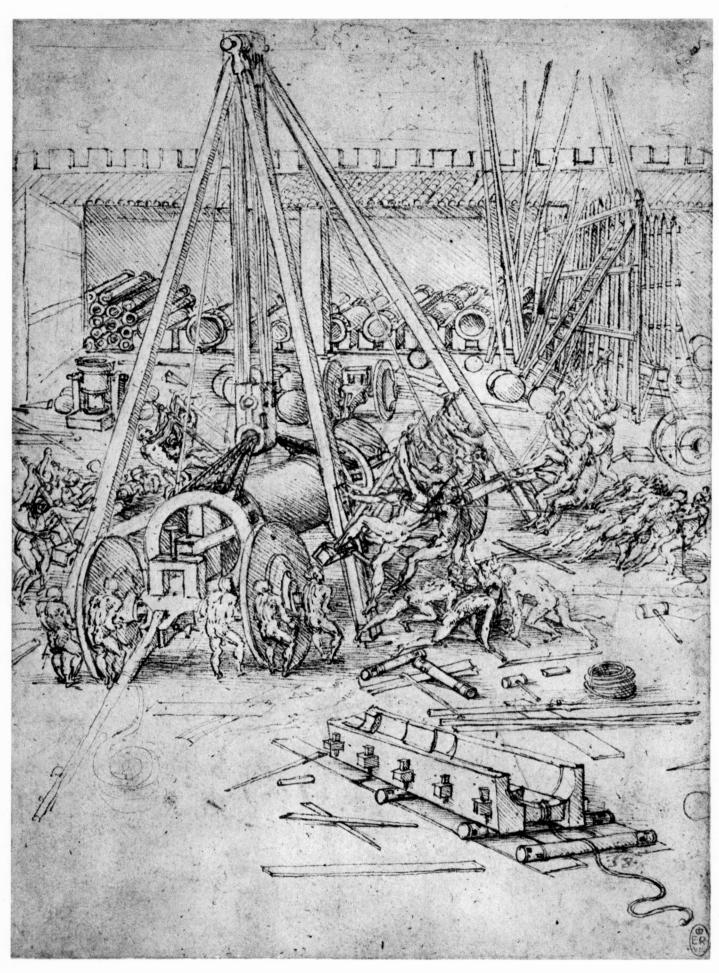

91. CANNON FOUNDRY. C. 1490. Pen, 9 7/8 × 7 1/4".

Royal Library, Windsor Castle. Reproduced by Gracious Permission of Her Majesty Queen Elizabeth II

BIOGRAPHICAL OUTLINE

- 1452 APRIL 15: Leonardo da Vinci born at Anchiano, near Vinci.
- 1469 Possibly enters the Florentine workshop of Andrea del Verrocchio; Lorenzo de' Medici assumes power in Florence.
- 1472 Enters the painters' guild of St. Luke in Florence.
- 1473 AUGUST 25: Date on a landscape drawing by Leonardo in the Uffizi (his earliest known dated work).
- 1476 APRIL 8: Anonymously accused of sodomy; still living with Verrocchio.
- 1478 JANUARY 10: Receives his first independent commission, for an altarpiece for the chapel of S. Bernardo in the Palazzo Vecchio.

 APRIL 27: Lodovico Sforza arrives in Florence to console Lorenzo de' Medici after the assassination of his brother, Giuliano.

 DECEMBER: Notes on a dated drawing in the Uffizi that he has begun two compositions of a Virgin and Child; one
- 1479 DECEMBER 28: Date on a drawing by Leonardo in Bayonne showing the hanging of Baroncelli, one of the assassins of Giuliano de' Medici.

of these may be the Benois Madonna.

- 1481 MARCH: Receives a commission for an Adoration of the Magi for the monastery of S. Donato a Scopeto, near Florence.
- 1483 APRIL 25: Receives the commission (with Ambrogio and Evangelista de' Predis) for the *Madonna of the Rocks* from the Confraternity of the Immaculate Conception soon after his arrival in Milan.
- 1485 APRIL 23: Receives a commission for a *Nativity* to be sent to Matthias Corvinus.
- 1487–88 Receives payments for a model of the cupola of Milan Cathedral.

- 1490 APRIL 23: Records in his notebooks that he has resumed work on the Sforza equestrian monument.
- 1492 APRIL 8: Lorenzo de' Medici dies.
- 1493 NOVEMBER 30: Clay model of the colossal horse ("colosso") for the Sforza monument is exhibited.
- 1494 FEBRUARY: Sees a large stairway with waterfall at Vegevano, near Milan.
- 1497 JUNE: Has nearly completed the Last Supper in the refectory of S. Maria delle Grazie in Milan.
- Decoration of the Sala delle Asse in the Castello Sforzesco is in progress.

 OCTOBER 2: Given a vineyard by Lodovico Sforza.
- 1499 OCTOBER-NOVEMBER: Louis XII of France is in Milan; Leonardo is commissioned by Robertet to paint the now-lost *Madonna with the Yarnwinder*. He is also possibly commissioned by Louis XII to execute the Burlington House Cartoon of the *Virgin and Child with St. Anne*. Louis XII contemplates transporting the *Last Supper* to France.

 DECEMBER 15: Leaves Milan.
- 1500 FEBRUARY: In Mantua, where he is commissioned by Isabella d'Este to paint her portrait.

 MARCH: In Venice.

APRIL 14: In Vaprio, near Milan, according to an entry in his notebook: ". . . and this I have observed in the flight of a young falcon above the monastery at Vaprio, to the left of the Bergamo road, on the morning of the fourteenth of April 1500." Next to this he wrote: "The Duke [Lodovico Sforza] has lost his state and his freedom, and no work was ever finished for him." LATE APRIL: Returns to Florence.

1501 APRIL 3 and 14 (?): Fra Pietro da Novellara sends two letters to Isabella d'Este in which he mentions that

- Leonardo is working on the Madonna with the Yarnwinder for Robertet and on a cartoon for a Virgin and Child with St. Anne; the latter was possibly commissioned by Louis XII.
- 1502 With Cesare Borgia in northern Italy to inspect military fortifications.
- 1503 MARCH 4: Back in Florence by this date.

 OCTOBER 23: Begins the cartoon for the Battle of Anghiari in the Hall of the Great Council of the Palazzo Vecchio.
- 1504 JULY 9: Father dies.
- 1505 JUNE 6: Begins to paint the Battle of Anghiari.
- 1506 MAY 30: Returns to Milan.
- 1507 JANUARY 14: Louis XII, in France, writes to the Florentine government asking that Leonardo be permitted to remain in Milan until he arrives there himself.

MARCH 5: In Florence.

MARCH 12: Cesare Borgia dies.

MAY 24: Louis XII arrives in Milan; Leonardo follows some time before July 5.

JULY 26: Louis XII appoints Leonardo his painter and engineer.

AUGUST 26: Represented (while in Florence again) by Ambrogio de' Predis in a new contract with the Confraternity of the Immaculate Conception to finish the *Madonna of the Rocks*.

1508 MARCH 22: Working on two Madonnas for Louis XII, one of them possibly the Virgin and Child with St. Anne now in the Louvre.

- MAY 27: Lodovico Sforza dies in captivity in France. JULY: Back in Milan.
- 1509 Publication in Venice of Luca Pacioli's *De divina proportione*, for which Leonardo provided illustrations.
- 1513 JANUARY 9: Leaves Milan for Rome with a brief stopover in Florence; arrives in Rome by December 1 and is given an apartment by Pope Leo X (Giovanni de' Medici) in the Belvedere of the Vatican.
- 1514 Travels to Cività Castellana. SEPTEMBER 25: In Parma.
- 1515 Stops in Florence on his way back to Rome.

 JANUARY I: Louis XII dies.

 OCTOBER: François I, successor to Louis XII, recaptures Milan.

 DECEMBER: François I is in Rome.

 DECEMBER 9: In Milan again.
- 1516 MARCH 17: Giuliano de' Medici, son of Lorenzo de' Medici and Leonardo's patron in Rome, dies. WINTER: Leaves for France.
- 1517 JANUARY 17: Designs a project for the royal castle at Romorantin.

 OCTOBER 10: Cardinal of Aragon, accompanied by his secretary Antonio de' Beatis, visits Leonardo at Cloux and is shown three paintings: a portrait of a lady commissioned by the late Giuliano de' Medici (probably the Mona Lisa); St. John the Baptist, now in the Louvre; and the Virgin and Child with St. Anne, also in the Louvre.
- 1519 APRIL 23: Draws up his will.

 MAY 2: Dies at Cloux.

Painted between c. 1470 and c. 1472-73

BAPTISM OF CHRIST

Tempera and oil on panel, $69\ 5/8 \times 59\ I/2''$ Uffizi, Florence

The Baptism of Christ by Verrocchio, to which Leonardo had added the angel on the left (colorplate 1), cannot be dated with precision. Nor can Leonardo's contribution: the fact that Leonardo repainted most of the panel in oil, even those parts that Verrocchio had already completed in tempera, implies that the two artists were not engaged in direct collaboration, but that the panel had been sitting for some time in Verrocchio's studio before Leonardo began his work on it. Leonardo approached his assignment as a master in his own right, as one who was permitted to make whatever changes he felt necessary. The most plausible time when this could have taken place is the period of two years or so beginning in 1472. In that year, Leonardo was admitted to the painters' guild of St. Luke, but had nevertheless chosen to remain in Verrocchio's studio in charge of painting commissions. If what we have proposed here is true, one might then be justified in dating the original painting by Verrocchio a little earlier, at about 1470.

The parts of the original composition that Leonardo repainted include portions of Christ's figure and of the landscape, as well as the angel on the left. He retouched areas of Christ's torso and added the heavy lids to his eyes, which give the face its soulful expression. He radically altered the landscape in the distance (colorplate 3) and brought the water forward from the middle ground so that it eddies around Christ's feet. In so doing, he had perhaps hoped to disguise the precipitous cleavage between the middle distance and the foreground of the painting, thereby unifying them. And despite the fact that he was not entirely successful, the attempt shows an early predilection for the logic of

representation.

Leonardo was in no way encumbered by pre-existing forms when he added his angel, although it can be assumed that Verrocchio himself had intended to include an angel in the same area. The clue to the final appearance of the composition had Verrocchio finished it himself is probably reflected in a Baptism of Christ by another of his assistants, Migliore Attavante (fig. 53). Here we find the angel kneeling and facing obliquely forward and toward the center, as is typical in fifteenth-century scenes of the subject. Leonardo broke with his contemporaries by turning his angel around so that it is seen in three-quarter view, from behind, and he arranged the posture in gently contrasting turns that make the angel a more eloquent and expressive figure and that yet allow him to face the important baptismal scene. The result of this innovation was the establishment of a compact and rhythmic relationship between the two angels and the creation of a consistent triangular form that encloses and helps unify the overall composition. The systematic integration of figures through movement and contrapposto and of the entire painting through formal geometric devices begins here and will remain constant throughout Leonardo's career.

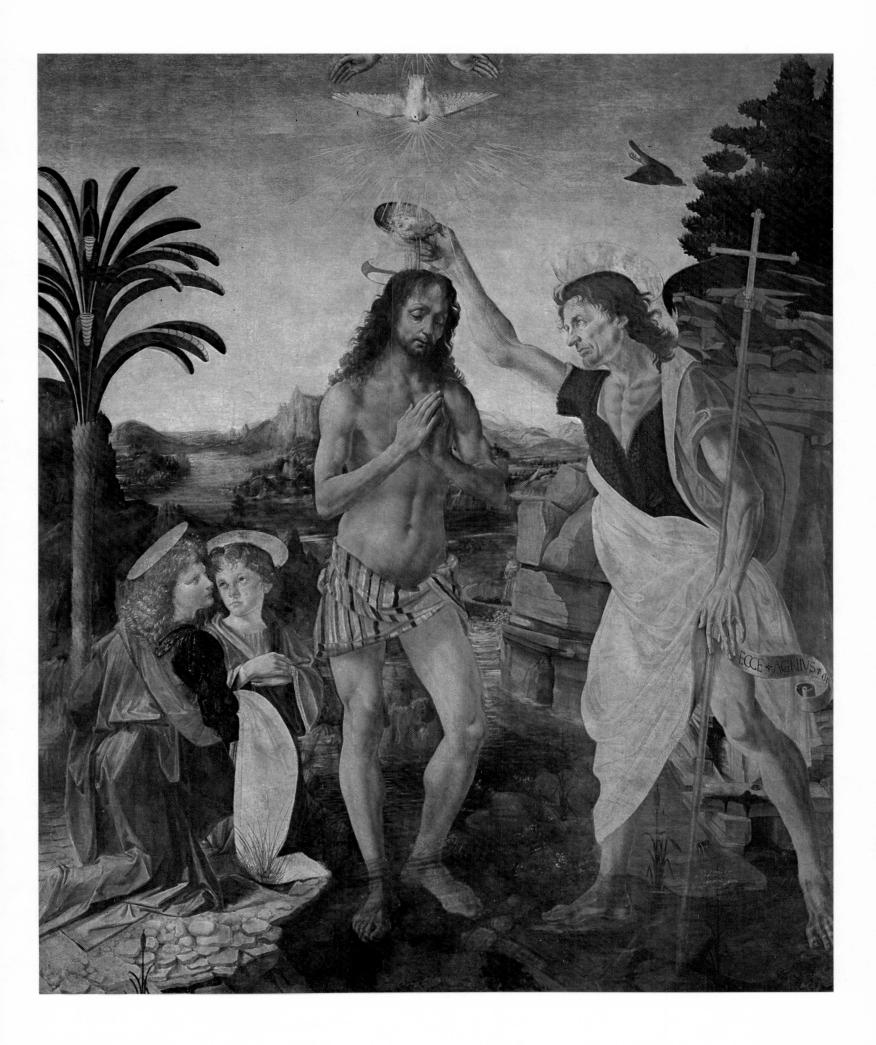

Painted between c. 1470 and c. 1472-73

BAPTISM OF CHRIST, detail

Tempera and oil on panel
Uffizi, Florence

We have in this colorplate a detail of the distant landscape directly above the heads of the two angels in the Baptism of Christ. It is Leonardo's landscape, which he actually painted over an earlier one by Verrocchio, still faintly visible upon close inspection. The conceptions of landscape held by master and pupil could not be more different. An idea of the character of Verrocchio's may be gained from the original forms that are still preserved intact in the middle ground of the painting (colorplate 2): the rough-hewn boulders, the evergreens on the right, and the palm tree on the left. It probably resembled the landscape in a contemporary painting by Pollaiuolo, the Martyrdom of St. Sebastian (fig. 54). Verrocchio's landscape must have consisted of a fragmented accumulation and repetition of trees, hills, patches of earth, and areas of water that were unified by their even illumination and immersion in a carpet of greens, blues, and browns extending to a distant horizon of pale blue.

Leonardo painted his landscape with a uniqueness of vision that is also found in a landscape drawing of 1473, executed around the time of the painting (fig. 86). Nature for Leonardo had the quality of a living organism, with a mobility to its elements, to atmosphere, light, and wind. Although this landscape is viewed objectively from a distance, Leonardo's skill in portraying it allows for a direct visual and sensual experience of the panorama. Color in the painting is essentially monochromatic, and whatever individual colors do appear—green, blue, and yellow—take on the reflected tone of the pervasive one, an earth brown. Furthermore, atmosphere and light spread a veil over the landscape that imparts a uniform texture to everything, softening and generalizing all the forms.

Painted between c. 1473 and 1475

ANNUNCIATION

Oil on panel, 38 $3/4 \times 85$ 1/2''Uffizi, Florence

Like so many of the paintings attributed to Leonardo, nothing certain is known about the early history of the Uffizi Annunciation. It was brought to public attention in 1867, when it entered the Uffizi collection and was for the first time exhibited as an original work by Leonardo. Before that date, it had been owned by the monks of S. Bartolomeo at Monte Oliveto, who believed it to be by Domenico Ghirlandaio, a younger contemporary of Leonardo. The attribution to Ghirlandaio, which I believe mistaken, has been sporadically revived; in fact, the painting was recently deemed a collaborative effort between him and Leonardo. Actually, all that critics really agree on is that Leonardo was personally responsible for the landscape in the distance (colorplate 5) and that the panel was painted in Verrocchio's studio. The richly detailed pulpit and architecture and the tall trees behind the angel are elements that are usually found in Verrocchio's work. Therefore, a date for the painting between 1473 and 1475, when Leonardo (and probably Ghirlandaio too) was still associated with Verrocchio, is inescapable.

It is likely that the painting's masterful design is Leonardo's own, even if the actual execution of most of the panel is not. The composition is divided into two unequal parts. A narrow area on the right is reserved exclusively for the Virgin, whose figure emerges strongly against the vigorous framing provided by the quoins at the corners of the building. On the left, the angel and landscape fill an extended oblong area. However, although the two parts are diversely conceived, they are harmonized and made continuous. This is partly achieved by the connecting figure of the angel; it establishes a flow of action from the left side to the right as it moves toward the Virgin, who in turn responds to the angel's prophetic gesture. The pictorial unification is also achieved by the repetition of four pine trees arranged at approximately equal intervals across the painting; their verticality is echoed by that of the quoins ascending along the corner of the building. The long, low parapet behind the angel-interrupted just long enough to frame and emphasize the head, hand, and lilies—parallels and underscores the procession of trees and also finds its echo in the horizontal placement of each alternate quoin. Thus, the forms of nature are made to interact with architectural forms and with the figures they enclose.

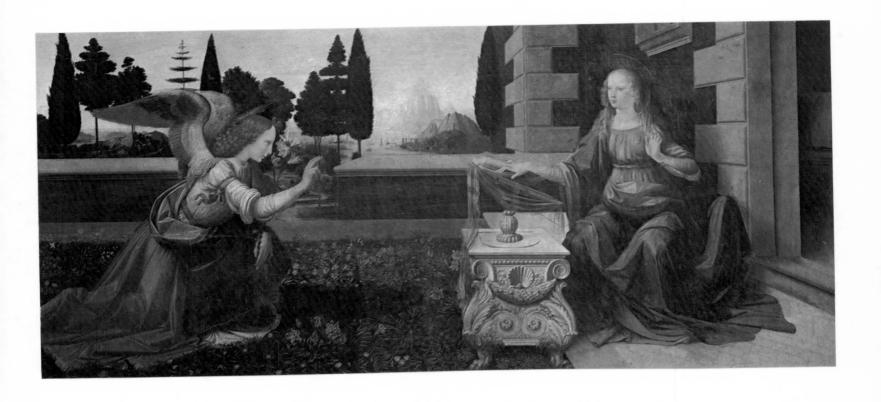

Painted between c. 1473 and 1475

ANNUNCIATION, detail

Oil on panel

Uffizi, Florence

The angel is the one part of the Uffizi Annunciation (colorplate 4) that is most often cited to prove Leonardo's authorship of this panel. The paint here has been applied with some of the lightness and transparency we have come to associate with Leonardo; moreover, he has left a contemporary drawing of the angel's sleeve (fig. 78). But can the attribution withstand a comparison of the head of this angel with that from the earlier Baptism of Christ (colorplate 1)? It takes little experience, I think, to recognize the marked differences between them. The head of the later angel fails to evolve as a three-dimensional volume in space; it is flat and rather disjointed, for all the gentle modeling of surfaces. Furthermore, the hair is strangely stiff and dry and without the silken curls and sparkling light we see in the Baptism angel. In short, it is out of keeping with Leonardo's conception of facial anatomy and with the development of his style during this period of his career, which culminates in the Adoration of the Magi (colorplate 10). Unfortunately, I cannot surmise the name of the artist responsible for the angel in this Annunciation.

The angel's wings were considerably enlarged at a later date. This is regrettable, since it interferes with a proper view of the landscape. Nevertheless, the landscape is unquestionably Leonardo's and we can perceive in it his growing sensitivity to a nature that is poetic and evocative. Atmosphere, moreover, now has a palpable physical existence in the form of mist, which helps to create the mood of dusk. This is an important advance beyond the landscape he painted in the *Baptism* (colorplate 3), where atmosphere was not yet a separate phenomenon from the forms it enveloped, but merely implied—an illusion Leonardo achieved by softening and blurring the surfaces of natural forms.

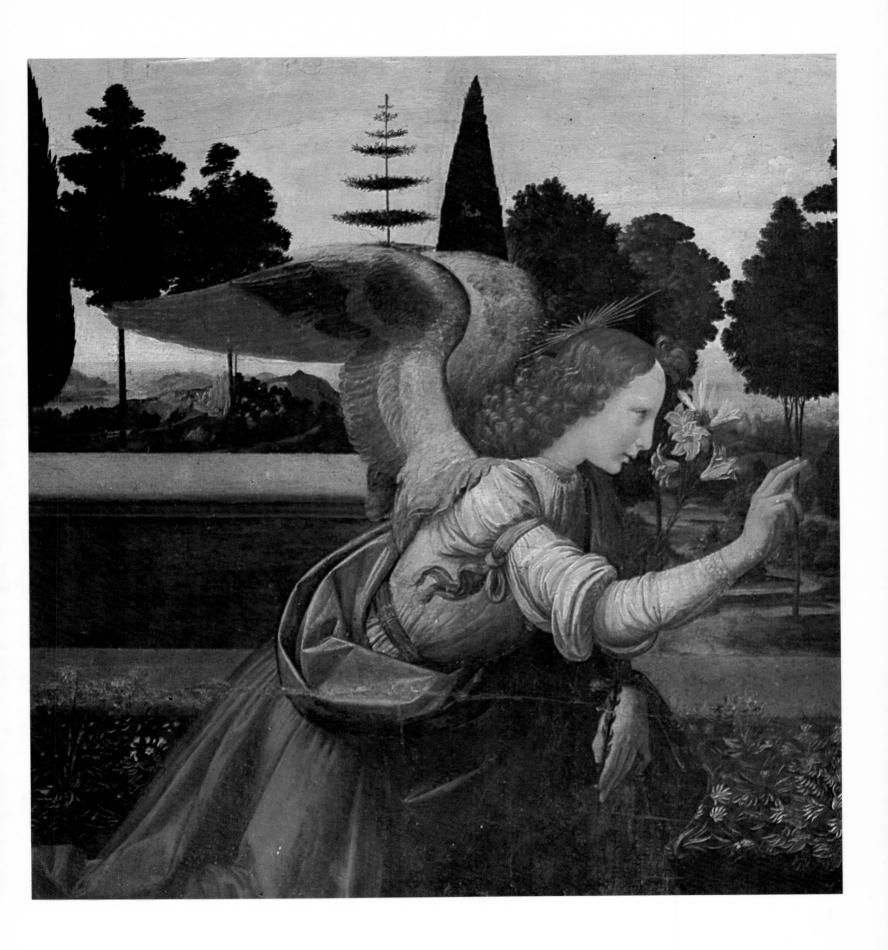

Painted between c. 1473 and 1475

ANNUNCIATION, detail

Oil on panel

Uffizi, Florence

There is almost nothing in this detail of the Virgin from the Annunciation to recommend it as a work by Leonardo. It is true that the area around the face was extensively repainted; still, the original paint is thick and opaque, which was not typical for Leonardo. It certainly does not bear comparison with the angel from the Baptism of Christ (colorplate 1) or with the Benois Madonna of about 1478 (colorplate 8), yet the type of head is one that was familiar to Verrocchio's apprentices (fig. 60).

The fingers of the Virgin's hand resting on the prayer book were later lengthened to give them a slender elegance that is reminiscent of a drawing of hands by Leonardo at Windsor Castle (fig. 29). However, the hand in the *Annunciation* lacks anatomical conviction and volume. It is composed mainly of lines and surfaces arranged in gracefully undulating rhythms for their own sake and not consonant with the natural behavior and structure of the hand as Leonardo had ordained in his drawing.

The only part of the Virgin's figure that evokes the spirit of Leonardo is the great expanse of drapery that covers her lap and defines the legs underneath (colorplate 4). Even so, the paint has been applied crudely and heavily by another artist, who may have used a drawing by Leonardo as his model.

The angel (colorplate 5) is quite unlike the Virgin, which makes it clear that the Annunciation was a composite work painted by at least two artists besides Leonardo. Labor was normally divided between the master and his assistants in Renaissance workshops, and the Annunciation was the product of this system. Leonardo, who after 1472 had assumed responsibility for the execution of panel paintings in Verrocchio's studio, designed the composition of the Annunciation and painted the landscape and perhaps several other parts. He assigned the rest of the panel to unidentified assistants.

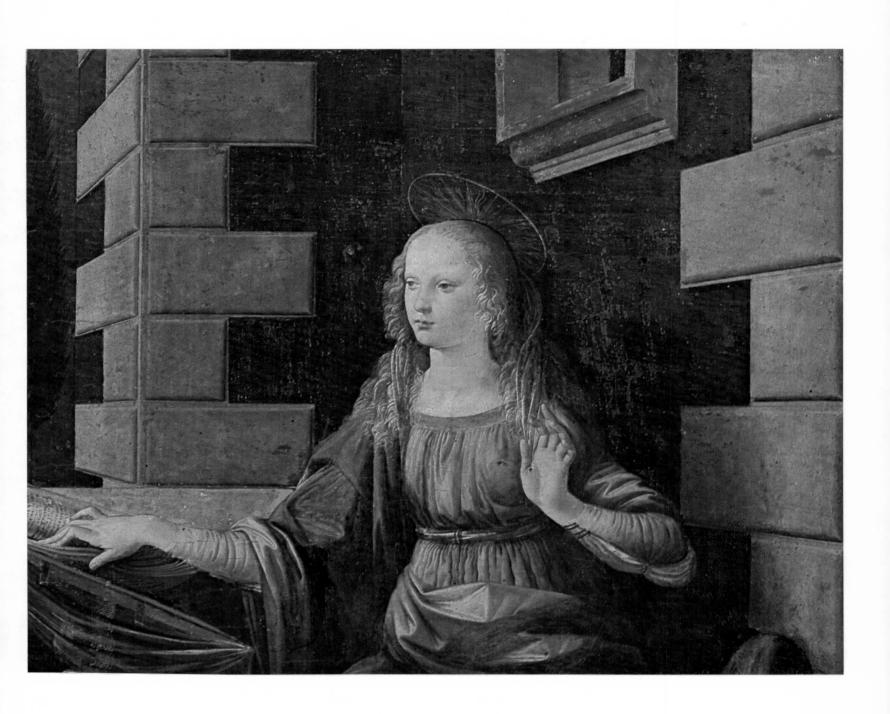

Painted c. 1474

GINEVRA DE' BENCI

Oil on panel, 15 $1/8 \times 14 1/2''$

National Gallery of Art, Washington, D.C. Ailsa Mellon Bruce Fund

Giorgio Vasari, elaborating on an earlier sixteenth-century tradition, states that Leonardo painted a portrait of Ginevra de' Benci, daughter of Leonardo's friend Amerigo di Giovanni Benci. This portrait is widely assumed to be that in Washington, D.C. of a young woman. However, the attribution of the Washington portrait to Leonardo has been questioned by some scholars, and with some justification. Leonardo, for example, could not have been responsible for the disjointed anatomy of the face. Moreover, the symmetry of the hair framing the face and the regularity in the arrangement of the eyes, nose, and mouth are too calculated and tend to fix the head into a two-dimensional pattern on the surface of the painting, thus preventing volume from evolving continuously in space. This is entirely uncharacteristic of Leonardo's manner of painting, as is the treatment of the blond hair: it is hard and linear and illuminated by a light that seems excessively sharp.

Still, the painting has considerable beauty and psychological power, which is registered as sullenness and feline languor. This emphasis on a heightened expression of personality, as well as the general shape of the head and the pose of the figure, anticipates the *Mona Lisa*, which argues strongly for at least a partial attribution of the portrait to Leonardo.

The identification of the sitter in the Washington portrait depends on the juniper tree in the background and on the juniper twig in the emblem on the verso (fig. 28). They indicate that the woman portrayed was named Ginevra (ginepro meaning "juniper" in Italian). Awaiting proof, however, is her identity as Ginevra de' Benci. It may come when we have deciphered the emblem on the verso, consisting of a garland of laurel and palm leaves enclosing the juniper twig and bearing the Latin motto Virtutem Forma Decorat ("Beauty is the ornament of Virtue").

The life of Ginevra de' Benci is surprisingly well documented. She married Luigi Bernardi di Lapo Nicolini in 1474 at the age of seventeen. The subsequent years were not happy ones for her. Soon after their marriage, her husband found himself in serious financial difficulties, and in 1480 Ginevra was reported to be constantly in bad health. It seems that she was involved in an extramarital affair with Bernardo Bembo, Venetian ambassador to Florence and father of the humanist Cardinal Pietro Bembo. She died childless years later. If the woman in the Washington portrait is indeed Ginevra de' Benci, then it is tempting to believe that her pallid complexion and the disquieting expression on her face reflect the sickness and anxiety that marred her life.

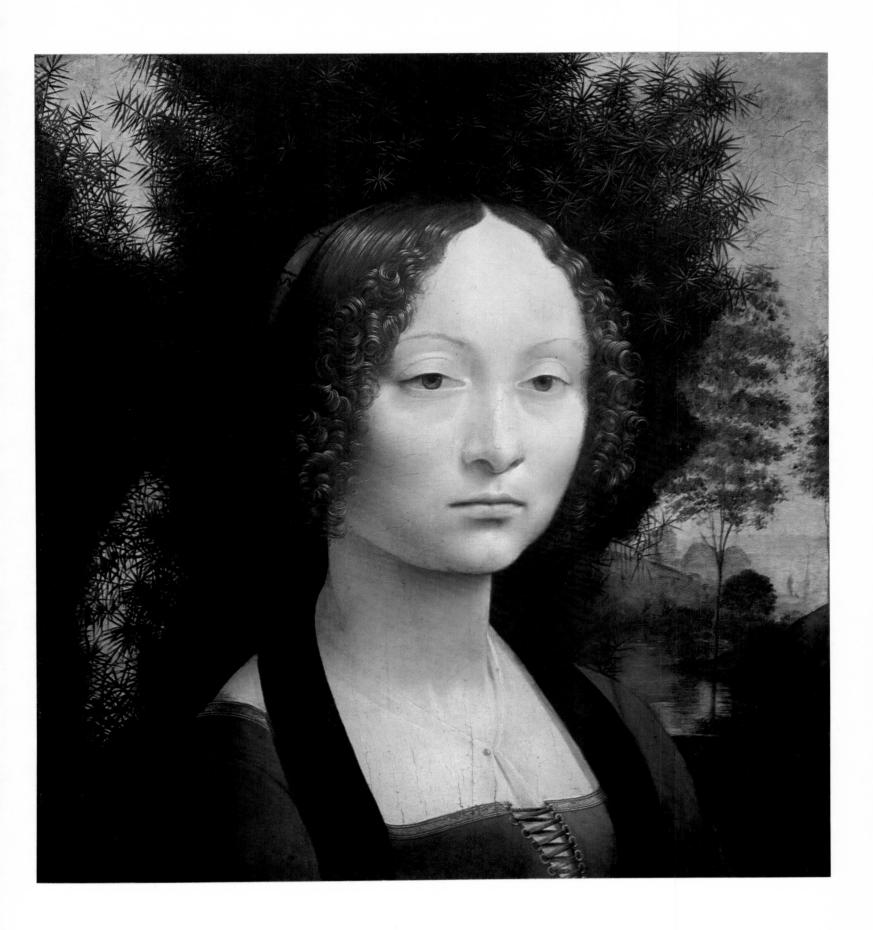

Painted c. 1478

BENOIS MADONNA

Oil on canvas (originally panel), 19 $1/2 \times 12 3/8''$ Hermitage, Leningrad

In 1478, Leonardo recorded that he had begun two paintings of a Virgin ("inchominciai le 2 Vergine Marie"). The Benois Madonna is quite likely one of them. In 1909, Ernst de Liphardt included it in Leonardo's oeuvre. This met with some early skepticism, but autograph drawings that are obviously projects for the painting (fig. 34) have today dispelled all doubt as to its authorship.

The painting has fared reasonably well over the centuries. True, it is in need of cleaning and it suffered damage when it was transferred from panel to canvas, which necessitated some repainting in the draperies, around the mouth, neck, and hand of the Virgin, and in the background. But for all that, the *Benois Madonna* still retains much of its original freshness and charm.

The Virgin—youthful, smiling, and animated—is seated on a bench. Her legs, one extended and the other drawn back, support a pillow on which the nude, pudgy Christ Child sits. Despite its human and playful qualities, the scene has been raised to a ceremonial and modestly religious plane by the halos and by the serious countenance of the Child. The action is set in what appears to be a simple and rather drab interior, enlivened only by a small window through which light enters to illuminate the background on the right. The figures, however, are illuminated by a different light—one that enters diagonally on the left and that, joined by the shadows it casts, imparts a three-dimensionality to them. Dirt and overpainting hide certain aspects of the left background, but these may perhaps be recaptured with the aid of a contemporary copy that is attributed to Lorenzo di Credi (fig. 35). Barely visible above the Virgin's head is a gathered curtain and behind her a vertical shape that is vaguely reminiscent of the background in the copy, in which a column stands on a draped ledge. This serves the Virgin as a table on which to rest her prayer book. In the original of the Benois Madonna, the ledge and book are not visible, while the column (one of the symbols of the Passion, and a reference to the column to which Christ was bound during the Flagellation) seems to occupy the entire space.

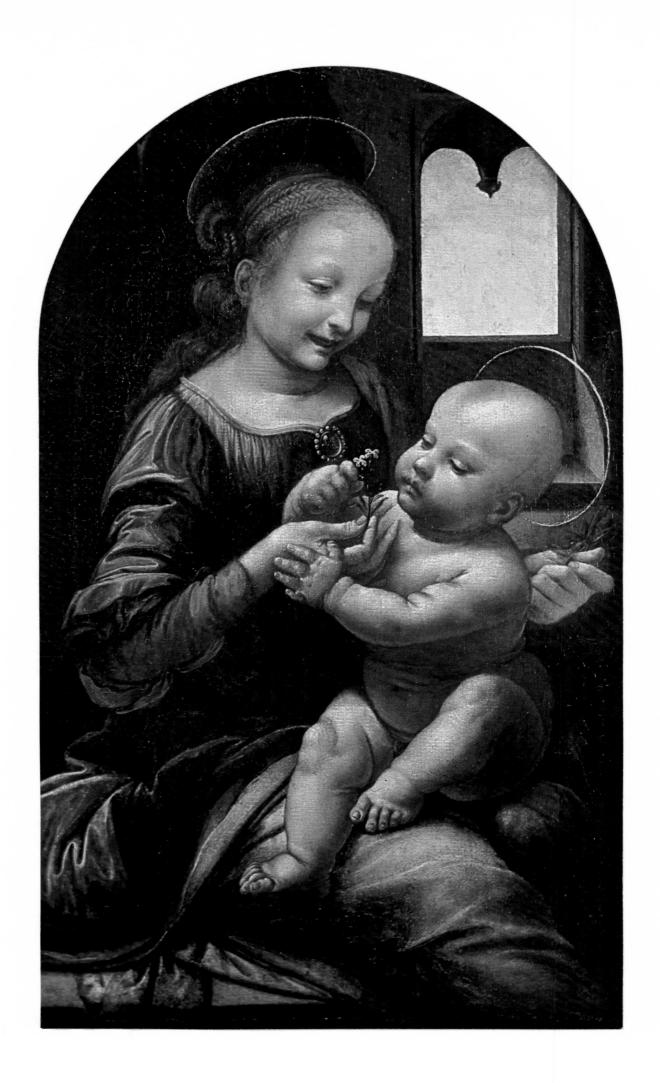

Painted c. 1478

BENOIS MADONNA, detail

Oil on canvas (originally panel)

Hermitage, Leningrad

The head of the Virgin from Leonardo's Benois Madonna is related to that of the angel he painted in Verrocchio's Baptism (colorplate 1): both have a full and rounded shape and a strongly protruding chin. The Virgin's braided hair is conceived in direct imitation of Verrocchio and is one of the motifs Leonardo adopted from his master's repertoire. Vasari reports that Verrocchio made drawings of female heads that were "so beautiful and with such charming hair that Leonardo was always imitating them." Kenneth Clark points out that Verrocchio found special pleasure in depicting hair that was elaborately braided. However, this style was not one that Leonardo commonly used in his paintings and it is not seen again in his work until many years later, when he began the now-lost Leda and the Swan (figs. 50, 52).

With the *Benois Madonna*, Leonardo began to depart from his youthful manner and from Verrocchio's example. New are the Virgin's fresh and winsome expression (which shows his increasing interest in Desiderio da Settignano, the charming Florentine sculptor of the previous generation) and the harplike outline of her face. The latter, apparently his own invention, establishes a pattern of rhythmic and ornamental grace that nevertheless conforms to the natural structure of the face. Now more solid, the head is highly sophisticated by comparison with that of the *Baptism* angel. It is quite different from the Verrocchio-like head of the Virgin in the *Annunciation* (colorplate 6) and from any of those we find in paintings that are occasionally attributed to Leonardo in these early years. The *Benois Madonna* is, therefore, a transitional work that anticipates the Virgin of the *Adoration of the Magi* (colorplate 11) and the angel of the *Madonna of the Rocks* in the Louvre (colorplate 20), in which this new facial conception will be greatly refined.

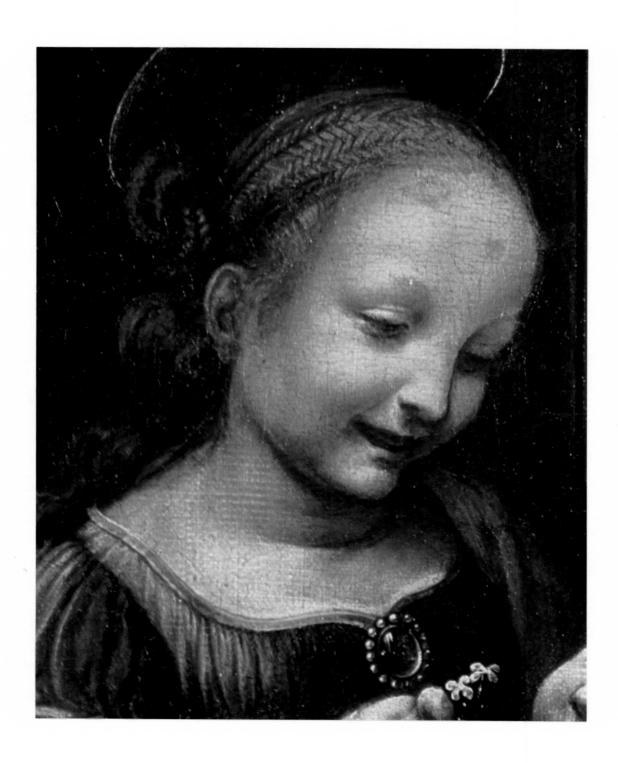

Painted 1481-82

ADORATION OF THE MAGI

Underpainting on panel, 97 $1/8 \times 95 7/8''$ Uffizi, Florence

The Adoration of the Magi, begun in 1481 for the monastery of S. Donato a Scopeto near Florence, was left unfinished when Leonardo departed for Milan in 1483. What remains today is little more than a monochromatic drawing awaiting pigment, with large areas of light and shadow blocked in. Yet the panel still reveals Leonardo's extraordinary ability to cast a traditional subject into fresh form and to exploit fully its narrative and religious content.

The principal protagonists have been brought together in the center, where they form the core of a broad pyramidal composition. Arranged behind them in an arc is a myriad of dramatically gesticulating people, consisting of the followers of the Magi, shepherds, and wingless angels, who react in unison to the miracle of the Epiphany (Christ's self-revelation). Christ's act is acknowledged or contemplated by two standing male figures in the left and right corners who formally frame the central group and anchor the great and tremulous arc enclosing it. The figures make fully apparent the symmetry of the overall composition. The man on the extreme right, the younger of the two, actively addresses an unseen companion as he points toward the central scene. The older man on the left, designated by many as "the Philosopher," is attentive to the discourse of his neighbor and thoughtfully reflects upon the miracle taking place before him. The contrasting attitudes of these lateral figures has led some scholars to propose that they in fact embody the Neo-Platonic opposites of the active and the contemplative life.

The background is cut off from the foreground scene by the terrain rising between them. In the rear, soldiers in combat or in animated conversation are seen in the context of a great architectural ruin and a sketchy landscape. This scene of warfare has been variously interpreted as representing the jousting retainers of the Magi or as the world of vice, set against a backdrop of decaying Hebrew civilization (symbolized by the crumbling architecture), which is the antithesis of the new Christian civilization portrayed in the foreground. Perhaps, instead, it really represents some still undetermined aspect of the history of the monastic order that commissioned the panel.

Despite the painting's dramatic and narrative impact, it has an equally strong emblematic quality, although such was not yet the case in Leonardo's preparatory drawing (fig. 25). This emblematic quality is due essentially to the disciplined order that governs the composition and to the elimination of the familiar terrestrial accounterments of the scene (the manger and animals) to a less conspicuous location in the rear and right side of the painting. In all probability, it was Botticelli who inspired Leonardo to centralize his composition; the more common arrangement of figures in earlier fifteenth-century paintings was in horizontal bands across the panel, beginning with the scene of the Adoration itself on the extreme left side. However, Leonardo has encompassed the spiritual content of this scene within a consistent geometry of forms that symbolizes the control by a cosmic force over human actions and destiny.

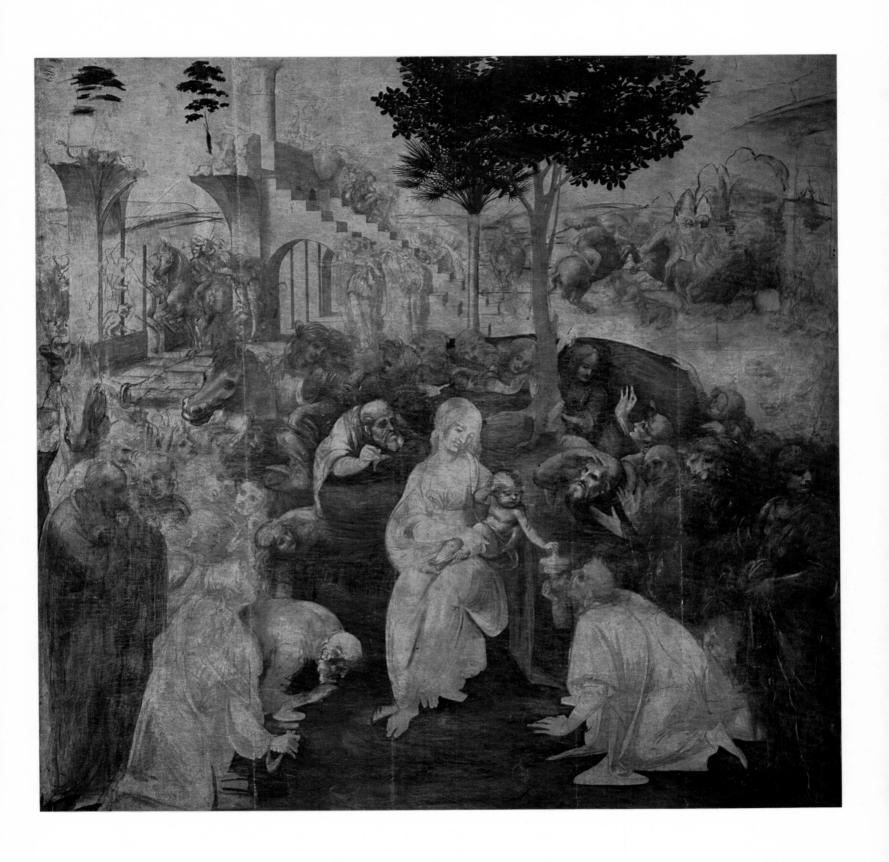

Painted 1481-82

ADORATION OF THE MAGI, detail

Underpainting on panel
Uffizi, Florence

Leonardo's unfinished head of the Virgin from the Adoration of the Magi continues the type he had introduced in the Benois Madonna (colorplate 9) a few years before. The harp-like outline and the high, clear forehead are the same, as are the squat proportions. However, Leonardo has progressed toward the definition of his mature female type in several ways. The braiding of the hair in the Benois Madonna, the strongest remnant of his youthful association with Verrocchio, has been discarded in favor of a casual treatment here, and the adolescent laugh, a rather frivolous attribute in the representation of the Mother of Christ, has been replaced by a tender solemnity and heavy-lidded languor that are to become hallmarks of Leonardo's mature style. The Virgin is a little older now and her attitude comparably more reserved, introspective, and formal, as befits the Queen of Heaven. It is, in fact, characteristic of Leonardo that he conceives each successive Virgin as a little older than the previous one; in each instance, he seems consciously to select an older model as more suited to his own maturing temperament and taste. We can follow this process from the Benois Madonna to the Virgin in this Adoration, to the Virgin in the Madonna of the Rocks, first in the Louvre (colorplate 18) and then in London (colorplate 19), to the Virgin in the Burlington House Cartoon (colorplate 33), and finally to the one in the painted version of the Virgin and Child with St. Anne in the Louvre (colorplate 38).

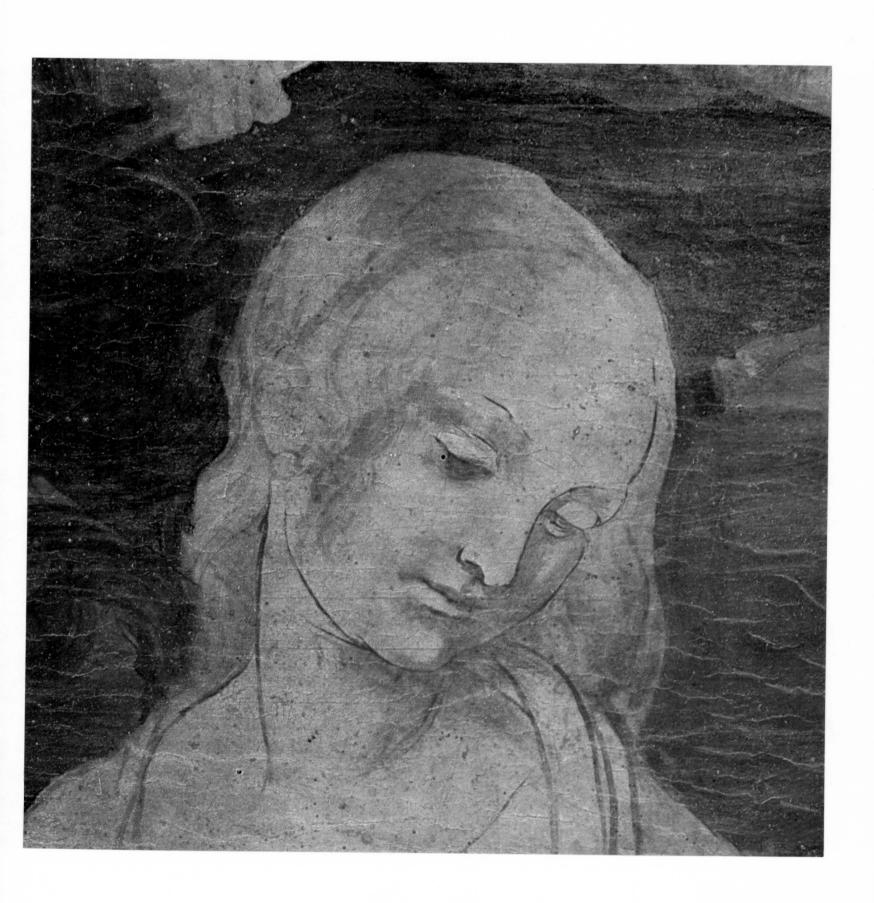

Painted 1481-82

ADORATION OF THE MAGI, detail

Underpainting on panel
Uffizi, Florence

One of the remarkable aspects of the Adoration of the Magi is the range and depth of human feeling with which Leonardo has imbued the chorus of figures surrounding the principal actors in this drama. In this detail of heads from the group on the right, he has registered a gamut of expressions from classical dignity and restraint to tender yet impassioned devotion, and to excruciating ascetic suffering. If we turn back to the whole painting (colorplate 10), we also find wonder, ecstasy, solemn contemplation, prophetic exegesis, worldly curiosity, and many other psychic attitudes. Here are Leonardo's own words on this aspect of his art: "A good painter has two subjects of primary importance: man and the state of man's mind. The first is easy, the second difficult, since it must be conveyed by means of the gestures and movements of the various parts of the body. This one should learn from the deaf-mutes; for they express themselves better in this way than any other group of human beings."

This treatment of psychological states constitutes a radical break with Leonardo's own past work and with the work of such contemporaries as Ghirlandaio, Perugino, and Botticelli. Half a century before, Leon Battista Alberti had already formulated the principle of affetti, which is the term we use to characterize the artistic procedure described by Leonardo in the preceding quotation. Only Leonardo, however, fully recognized its potential in the representation of human events, insofar as he conveyed powerful and identifiable emotions and raised them to such a level of universality that they inspire in the beholder comparable feelings of awe and devotion. In the work of Leonardo's contemporaries, on the other hand, the definition and intensity of feelings are usually blurred or mitigated, and idealized types—men in states of beatitude—are intermingled with individuals who wear modern dress and have familiar features. His contemporaries did not attempt to represent the biblical episode of the Epiphany with decorum, as an event that had occurred centuries ago, or with a consistent mood and set of characters.

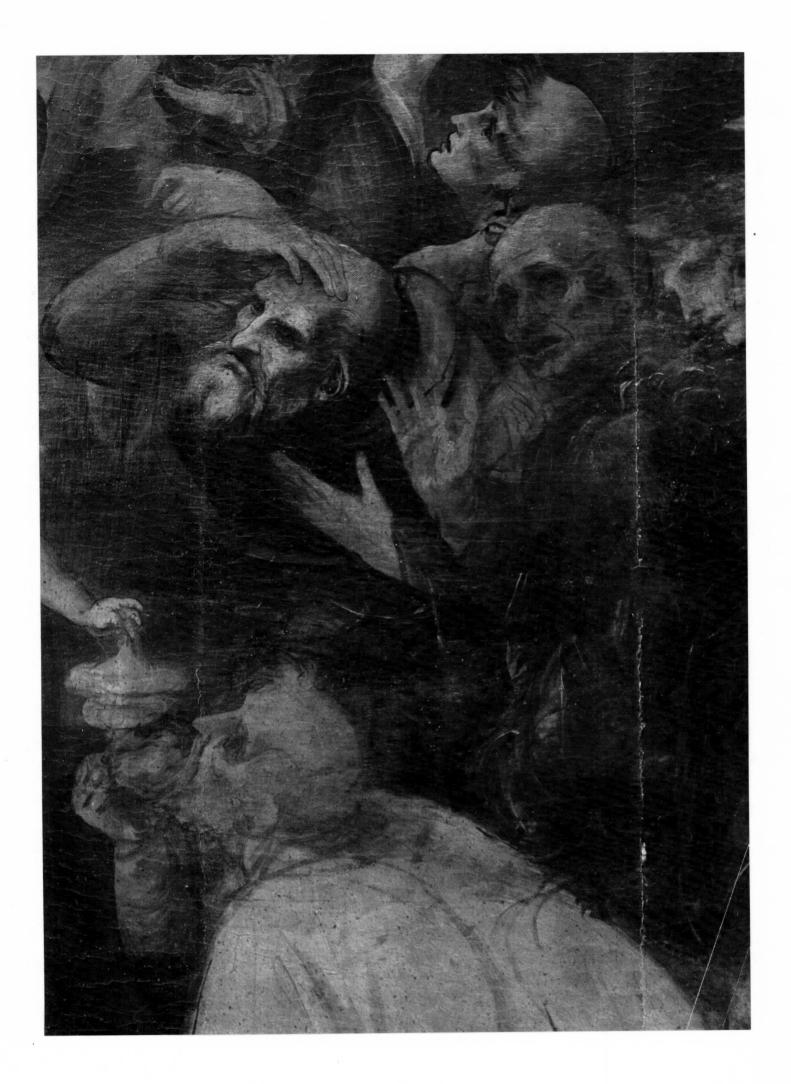

Painted 1481-82

ADORATION OF THE MAGI, detail

Underpainting on panel
Uffizi, Florence

Leonardo's first drawings of horses predate his work on the Adoration of the Magi. In 1478, he had received a commission (his first independent one) for an altarpiece for the chapel of S. Bernardo in the Palazzo Vecchio. The subject of the painting for which he made his earliest equine sketches was presumably an Adoration of the Shepherds, and from that time forward his interest in this animal grew into an abiding love. Already in the projects for the S. Bernardo painting (which he never actually executed), Leonardo studied the rearing as well as the striding and standing animal, but his ability as an observer of nature had not yet fully matured, resulting in a naive treatment of form and outline (fig. 68). However, his growing command of empirical observation and his superior talent as a draftsman made his drawings of horses more vital achievements in naturalism and energy than any we find in early fifteenth-century art.

It was in the Adoration of the Magi that Leonardo gave the horse monumental and mature expression. As the animals on which the Magi and their retainers rode in search of the Christ Child, horses had a traditional role in the representation of this scene and scarcely a painting of the subject was without them. The horse and rider also appear in a variety of other subjects in Florentine painting of the fifteenth century: in processions, in the hunt, or in battle scenes. Leonardo's jousting horsemen, then, are the culmination of such representations. No other artist understood better the anatomy of this animal or could portray it with such bold feeling for the dynamics of action and the tension of combat. The very air and ground are disrupted by clouds of dust resulting from the impact of these clashing bodies. It is the mark of Leonardo's genius that, while systematically coordinating the two battling equestrian groups in counterbalanced turns and masses, he in no way minimizes the force of movement and the accidental quality intrinsic to such physical and emotional encounters.

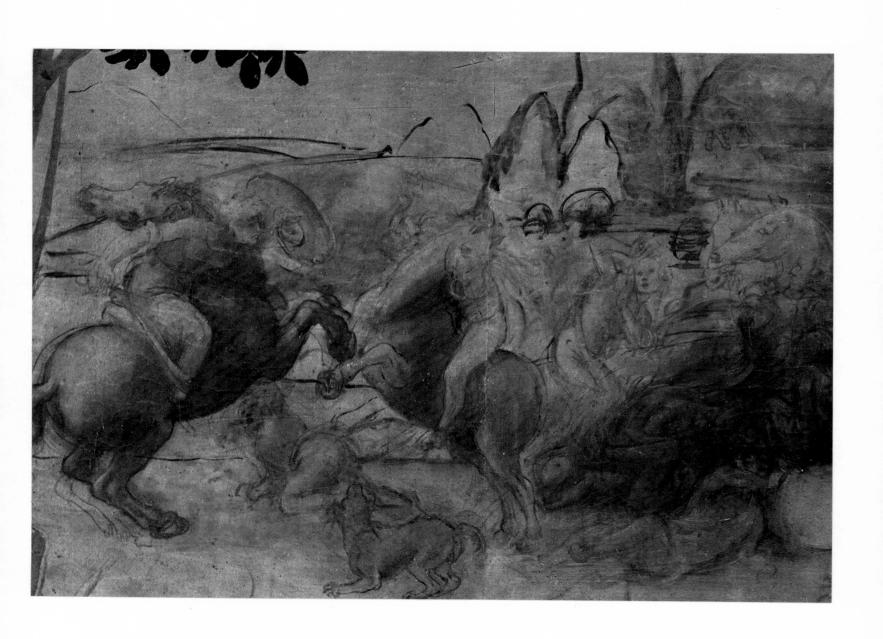

Painted c. 1482

ST. JEROME

Underpainting on panel, 40 $5/8 \times 29$ 1/2''Vatican Museum, Rome

Documentary and literary references to the St. Jerome have not survived. Nevertheless, the authenticity of the painting as Leonardo's has never been doubted. The earliest confirmations of the painting's existence are visual: a Roman woodcut of about 1500 by an artist from the circle of Leonardo (fig. 38), and a seventeenth-century painting by the Spanish artist Francisco de Zurbarán (fig. 36), both of which imitate the kneeling pose of Leonardo's saint. We know further that the St. Jerome had been in the Vatican Museum at one time and that it was acquired in the eighteenth century by the Swiss artist Angelica Kauffmann. After it left her possession, it was cut in two and in other ways seriously damaged. Legend has it that Joseph Cardinal Fesch, uncle of Napoleon, "miraculously" rediscovered both parts on separate occasions, one part in a junk shop and the other in the shop of a cobbler, after which the painting was reassembled and restored. Later, Pope Pius IX (1846–78) bought it from the Cardinal's heirs and returned it to the Vatican Museum.

Precise dating of the St. Jerome is difficult. Not only is its history too spotty to be of use for this purpose, but the panel itself is little more than a poorly preserved drawing in which only the major forms (saint, lion, and landscape) and the broadly distributed areas of light and shadow have been set down. Still, a date of around 1480–83, assigned to it by tradition, seems reasonable enough in view of the similarity of the landscape to the one in the Louvre Madonna of the Rocks (colorplate 23) and the comparability of the intense emotions expressed by the saint and by the crowds in the Adoration of the Magi.

The iconographic treatment of St. Jerome as we find it in this panel seems to emerge in the 1480s, and is found also in the circle of Antonio and Piero Pollaiuolo. Earlier portrayals show the saint standing or, more commonly, seated fully dressed and deep in thought in his study. Leonardo's semi-nude penitent who kneels before a vision of Christ on the Cross became the standard depiction for centuries to come.

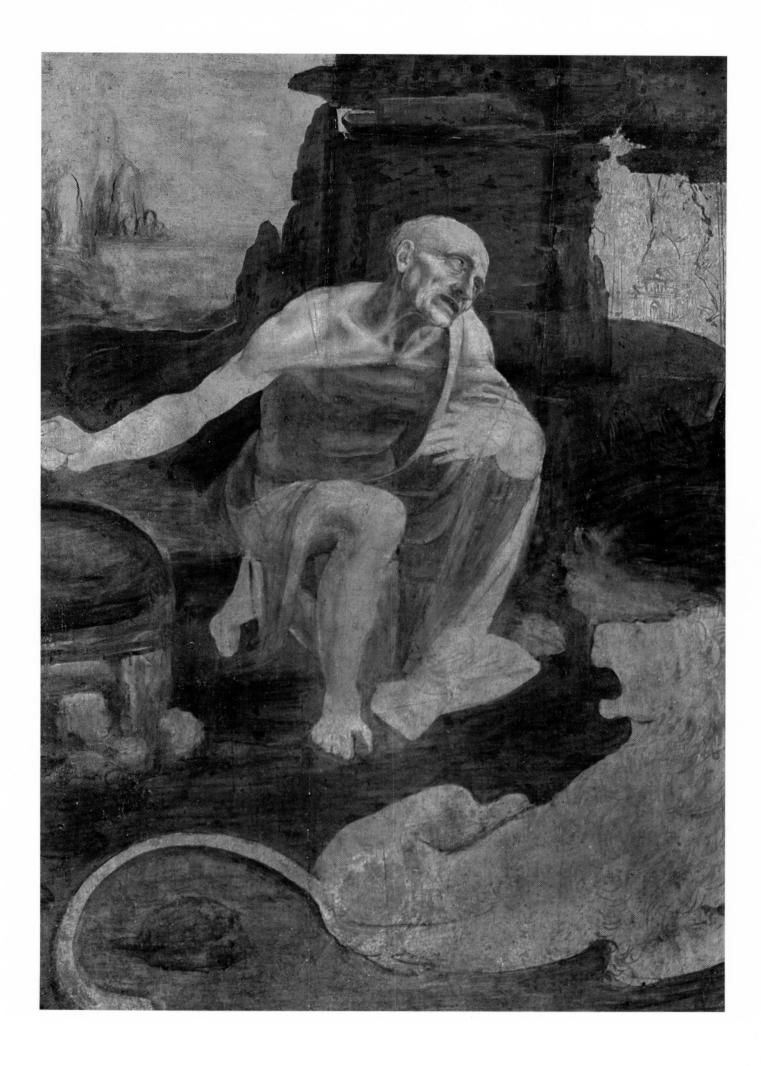

Painted c. 1482

ST. JEROME, detail

Underpainting on panel

Vatican Museum, Rome

The element of religious ecstasy that Leonardo tried to capture in the angel of the Baptism (colorplate 1) has become infinitely more profound and intense in the St. Jerome. Much had happened in the decade that separates the painting of the two heads to cause this change. We should not, first of all, neglect the fact that Leonardo, now thirty years old, had attained maturity as a person and the rank of a great master. He had already conceived his magnificent Adoration of the Magi, with its emphasis upon physical, mental, and emotional stress (colorplate 12)—part of an artistic trend current in the second half of the fifteenth century. Moreover, Leonardo had also begun his studies of human anatomy; these necessitated the dissection of corpses, a technique he presumably had learned from Pollaiuolo. The St. Jerome is clearly related to his famous anatomical drawings (fig. 26) in the emphasis given to the skeleton and the cartilage and muscles beneath the flesh.

By the time Leonardo created this work, he had undoubtedly already developed the interest in grotesque human heads that Vasari described so well: "He used to like it so much when he would see bizarre heads, either with beards or with hair of normal men; and the one he would chance to like he would follow the whole day; and he would imprint his features so firmly in his mind that when he went home he drew him as though he had him present." A large number of such drawings resulted, and some of them (fig. 73) resemble in their toothlessness and eccentric features the head of St. Jerome as well as some of the heads in the nearly contemporary Adoration of the Magi.

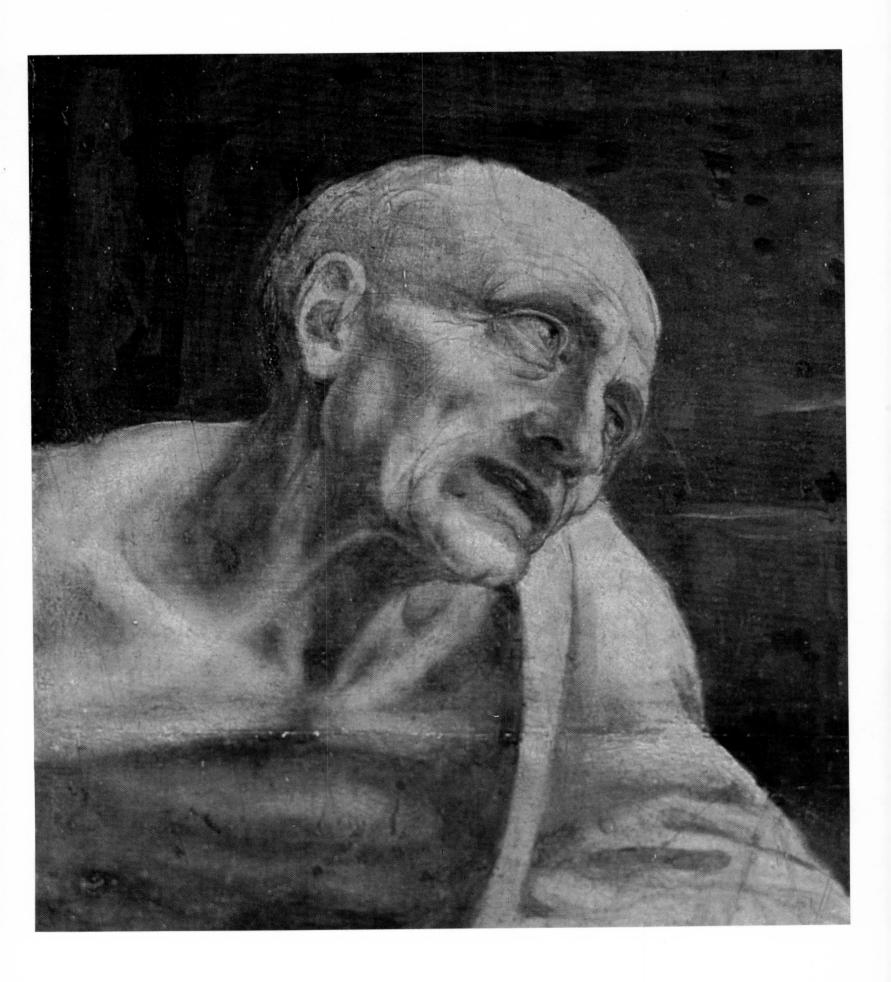

Painted 1483-85

MADONNA OF THE ROCKS

Oil on canvas (originally panel), $78 \times 48 \text{ I/2}''$ Louvre, Paris

On April 25, 1483, Leonardo and two Milanese artists, the brothers Ambrogio and Evangelista de' Predis, jointly contracted with the Confraternity of the Immaculate Conception in Milan to complete a wooden ancona that had been constructed and delivered the year before by the sculptor Giacomo del Maino. It was to be installed in the Confraternity's chapel in S. Francesco Grande. The contract required the artists to gild the ancona (Evangelista seems to have been assigned this task) and to execute three paintings (the central devotional altarpiece of the Virgin and two flanking panels with music-making angels) that were to be included in spaces reserved for them in the ancona. Maino's structure was later destroyed, but an ancona by his son, Angelo del Maino, may give some idea of its appearance (fig. 37).

While most critics agree that the Madonna of the Rocks in the Louvre was painted entirely by Leonardo to serve as the central altarpiece of the ancona, other critics believe that it was executed in Florence prior to the master's departure for Milan. They cite the painting's Florentine elements as evidence for this view: the pyramidal arrangement of the figures in ascending layers, as in the main group in the Adoration of the Magi (colorplate 10), and the head of the infant St. John, patron saint of Florence, which is modeled after that of the Christ Child in the Adoration. However, providing the Paris panel with a Florentine provenance creates a number of difficulties. It makes problematical the heavy mists in the background, which seem to imply a familiarity with the humid atmosphere of Lombardy. It also presupposes that the dimensions and particular shape of the panel were by sheer coincidence the same as the space allocated the altarpiece in the ancona, even though the latter had been delivered to the Confraternity the year before Leonardo's arrival in Milan.

Advocates of the Florentine origins of the painting may possibly find a way out of this dilemma if they were to assume that Leonardo had adapted the painting to a new situation: to the climate of Lombardy by adding the thick vapors to the painting after he arrived there, and to the apparently distinctive shape of the space allotted the altarpiece in the ancona by enlarging his panel to include the arch on top. Some evidence that additions to the painting were made at this critical point does in fact appear to exist. It takes the form of what looks like a seam running horizontally across the painting directly above the springing of the arch, exactly at the junction between the sharply striated rocks of the cave and the group of rounded, more softly textured boulders that rest on them (fig. 39). Unfortunately, it is impossible to determine the true character of this "seam," since the painting was transferred in the nineteenth century from its original wooden support to canvas; the impenetrable glue used for this purpose prevents proper X-ray examination of the area in question.

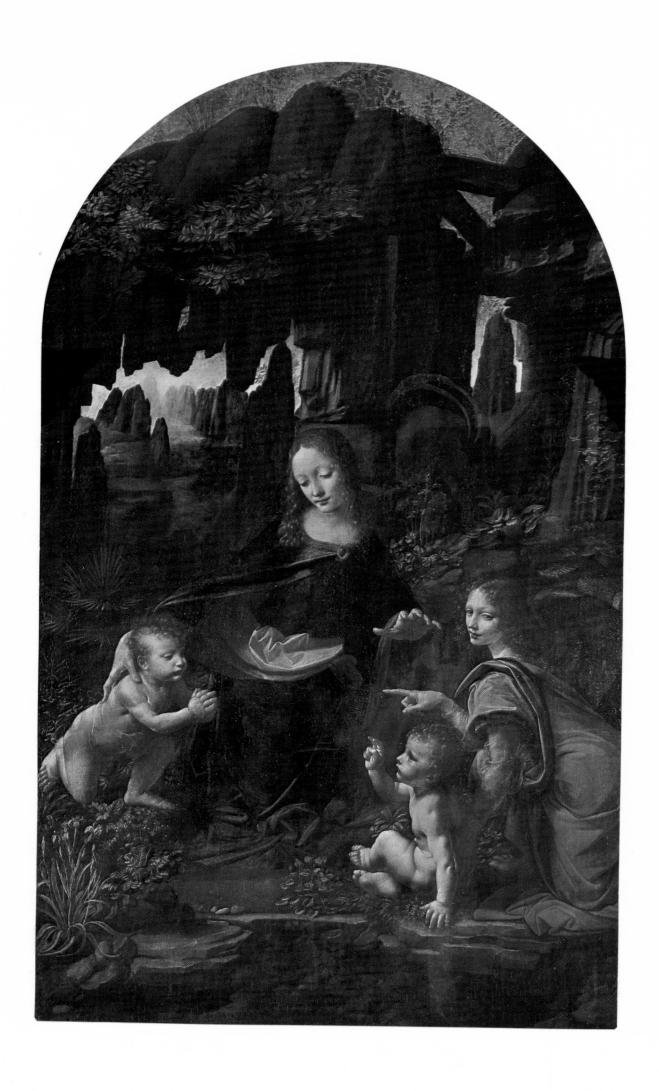

Painted c. 1486-90; 1506-8

PANELS FOR AN ANCONA

Oil on panel, $46 \times 24''$; $745/8 \times 471/4''$; $463/4 \times 24''$ National Gallery, London

The central panel in this colorplate is a second version of the *Madonna of the Rocks* and like the Paris altarpiece, which it closely resembles, was painted for the ancona belonging to the Confraternity of the Immaculate Conception. Why and when it was painted are elusive questions, even though much of the documentation regarding the commission is preserved.

In about 1494, approximately eleven years after the contract had been signed with the Confraternity and shortly after they had consigned the ancona (fitted out with the altarpiece and the two music-making angels), Leonardo and Ambrogio (Evangelista died about 1490) began a prolonged litigation with the Confraternity. The artists appealed to Lodovico Sforza, asking him to intercede in their efforts to obtain a larger payment for their work than was stipulated in the contract. The Confraternity should return "said Virgin executed in oil," they demanded, as an alternative to their receiving the additional money. The Confraternity evidently refused both options, since a second appeal was prepared in 1503, this time by Ambrogio alone (Leonardo was in Florence), which was addressed to Louis XII. It reveals that the ancona included a painting of the Virgin when it was delivered several years earlier and repeats the demand for additional money or the return of the painting. A settlement was finally reached between the artists and the Confraternity in 1506: it stipulates that the painting of the Virgin must be finished in two years for an additional payment of 200 lire (the artists had asked for 400 lire). Final payment was made in 1508, the year the painting was presumably returned to the Confraternity.

The cause of the litigation was most likely the London painting, because the Paris version was executed entirely in Leonardo's style of 1483-85, with no evidence that it was worked on in 1506-8. On the other hand, the London altarpiece is still unfinished in minor areas, varied in treatment (suggesting a prolonged execution), and was in place in the ancona when the latter was dismantled (and ultimately lost) in the eighteenth century. Therefore, it is probable that when the ancona was turned over to the Confraternity in the 1490s it contained not the Paris version but the one in London.

The Paris painting was probably sold to another buyer, perhaps Lodovico Sforza, so a second painting was needed to complete the ancona. We can only speculate on Lodovico's desire to own it, and in this I take my cue from the talismanic use to which the London altarpiece was put years later (it was twice invoked against the plague, in 1524 and 1576). Did the Louvre painting play the same role in the plague of 1485 and thereby set a precedent for the other painting? Would Lodovico have been impelled to buy it primarily for the presumed magical powers of its subject? Did Louis XII then confiscate the painting when he defeated Lodovico in 1499 and take it to France, where it was seen at Fontainebleau in 1625 by Cassiano dal Pozzo? We may never learn the answers to these questions.

The facts and hypothesis I have outlined point to the likelihood that the London painting was executed in the years 1486–90 (after the plague of 1485) and 1506–8 (after the settlement). The two panels with angels, seen in the colorplate foldout in the approximate relationship they had with the central panel in the ancona, were probably also painted in 1486–90. The angel in red playing the lute is by Ambrogio de' Predis; the angel in green playing the viol, on the left, may be the work of Marco d'Oggiono.

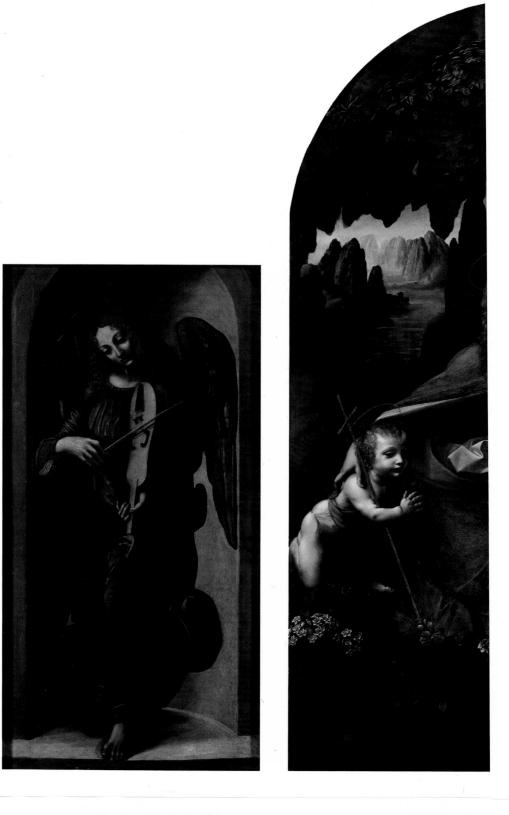

Painted 1483-85

MADONNA OF THE ROCKS, detail

Oil on canvas (originally panel)

Louvre, Paris

The steady progress Leonardo had made in the conception of the female head, beginning with his first surviving painted example, the Benois Madonna (colorplate 9), continued in the Virgin's head from the Madonna of the Rocks. However, a decisive change occurred midway between the two works: in the Adoration of the Magi (colorplate 11), the sweet girlish glee expressed in the Benois Madonna was replaced by an introspective solemnity. This develops in the Madonna of the Rocks into an ethereality that testifies to Leonardo's deepening concern with how spiritual and devotional qualities can be made to intermingle with human feelings of tenderness. There is, furthermore, a modification in the shape and proportions of the Virgin's head. The round and short proportions in the earlier paintings were emphasized by exaggeratedly stylized outlines. In the Madonna of the Rocks, the outline has been regularized and lengthened, giving the face a more natural and unified appearance. Inconsistencies do remain, however, as in the bulging, slanted eyes.

The Madonna of the Rocks is the starting point for Leonardo's new treatment of light. Earlier, in the Benois Madonna, light existed only by implication, being shadowless and inseparable from the forms it illuminated. In the present detail from the Madonna of the Rocks, on the other hand, light exists as an independent and mobile part of nature. Moreover, because it is imbued with atmosphere, it settles like a film over the painted forms and tempers the acute linearity of Leonardo's previous work by moderating the surfaces, which are made to vibrate gently through the subtle interpenetration and gradation of lights and shadows. Light thus conceived—tranquil, fluent, and delicate—has a quality of expression that complements as it echoes the veiled and tender emotions conveyed by the face of the Virgin.

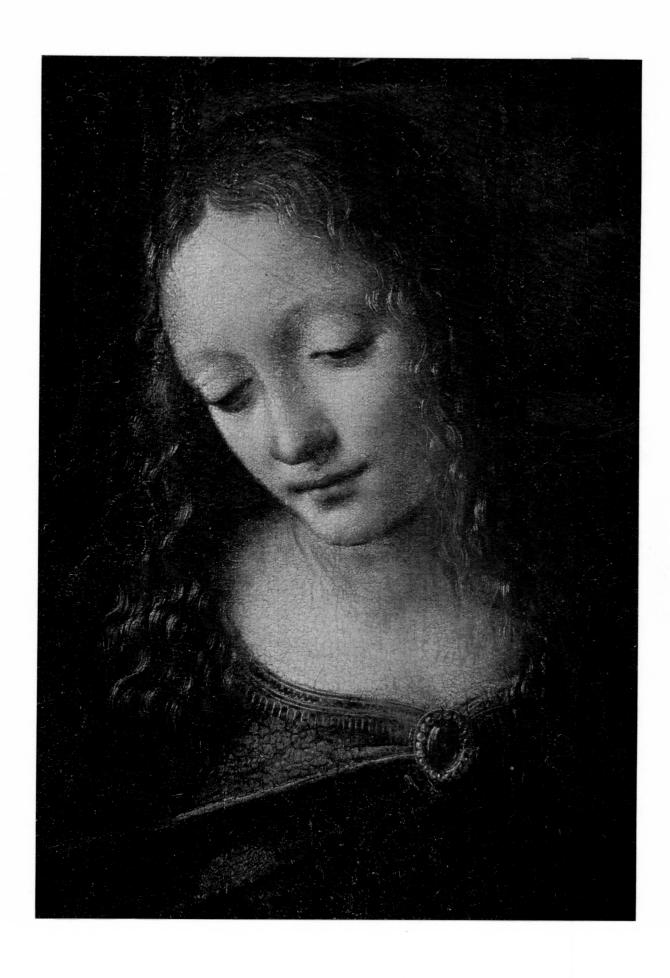

Painted c. 1486-90; 1506-8

MADONNA OF THE ROCKS, detail

Oil on panel

National Gallery, London

In most ways—in her facial features, arrangement of her hair, and set of her head—the Virgin in the *Madonna of the Rocks* in London is imitated from the earlier version in Paris (colorplate 18). So are the figure as a whole and the general composition (colorplate 16). It is unusual to find Leonardo repeating himself this way, although he seems to have done it again a few years later in painting the *Leda and the Swan*. In the case of the *Madonna of the Rocks*, the imitation was made necessary by the fact that the London painting was meant to replace the Paris version in the Confraternity's ancona. However, there are still significant differences between the two altarpieces. The Virgin in the later work is older, her facial forms are heavier and larger, and she has a serious countenance, whereas her counterpart in Paris expresses tender warmth and dreamy remoteness. Moreover, her entire body is larger and more voluminous and monumental, occupying a greater area of the panel than does the Virgin in the Paris painting.

Leonardo must have been responsible for these changes, since they conform to the evolution that is evident in his work beginning in the later 1480s and that culminates in the Last Supper of 1495-97. The fact that Leonardo left so strong an imprint on the painting accounts for its compelling attraction and power.

On the other hand, missing in the London panel are the crispness and spontaneity of execution we find in the Paris altarpiece. The Virgin's drab and lusterless hair and sharp-edged forms, the mechanical way light and shade are distributed in separate and dense areas, the loss of radiance in the light and the loss of the atmospheric veil suggest that the Virgin was not actually painted by Leonardo. I am inclined to see in the painting primarily the hand of Ambrogio de' Predis, with some small assistance from Leonardo.

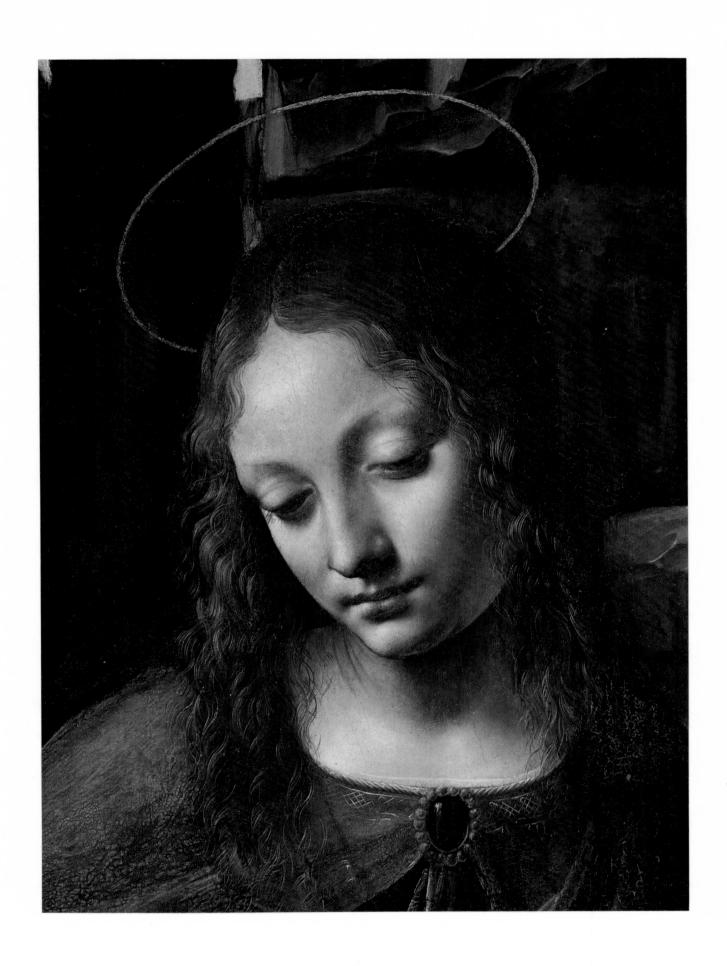

Painted 1483-85

MADONNA OF THE ROCKS, detail

Oil on canvas (originally panel)

Louvre, Paris

The qualities of freshness and charm that we find in the Virgin from the Madonna of the Rocks in the Louvre (colorplate 18) are evident also in this head of the angel from the same painting. It is endowed with vivacity and looks out at the beholder with the candid directness of youth. The angel makes an effort to catch the beholder's attention and then to guide it to the center of the painting-specifically toward the infant St. John-by means of his pointing finger (colorplate 16). If it is true that the painting was designed and begun in Florence, then the focus on St. John may have been dictated by his importance to the Florentines as patron saint of their city. The introduction of a "commentator" here and in the earlier Adoration of the Magi (colorplate 10) conforms to a fifteenth-century, primarily Tuscan, tradition that was given verbal definition by Leon Battista Alberti in his treatise on painting of 1435: "In an epic painting I like to see someone who admonishes and points out to us what is happening there." However, Leonardo has transferred the role of the commentator from an adult St. John, who normally performed it in Florentine art (colorplate 41), to a lay figure in the Adoration of the Magi, and finally to an angel in the present painting. The angel's hand serves other purposes besides pointing out to us the infant St. John: it also fills the interval and clarifies the vertical accent that result from the foreshortened hand of the Virgin, which she extends to crown the Christ Child. This helps to re-establish the prominence that Christ is in danger of losing by His subordinate location in the composition.

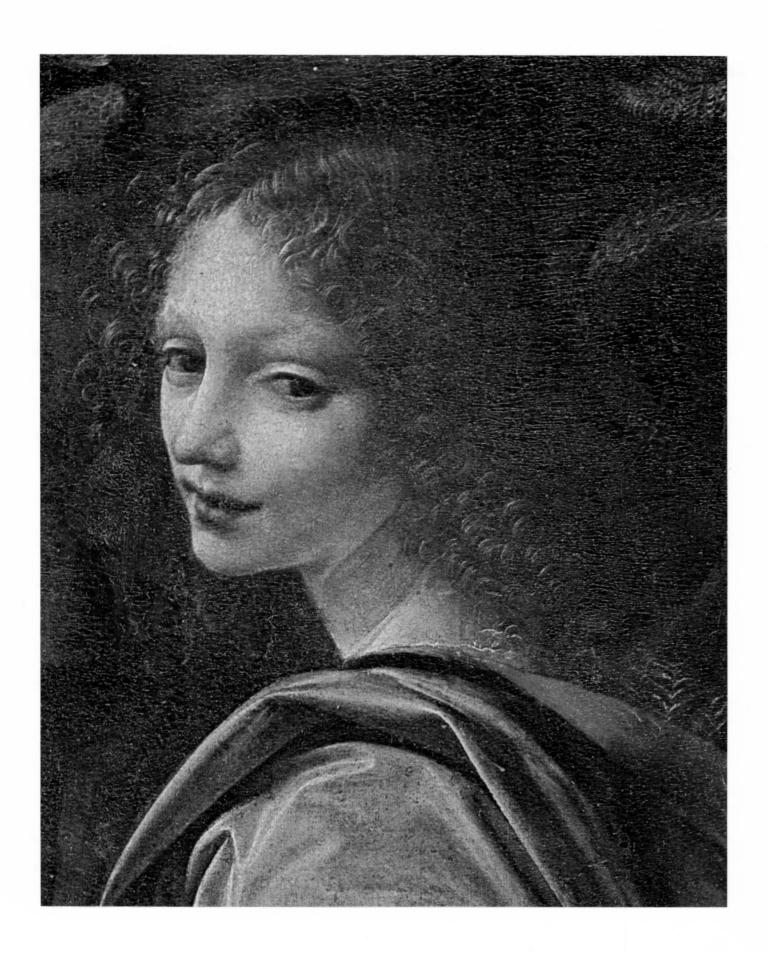

Painted c. 1486-90; 1506-8

MADONNA OF THE ROCKS, detail

Oil on panel

National Gallery, London

The head of the angel from the London version of the *Madonna of the Rocks* is possibly the only part of the painting in which Leonardo's hand may still be seen. It has some of his vivacity and sensitivity of handling, and the dappled light over the delicately swirling curls of hair is surely his invention. However, one should not assume that Leonardo was solely responsible for the head. In all likelihood, Ambrogio de' Predis was also involved, since a certain slickness pervades the facial expression and may be attributable to Ambrogio. This probable collaboration between the two artists and the refinement and slenderness in the proportions of the angel's head (compare the bulkier form of the Virgin's head) may denote an early phase in the protracted execution of the panel before its delivery to the Confraternity in about 1490.

A drawing in Turin of a woman's head (fig. 63), sketched from life, although generally considered a preliminary study for the angel in the Louvre panel, would seem to me rather to have some connection with the London angel. We must not be misled into assuming a connection with the earlier angel by the same turn of the head and the way the eyes are made to observe the beholder. If, as I have suggested a number of times in this book, Leonardo's female models or his ideal female type aged as he himself grew older, then in this feature alone the woman in the drawing would seem more like the later angel. However, there are other more basic reasons for making this connection. The modeling of the face in the drawing is tighter, fuller, more regular and idealized than before, as it is in the painted head of the angel, and the systematically distributed chiaroscuro approximates Leonardo's controlled use of it in the later 1480s.

The angel in the London altarpiece differs from its counterpart in the Paris panel by being represented in a state of reverie, which establishes its psychological relationship with the other figures in the painting. Leonardo must have been responsible for this change, because it is consistent with the way he will cause the figures in the Last Supper (colorplate 24) to interact with each other. A second difference between the two angels is the elimination of the pointing finger in the later painting. A "commentator" figure who points to an important element in a scene was commonly used by fifteenth-century painters; therefore, the elimination of this device in the London work may have been dictated by a desire to modernize the composition. However, the awkward interval this creates above the head of Christ suggests that Ambrogio de' Predis was responsible for the change.

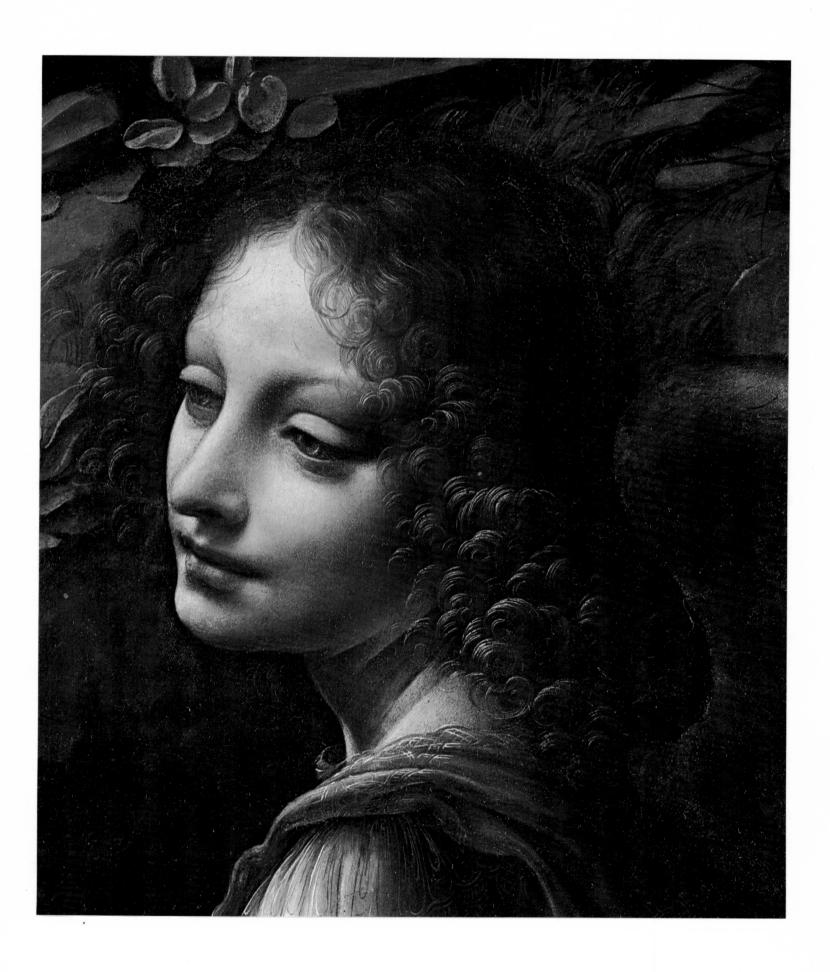

Painted 1483-85

MADONNA OF THE ROCKS, detail

Oil on canvas (originally panel)

Louvre, Paris

The Christ and St. John from the Madonna of the Rocks in the Louvre are two of the most delectable children in the history of art. Both, however, depend on examples Leonardo had seen in fifteenth-century sculpture. Their round and fleshy forms are the direct heirs of Donatello's and Verrocchio's sculptured putti, while their sweetness, refinement, and naturalism conform to the then popular taste in art established by Antonio Rossellino and Desiderio da Settignano. More specifically, the puffy cheeks, the shape of the mouth, and the recessed chin are close to such examples as the Bust of a Little Boy by Desiderio in the National Gallery of Art in Washington, D.C. (fig. 6). In this, Leonardo demonstrates his extraordinary ability to transform what he has seen in the work of others into inimitable conceptions of his own.

Beautiful as these children are, they have certain anatomical incongruities that are puzzling in so great an artist and in one whose work is so consistently based on an empirical observation of nature. Especially disconcerting are the feet, which are so disproportionately large as to seem grotesque. How can one account for this except by assuming that Leonardo was adhering too strictly to a system of proportions whereby, as he put it, the "foot is as long as the whole head of a man"? This formula, illustrated in several of his drawings, is proper in the portrayal of an adult figure, but not when it is applied to a child.

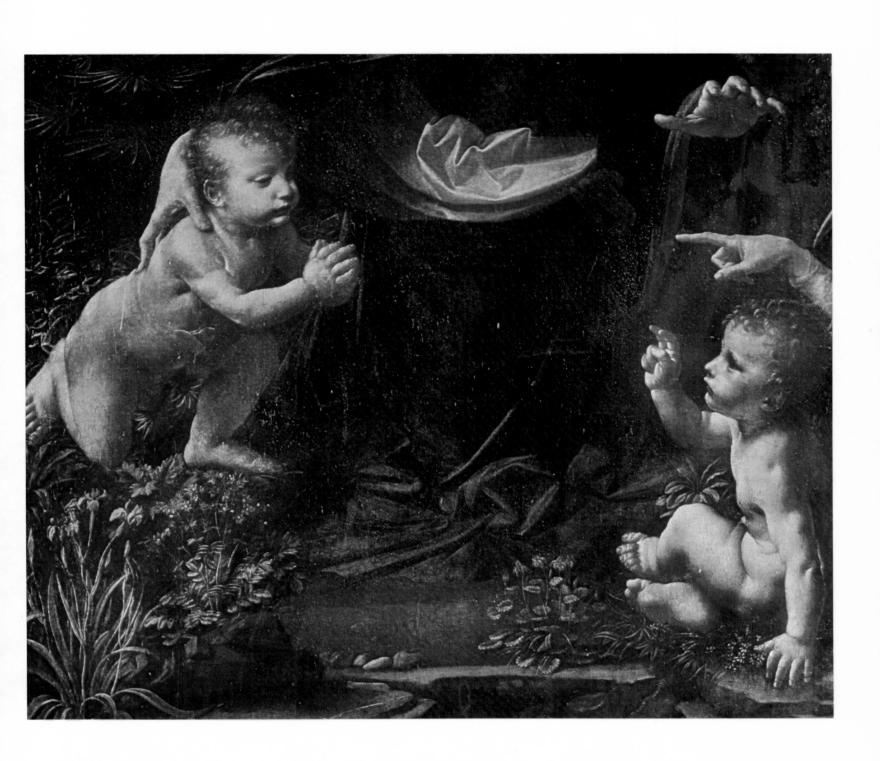

Painted 1483-85

MADONNA OF THE ROCKS, detail

Oil on canvas (originally panel)

Louvre, Paris

Beyond the semi-darkened cavern that provides a backdrop for the figures who enact their tender spiritual roles in the Madonna of the Rocks, one can look out suddenly at a world of air and light. It is not, however, a world of cheer and joy, but one that is haunting and spectral, in which the eye seeks avidly (if unsuccessfully) to penetrate the heavy mists that seem to dissolve the rough-hewn cliffs. This strange and barren landscape contrasts dramatically with the one that is inhabited by the holy figures, where the bare stone is ornamented with a luxuriant and naturalistic vegetation. By creating this contrast, was not Leonardo attempting to distinguish between the world of Christian grace—a proper setting for the reverential scene—and the world without grace, the world of foreboding beyond? For Leonardo, landscape was not an adjunct that simply established the context for a narrative or devotional representation; nor was it merely a self-conscious demonstration of his great ability to record visual experiences with precision. It is true that the geological and empirical exactitude with which he conceived the background as well as the floral forms in the foreground is a direct reflection of his scientific interests. Yet in his hands nature becomes expressive in its own right, while it simultaneously extends the range of the emotional and symbolic content of his painting. Beginning with Giorgione, the Venetians were to understand this new conception of landscape better than anyone else. Leonardo's Florentine compatriots would for a time still continue to conceive their landscapes as collateral elements and descriptive details rather than as evocative, integral parts of the whole.

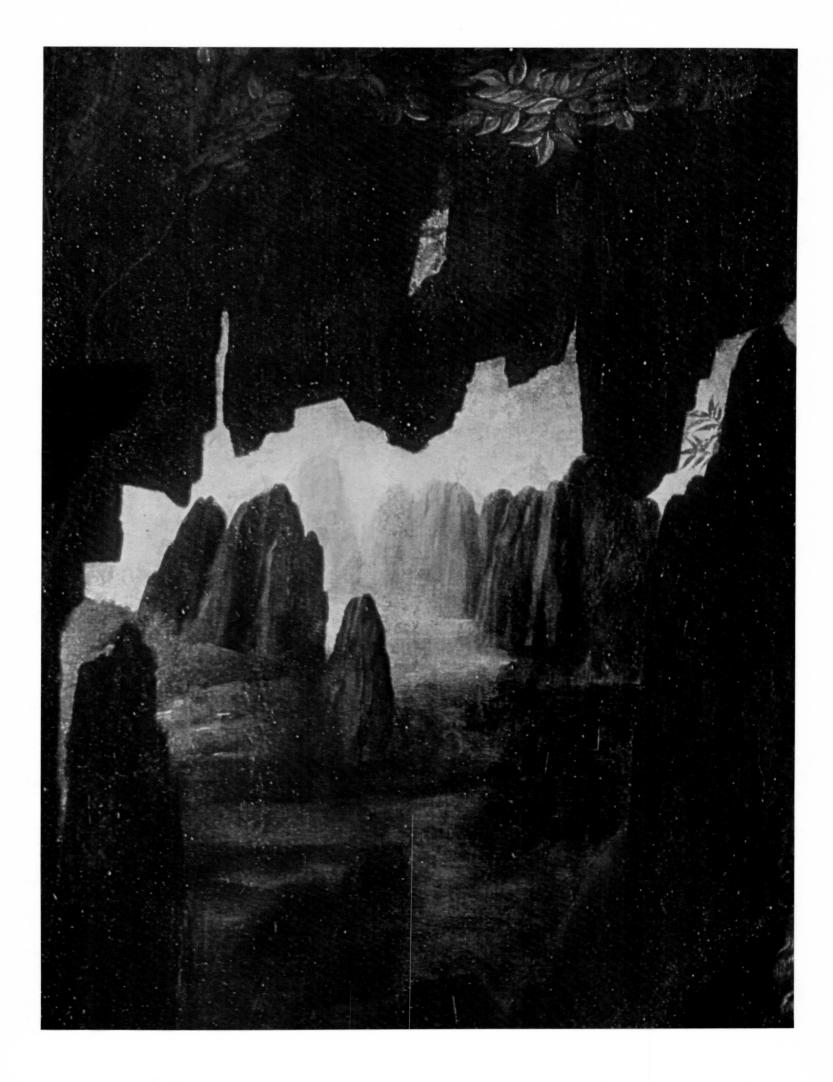

Painted 1495-97

LAST SUPPER

Oil-tempera mixture on wall, 13' 10" × 29' 7 1/2"

Refectory, S. Maria delle Grazie, Milan

The decayed and ascetic impression the *Last Supper* makes today hides what was once probably a luminous and richly decorated painting. The clear and vivid colors (blues, reds, greens, and yellows) no longer vibrate in the light, and the tablecloth and eight wall hangings have faded into neutral tones and nearly lost their patterns of ornamentation. Leonardo must be held chiefly accountable for the near ruin we see today.

Matteo Bandello, author of the novella of Romeo and Juliet on which Shakespeare based his play, frequently witnessed Leonardo engaged in painting the Last Supper in the refectory of the monastery in which Matteo's uncle was prior. Here is his fascinating report of what he saw: "He would often come to the convent at early dawn; and this I have seen him do myself. Hastily mounting the scaffold, he worked diligently until the shades of evening compelled him to cease, never thinking to take food at all, so absorbed was he in his work. At other times he would remain there three or four days without touching his picture, only coming for a few hours to remain before it, with folded arms, gazing at his figures as if to criticize them himself. At midday, too, when the glare of a sun at its zenith has made barren all the streets of Milan, I have seen him hasten from the citadel, where he was modeling his colossal horse [the Sforza equestrian monument], without seeking shade, by the shortest way to the convent, where he would add a touch or two and immediately return."

Clearly, Leonardo was not by temperament (or by training, as we have seen) a fresco painter, being spontaneous and contemplative in his execution of paintings and indulging to the highest degree his inspiration of the moment. True fresco painting is an orderly process and requires that the artist arrange his work in a series of days, with the activities of each day reserved to a single section of the composition that has been established beforehand. Pigment mixed in water is applied to wet plaster, and both are allowed to dry together and fuse permanently. Leonardo's medium was as personal as his method, since it was one that he himself had compounded. From the beginning of his career, he had favored the use of an oil mixture because it permitted him to attain atmospheric effects and veiled, sensuous surfaces. Used on the scale of the *Last Supper* and on dry plaster, the mixture could not withstand the build-up of humidity, nor could it adhere to the wall. Therefore, the mural had begun to fade and flake even in Leonardo's lifetime; half a century after the painting was completed it was described by Vasari as a "muddle of blots."

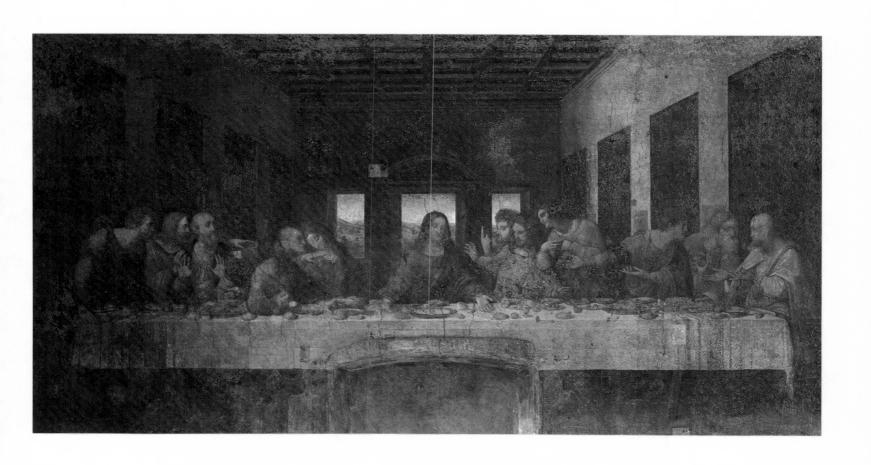

Painted 1495-97

LAST SUPPER, detail

Oil-tempera mixture on wall

Refectory, S. Maria delle Grazie, Milan

In painting the Last Supper, Leonardo revealed the same propensity he had shown in the Adoration of the Magi for representing the totality of a scene as described in the Scriptures. The biblical Last Supper was an emotional occasion during which the apostles were stunned by Christ's unexpected and damning pronouncement that one of them would betray Him. Leonardo here had an opportunity to portray an explosive and highly dramatic scene and to delve more deeply than ever before into the psychological attitudes of his protagonists. The episode was also the occasion for a symbolic revelation in which Christ identified His body and blood with bread (the sacrifice) and with wine (the remission of the sins of man), thereby establishing the sacrament of the Eucharist as the vehicle by which salvation can be attained. Christ's words to the apostles in the Gospel of St. John (6, 54) are these: "Whoso eateth my flesh and drinketh my blood hath eternal life and I will raise him up at the last day." Leonardo represented this aspect of the event also.

Christ is seen extending His arms outward in this detail of the fresco's central section. His left hand reaches toward a small loaf of bread, at which He glances with yearning. His right hand reaches simultaneously toward a bowl (into which He and Judas will place their hands, thereby identifying the betrayer) and a wine-filled glass. At this point, Leonardo links the multiple aspects of the Last Supper: drama and ritual; betrayal, sacrifice, and salvation. Oddly enough, as Leonardo represents it, the doctrinal lesson is lost to the apostles, who instead react solely to Christ's pronouncement of the impending betrayal. One has to assume from this, and from Christ's strongly frontal position in the painting, that Leonardo meant for Christ, in His didactic role, to address another audience—the monks assembled before Him in the dining hall. His outstretched arms serve to emphasize the elements of the Eucharist, and at the same time to appeal poignantly to the congregation partaking of their own meal before Him:

"And He took bread and gave thanks and broke it and gave unto them, saying this is my body which is given you.

"Likewise also the cup after supper, saying this cup is the new testament in my blood, which is shed for you." (Luke 22, 19-20)

The monks are thereby confirmed as partners of the Church (as Dominicans—Domini canes—they considered themselves its watchdogs) in a joint mission to reclaim the souls of men, which was for them the only road to salvation.

The marked intervals of space on either side of Christ isolate Him physically from the apostles, while His dignity, aloofness, and perfect calm distinguish Him psychologically and attitudinally from the apostles; finally, the strict triangularity of His silhouette as framed against the rectangular window and the crowning segmental arch endow Him with a spiritual and universal essence, with divinity.

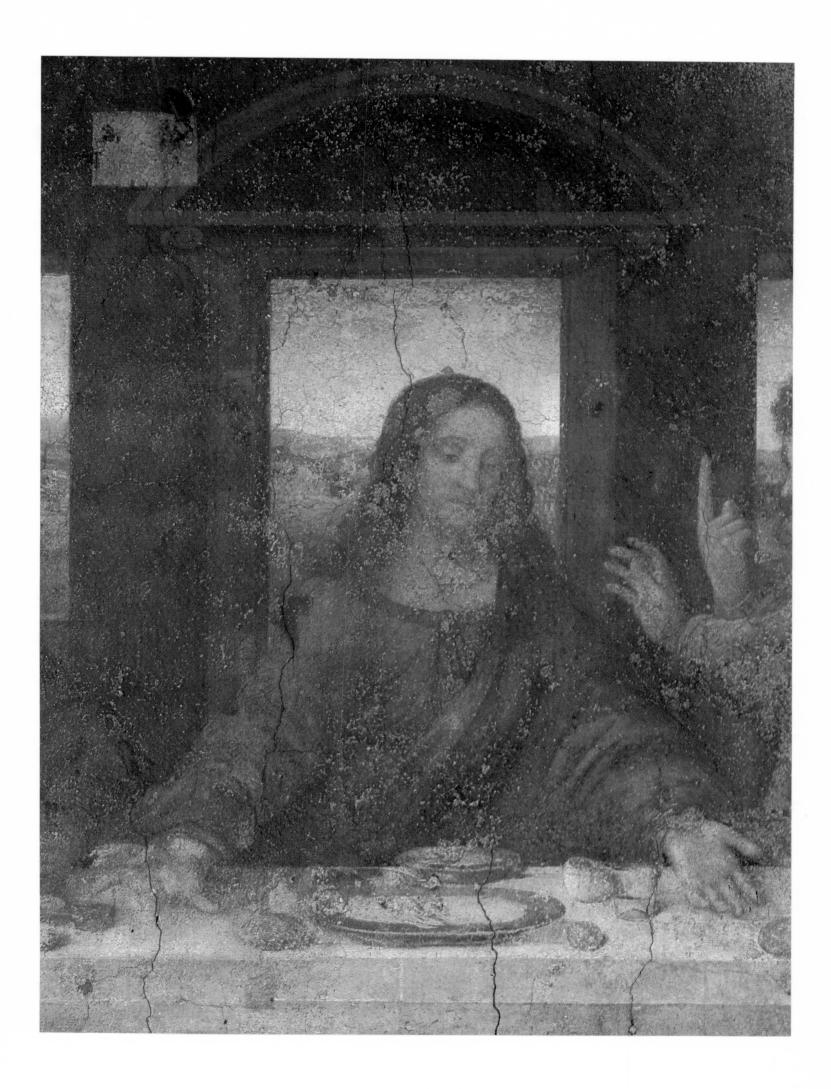

COLORPLATE 26 Painted 1495-97

LAST SUPPER, detail

Oil-tempera mixture on wall

Refectory, S. Maria delle Grazie, Milan

The seating arrangement of the apostles in representations of the Last Supper, in the few examples where their identities are disclosed by inscriptions, has always been fluid, with the exception of Peter, John, and Judas. It had become standard practice by Leonardo's time (fig. 27) to isolate Judas on the side of the table closest to the beholder and to locate Peter and John on the opposite side, flanking Christ. John is invariably shown resting his head on Christ's breast or on the table, an attitude that derives from a passage in one of the Gospels (John 13, 23): "Now there was leaning on Jesus' bosom one of his disciples, whom Jesus loved." The unnamed disciple has from time immemorial been assumed to be John himself. Leonardo followed this long tradition in his composition studies for the Last Supper, best seen in an anonymous copy in the Accademia in Venice (fig. 80), but in the painting itself he brought Peter, John, and Judas together to the left of Christ.

Why? In the first place, we have seen that Leonardo favored a close and accurate reading of the Bible, and it was there (John 13, 24) that he found in essence the relationship between Peter and John that he chose to depict: "Simon Peter therefore beckoned to him that he should ask who it should be of whom He spoke." Peter directs his question to the disciple "whom Jesus loved"—that is, to John—and he does so in response to Christ's announcement of the betrayal. Secondly, Leonardo revealed in the Last Supper a strong predilection for narrative continuity and logic. This made the psychological rapport between the elderly Peter and the young John preferable to the somnolent attitude with which John is normally portrayed and more consistent with the dramatic treatment of the scene as Leonardo envisioned it. Furthermore, it made untenable the isolation of Judas from the other apostles, since at the moment depicted in the painting his identity as the betrayer was not yet known to them. Another reason why Leonardo found it necessary to make these changes was his wish to adhere to the ritualistic aspect of the biblical meal, in which Christ established the sacrament of the Eucharist. Left in their traditional locations, John and Judas would have obstructed and thereby diminished the force of Christ's emblematic presence and didactic gestures. Finally, Leonardo's decision to bring the three apostles together made it possible for him to attain a very precise and formal compositional symmetry of four equal groups. The result was a brilliant juxtaposition of figures in sharply contrasting attitudes, in which Judas guiltily withdraws from Christ, while Peter vigorously addresses his request to an impressionable and attentive John.

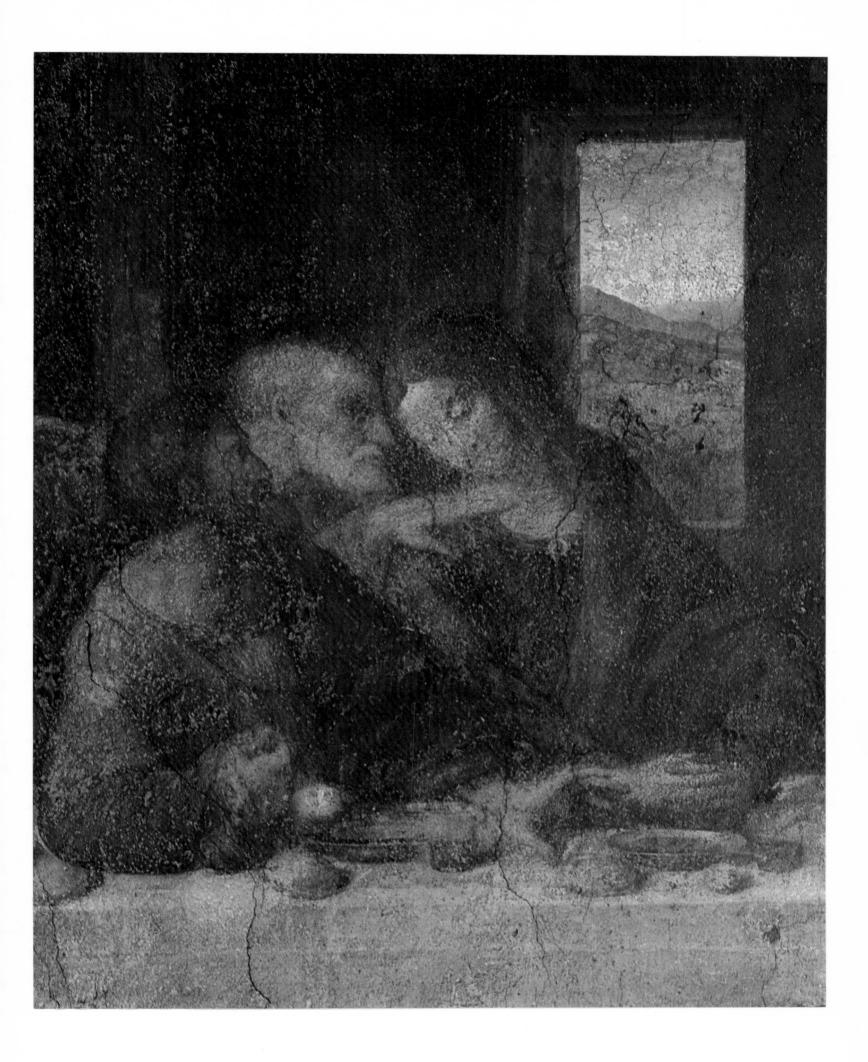

Painted 1495-97

LAST SUPPER, detail

Oil-tempera mixture on wall

Refectory, S. Maria delle Grazie, Milan

While it is safe enough to recognize the apostle with upward pointing finger in this detail as the Doubting Thomas, the other two are more difficult to identify. The figure with hands held to his breast is sometimes believed to be Bartholomew, because, it is maintained, he epitomizes John's description of this apostle as guileless (1, 45–48). I think he is Philip, since the comparable figure in a sixteenth-century copy of Leonardo's Last Supper is so inscribed.

The seated apostle with outstretched arms I take to be James the Greater and not James the Less, as certain scholars contend. There is, for example, sufficient biblical evidence for seating James the Greater in the immediate vicinity of Christ and in the intimate company of Peter and John. James and his brother John were, with Peter and his brother Andrew, the first to have been beckoned by Christ to follow Him (Matthew 4, 18-21; Mark 1, 16-20), and they were present with Peter alone at the Miracle of the Loaves and Fishes (Luke 5, 5-10). Moreover, James the Greater was privileged to witness the Transfiguration with Peter and John (Matthew 17, 1-2) and was called aside with them by Christ in the garden at Gethsemane (Matthew 26, 36-37). Finally, according to Mark (3, 17) and Luke (9, 52-56), Christ described both James and John as impetuous (boanerghes). Leonardo dwelled on this characteristic of James—whose role in the Last Supper is not mentioned in the Bible—because he could thereby define the apostle's personality and intensify the dramatic action of the painting. On the other hand, Leonardo chose to ignore the impetuous aspect of John's temperament and instead depicted him as dreamy and pliable, which is a variation of the way he appears in fifteenthcentury representations of the Last Supper, and in conversation with Peter (colorplate 26), which is the role John had in the biblical Last Supper. John is thus contrasted with his brother James and he becomes a foil for the aggressive Peter and the sly Judas.

Given this prominence of James the Greater and his close association with Christ, Peter, and John, it should not come as a surprise to find him, on the one hand, beside John in a copy of Leonardo's preliminary study for the painting (fig. 80) and, on the other, next to Christ in a copy of the mural at Ponte Capriasca. He is identified by an inscription in both copies. James and John, therefore, were both given seats of honor beside Christ in Leonardo's Last Supper. In so doing, did Leonardo have in mind an earthly prefiguration of a passage in Matthew (20, 20) referring to a request that Salome, mother of John and James, had made to Christ—that her two sons be allowed to sit beside Him in Paradise, "the one on Thy right hand and the other on the left in Thy kingdom"? The request angered the other apostles and elicited from Christ the evasive reply that this privilege was only God's to grant. Was it the assumption in Leonardo's time that the request had in fact been granted?

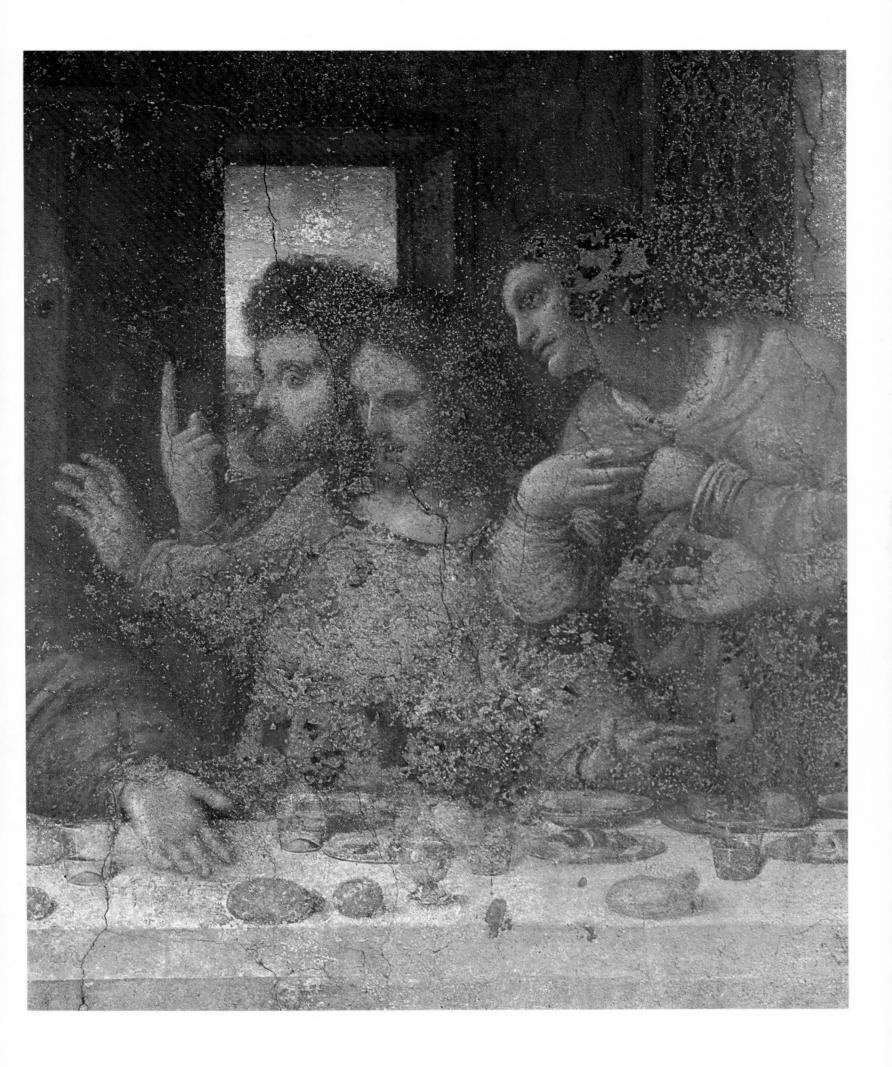

Painted 1495-97

LAST SUPPER, detail

Oil-tempera mixture on wall
Refectory, S. Maria delle Grazie, Milan

If we designate James the Greater as the apostle with outstretched arms on Christ's right, then the only other apostle who can be identified as James the Less is the central figure in the group here illustrated (the detail is taken from the extreme left of the painting). In fact, this figure is so inscribed (S. Jacob Mi) in the previously mentioned copy of Leonardo's Last Supper at Ponte Capriasca. Leonardo was following a literary tradition of recent origin when he conceived his St. James the Less: it was written that the saint resembled Christ so closely in outward appearance that the kiss of Judas was decided on as the signal of the betrayal in order to avoid confusing the two. Only the central figure in our illustration reasonably fits this description, even in the garment he wears.

The other two figures are more difficult to identify, if we must rely only on biblical references, which are sparse, or on fifteenth-century pictorial representations, which do not establish a consistent seating arrangement for the apostles in representations of the Last Supper. This accounts for the lack of correspondence in the placement of the apostles between Leonardo's painting and his preliminary drawing for the Last Supper, known from a copy in Venice (fig. 80). On the other hand, the figures in the Ponte Capriasca copy of Leonardo's mural are inscribed with the names of each of the apostles and enable us to identify the counterpart of the figure on the left in Leonardo's painting as Bartholomew. Otherwise, we have only John's reference (1, 45–48) to Bartholomew as "an Israelite indeed, in whom is no guile."

The figure on the right must be Andrew, since his counterpart in the Ponte Capriasca copy is inscribed with this apostle's name. Another clue to the figure's identity is the fact that he sits beside Peter, Andrew's brother, whom he also seems to resemble. Moreover, Leonardo filled the dish that is set in front of these two apostles with fish, perhaps to call attention to their trade as fishermen.

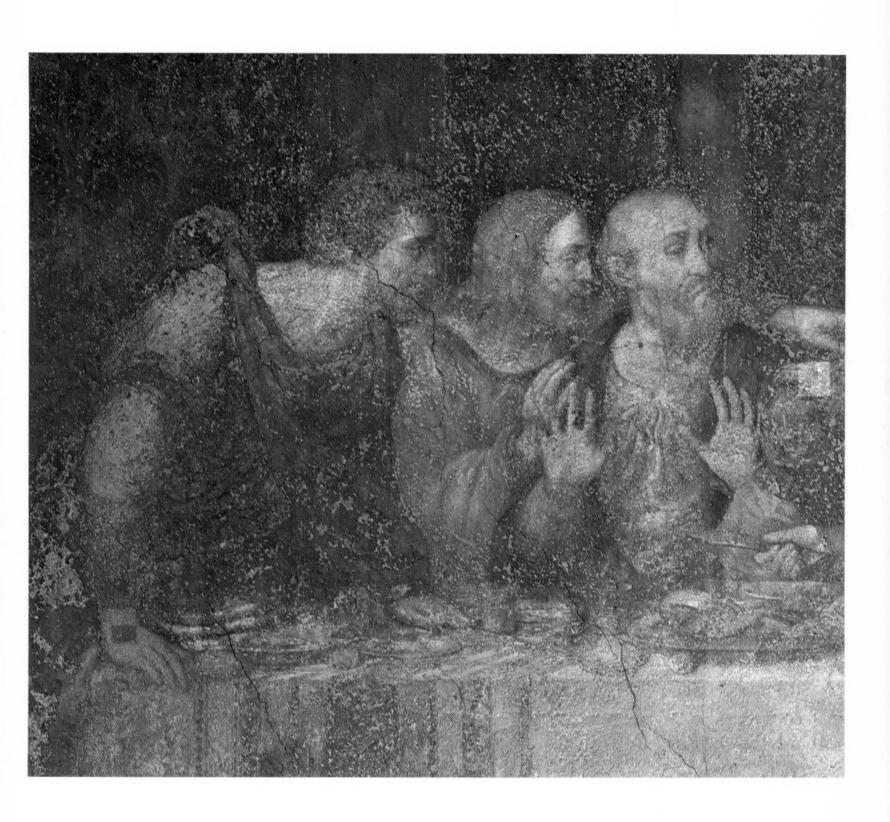

Painted 1495-97

LAST SUPPER, detail

Oil-tempera mixture on wall

Refectory, S. Maria delle Grazie, Milan

The remaining apostles, shown in this detail, are Matthew, Thaddeus, and Simon. Of these, only Matthew attained definition as an individual (he was Levi the tax collector before his conversion) and prominence as a historian (he wrote the first life of Christ). However, Leonardo did not symbolize either the individual or the biographer by means of a recognizable attribute (not even the familiar book). So again, we must invoke the Ponte Capriasca copy of Leonardo's Last Supper, in which we find the counterparts of the three figures in this detail inscribed from left to right as Matthew, Thaddeus, and Simon.

Responding to Christ's revelation of the betrayal at hand, the apostles gesticulate vehemently to display their distress; faces reveal a variety of deeply felt emotions and bodies twist and turn convulsively. Leonardo's model for the use of these descriptive pictorial devices, which were intended to project dramatically the psychological states of his protagonists, was probably Giotto's destroyed mosaic of the Navicella of 1310, formerly on the inner atrium façade of Old St. Peter's in Rome. In all likelihood, Leonardo had not yet seen the mosaic, but he must have read a description of it in Alberti's Treatise on Painting of 1435: "Eleven disciples, all moved by fear at seeing one of their companions passing over water. Each one expresses with his face and gestures a clear indication of a disturbed soul in such a way that there are different movements and positions in each one." Gesture, movement, and facial expression were for Leonardo, as for Alberti, necessary components of epic painting.

As compared to Giotto's Navicella, or even to his own Adoration of the Magi (in which dramatic-explicative gesticulations and facial expressions appeared for the first time in his work on a significant scale), Leonardo in the Last Supper tried—and largely succeeded—in making them conform more explicitly to the individual character of each apostle. This shows Leonardo's growing interest in human beings caught up in a mass action and viewed in a moment of spiritual stress. The correlation between the identities of the apostles and the specificity of their actions increases in the two groups that flank Christ: gestures and attitudes reveal more definitely who the apostles are and what they feel and think. This is partly due to the fact that their personalities and their roles in the biblical narrative are better known than those of the apostles in the two groups at either end. It is also a measure of Leonardo's dynamic conception of composition that he imposed the highest degree of physical and psychological concentration in the center, where the percussive force of Christ's words have their most direct and intense impact and where the apostles act most sharply as foils for Christ, willfully serene amid the anguish and turmoil of His disciples.

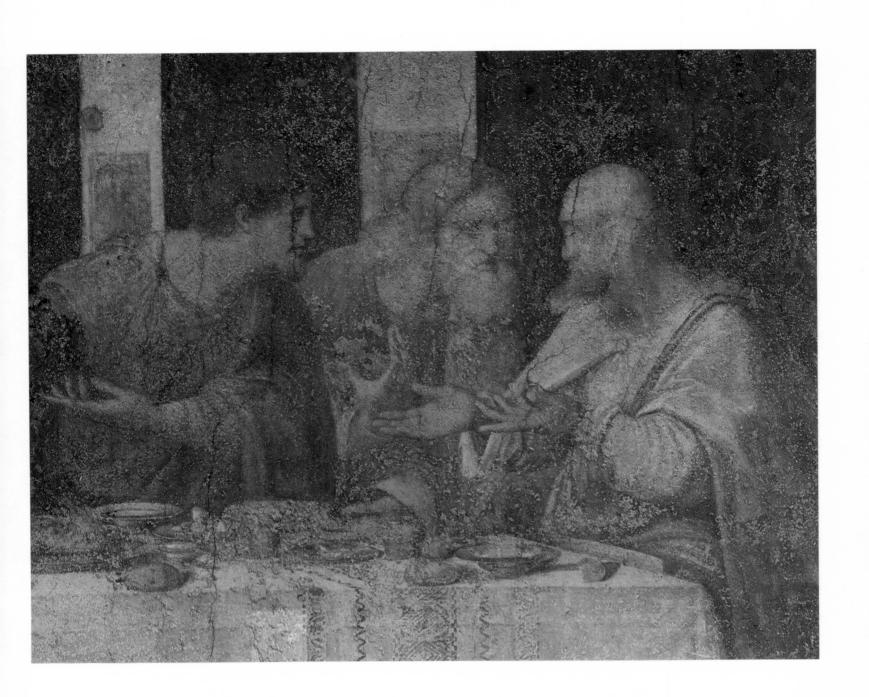

Painted c. 1483-86

CECILIA GALLERANI (LADY WITH THE ERMINE)

Oil on panel, 21 3/4 × 15 7/8"

Czartoryski Museum, Cracow

There is no documentation for this painting before it entered the collection of the Polish Prince Adam Czartoryski late in the eighteenth century. Not until the end of the nineteenth century do we encounter efforts to attribute it to Leonardo and to identify the sitter as Cecilia Gallerani, the young mistress of Lodovico Sforza. Despite frequent attempts today to attribute this portrait to other painters, it can hardly be doubted that it originated in the studio of Leonardo. There are several reasons for this view. The shape of the head is reminiscent of the angel's head in the Louvre version of the Madonna of the Rocks (colorplate 20), and the somewhat complicated posture recurs in a nearly contemporary drawing in Turin (fig. 63) as well as in the Last Supper. Moreover, parts of the painting are beautifully executed, particularly the hands and the animal.

Yet how shall we account for the tight and inflexible surfaces of the face, for its excessively sharp details, and for the ribbons of the dress that are so nonfunctional and treated merely as appliqués, unless we assume some involvement by assistants of Leonardo. These anomalous features cannot be attributed to the hand of a restorer, although at some point the painting was heavily repainted. This affected mainly the background, where X-ray examination reveals the prior existence of a window to the right of the head, thus accounting for the direction of the light. Another relatively recent addition is the inscription on the upper left. The figure itself, however, is intact, save for the addition of the pink glaze on the face and slight alterations to the outline.

The date of the portrait is difficult to establish precisely, but two dated references to a portrait Leonardo had painted of Cecilia Gallerani help. The first is by the poet Bernardino Bellincioni, who before his death in 1492 had praised the portrait in a poem. The other is a letter Cecilia Gallerani wrote to Isabella d'Este in 1498, in which she states that in the portrait Leonardo made of her years ago she is still "immature." What, in the mind of a thirty-three-year-old woman (Cecilia was born in 1465) of the fifteenth century, would constitute immaturity? I imagine the word to mean the years between her eighteenth birthday (she was eighteen in 1483, when Leonardo first arrived in Milan) and her twenty-first (which occurred in 1486, the terminal date of the portrait).

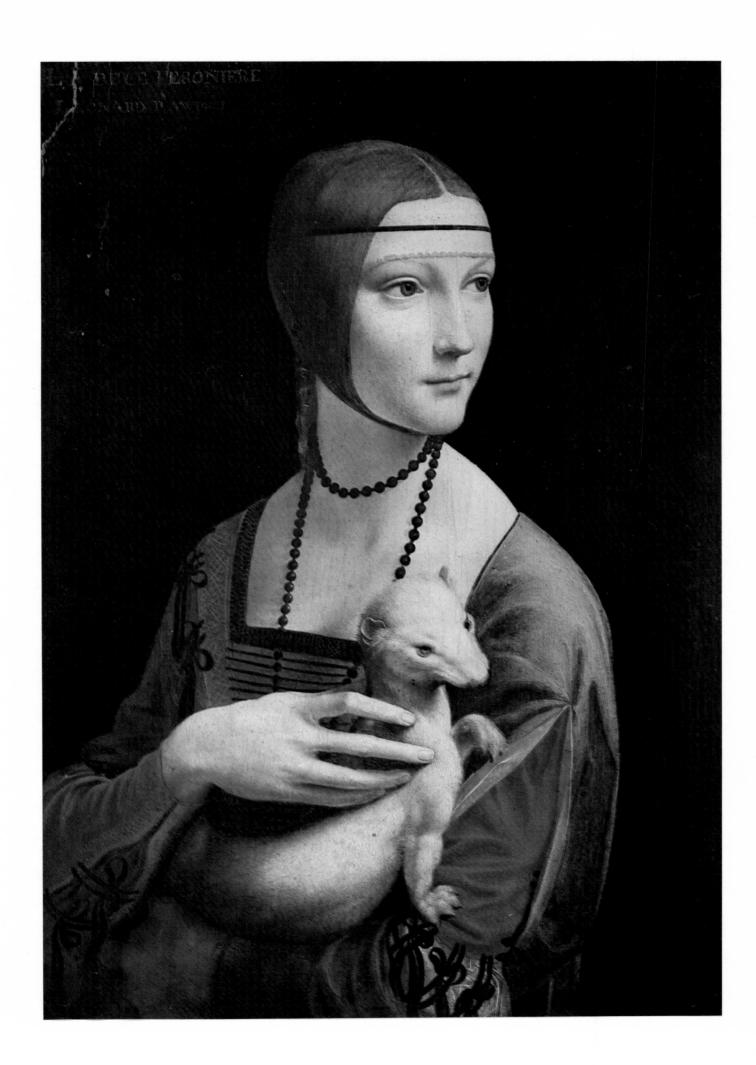

Painted c. 1490

PORTRAIT OF A MUSICIAN

Oil on panel, 16 × 11 7/8"

Biblioteca Ambrosiana, Milan

For all its plastic power and Leonardesque intonation, this portrait cannot comfortably be attributed to Leonardo, since it lacks the direct intensity of expression and characterization with which he normally endowed his faces. The portrait was first brought to public attention in 1686, in a catalogue of the Ambrosiana collection in Milan; the catalogue gave the name of the artist as Bernardino Luini, a distant follower of Leonardo, and the sitter as the Duke of Milan, presumably Lodovico Sforza. The catalogue attribution was changed at the turn of the century to Leonardo and the identity of the sitter to Franchino Gaffurio, the artist's celebrated friend and choir-master of Milan Cathedral, a post he had held since 1482. The musical notations and the mutilated inscription on the sheet held by the sitter (revealed after cleaning of the painting in 1904)—which reads "CANT . . . ANG" (Canticum Angelicum)—indicate that the man portrayed was a musician. This has made his identity as Gaffurio seem plausible. The fact that Leonardo had designed woodcut illustrations for Gaffurio's book Practica Musica (1496) was sufficient evidence for some scholars to link him with this portrait. Since then, the subject of the painting has been interpreted in many ways.

The matter is still far from settled today. My personal preference is to attribute the portrait to Ambrogio de' Predis, as others have done, whether or not the sitter is Gaffurio, and to assume that Ambrogio had painted it while in particularly close association with Leonardo (perhaps even under his supervision). De' Predis was Leonardo's host during the latter's first years in Milan and his co-worker on the altarpiece for the Confraternity of the Immaculate Conception from 1483 until 1508. I introduce now a page of drawings in the Louvre (fig. 40), which I believe to be by De' Predis, as a point of departure for my attribution. I am perhaps too much influenced in this judgment by the superficial similarities between the modish costumes and the hats set at swaggering angles—although I have some reservations arising from the fact that the bony structure and sharp features of the musician's head are unlike the rounded and uniform features of one of the youths in the page of drawings. On the other hand, something of the pronounced physiognomy of the painted head may be found in the partial profile on the left of the Louvre page, in other portraits by De' Predis (such as the Portrait of a Woman in the National Gallery in London), and in the London version of the Madonna of the Rocks (colorplate 17).

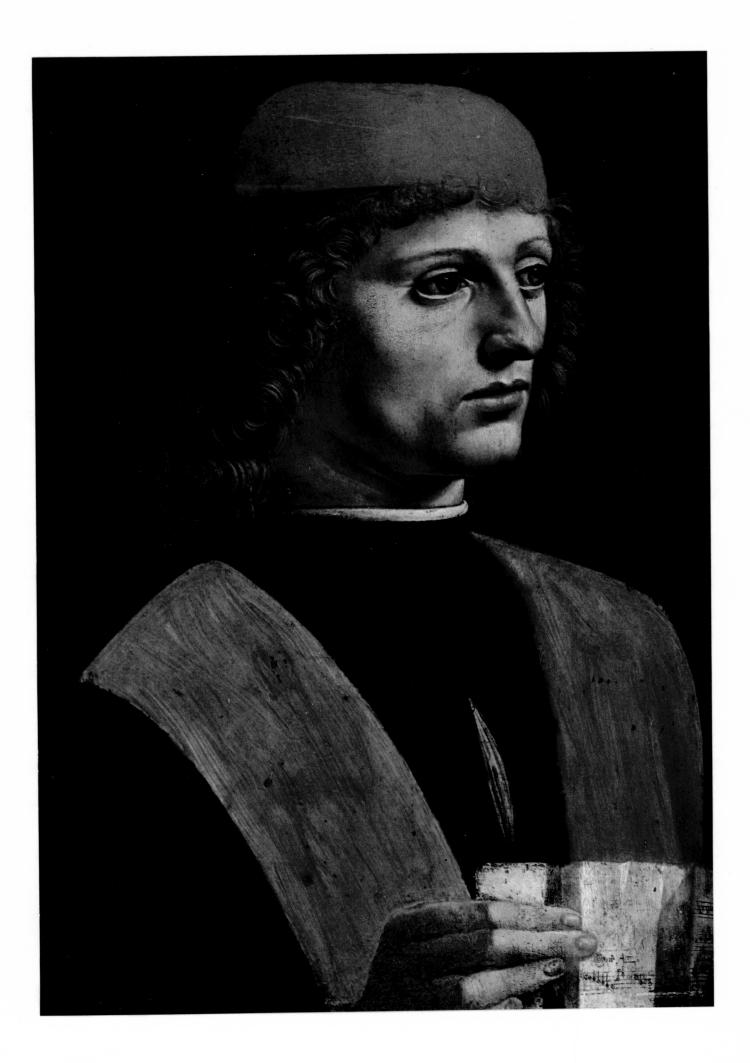

Painted 1499-1501

BURLINGTON HOUSE CARTOON (VIRGIN AND CHILD WITH ST. ANNE)

Charcoal heightened with white on brown paper, 54 $7/8 \times 39 7/8''$ National Gallery, London

It is not unlikely that the cartoon of the Virgin and Child with St. Anne in London's National Gallery was made for a commission Leonardo had received from Louis XII in October 1499, soon after the French monarch had entered the city of Milan at the head of his conquering army. I advocate this despite recent efforts to assign the cartoon to a much later period in Leonardo's career (1505, or even 1508).

St. Anne seems to have been as popular with the royal family of France as she was with the Florentines, but for different reasons. The tribute paid her in Florence, as one of those saints who had intervened to defend its citizens' threatened liberty, is matched in France by the fact that Louis XII's consort, Queen Anne, was from Brittany, one of the historical centers for the worship of her patron saint. The immediate occasion for the commision may have been the anticipated birth of Louis' first heir, which occurred a few days after the king entered Milan. The painting, for which the cartoon was preparatory, was perhaps to be given as a votive offering to some church in Brittany. (The widespread popularity St. Anne enjoyed in these years throughout Europe is further attested by the fact that Louis' successor, François I, specifically requested a painting on this subject when he invited Leonardo to settle in France in 1516.)

There are two additional reasons for believing that Louis XII commissioned the cartoon. In the first place, this was the claim made by the late seventeenthcentury collector-priest Padre Sebastiano Resta. However, since Resta's reputation for accuracy and even honesty is less than one might hope for, it is prudent that we move on to the second reason. In April 1501, Isabella d'Este of Mantua received a letter from Fra Pietro da Novellara, who had just visited Leonardo in Florence on her behalf. His letter quotes Leonardo to the effect that the artist was painting the Madonna with the Yarnwinder (now lost) for Louis XII's secretary, Robertet—which establishes Leonardo's connection with the French court in Milan-and that he had still to complete an "obligation to His Majesty, the king of France." Fra Pietro does not specify the nature of this obligation, but it may have been a cartoon on which Leonardo was then working and which Fra Pietro described in a second letter he wrote to Isabella some days later. This cartoon represented a Virgin and Child with St. Anne, but since the description does not quite fit the Burlington House Cartoon, it is my belief that it was intended as an alternative to it. Leonardo had evidently become dissatisfied with his work on the Burlington House Cartoon, left it unfinished (as it remains today), and started the cartoon described by Fra Pietro. This interpretation of events is made possible by the fact that the Burlington House Cartoon was definitely in existence in 1502, when the figures of the Virgin and the Child were copied by Filippino Lippi in a fresco (fig. 41) he completed that year in the Strozzi Chapel of S. Maria Novella in Florence.

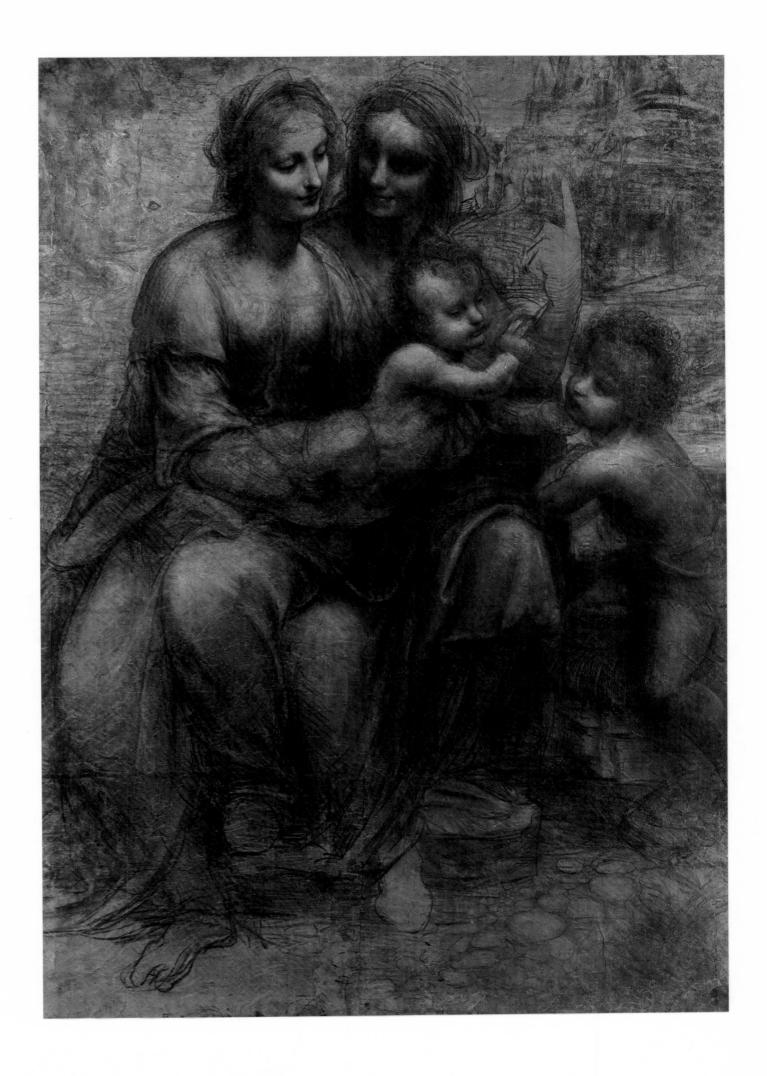

Painted 1499-1501

BURLINGTON HOUSE CARTOON (VIRGIN AND CHILD WITH ST. ANNE), detail

Charcoal heightened with white on brown paper

National Gallery, London

The face of the Virgin in the Burlington House Cartoon accords with the type Leonardo had established seventeen years before in the Virgin of the Madonna of the Rocks in the Louvre (colorplate 18), yet it betrays the deep changes these long years had wrought in his art and that the other Madonna of the Rocks, the London version, first began to reveal. Something of that sweet harmony and well-being have survived, but now the face is that of a mature woman and is suffused with feelings and compassion that are the direct result of an emotional and human concern with the actions of the children. Realistic behavior has replaced elusive ethereality. The Virgin's head is voluminous and its structure more systematically defined than in Leonardo's earlier work. Moreover, the slight incline of the head is no longer a convention, as it was in the Madonna of the Rocks, but the result of a conscious movement. However, she still has the force of an idealized and universal presence.

The contrast between St. Anne's strange face and the pleasantly candid one of the Virgin could not be more striking. The older woman's narrow, deep-set eyes, her deliberately compressed lips, and her curious mannered smile give the face an animation and a seer-like wisdom befitting one who attempts to communicate to a contented Virgin the dreadful knowledge of her son's future sacrifice. Leonardo's persistent search into the realm of the inner mind has given him access to emotions and psychological states that have now a mystical substance, which acts to expand upon and enrich the mere human condition.

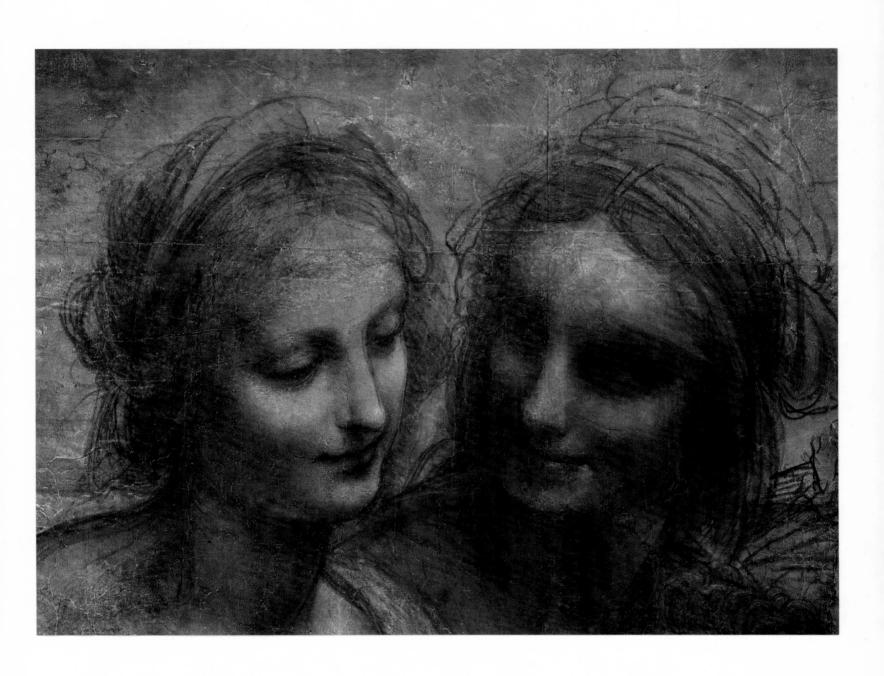

Painted 1503-7

MONA LISA (LA GIOCONDA)

Oil on panel, 30 $1/4 \times 20 7/8''$ Louvre, Paris

When Antonio de' Beatis in the company of the Cardinal of Aragon visited Leonardo's studio in France in 1517, he saw three paintings there: St. John the Baptist, the Virgin and Child with St. Anne, and the portrait of a "certain Florentine lady painted on request of the late Giuliano de' Medici." Giuliano will be remembered as Leonardo's sponsor in Rome from 1513 until his death in 1516. Despite glaring discrepancies revolving around its patronage and dating, this portrait is believed to be the Mona Lisa Vasari described a generation later. It is he who first introduced the sitter as the wife of the Florentine Francesco del Giocondo. Furthermore, Vasari seemed to imply that the Mona Lisa was begun in 1503 and finished in 1507, and that it had belonged to François I. The royal ownership was confirmed nearly a century later by Cassiano dal Pozzo, who in 1625 saw a portrait of a woman at Fontainebleau and identified her as "a certain Gioconda." The subsequent history of the Mona Lisa is relatively uncomplicated: it remained in the French royal collection until 1805, when it entered the Louvre in Paris.

The Mona Lisa is covered with layers of dirt and varnish that disguise an incredible delicacy, transparency, and luminosity. One dares not clean the portrait for fear of damaging it, so that only by means of infra-red photography (fig. 42) can we get some small idea of the original lightness of touch with which Leonardo executed it, of the richness of his modeling, of the most subtle gradations of light and shadow, and of the inimitable treatment of surfaces that creates the illusion of an atmospheric veil around the face. Infra-red photographs further reveal the true character of the landscape, whose forms are not the hard and heavy galvanic eruptions they appear to be to the naked eye; they are instead fragile and foam-like elements of nature that virtually evaporate into mist. The landscape is a mysterious and evocative place in which the only evidence of human existence is vestigial, taking the form of the bridge on the extreme right of the panel.

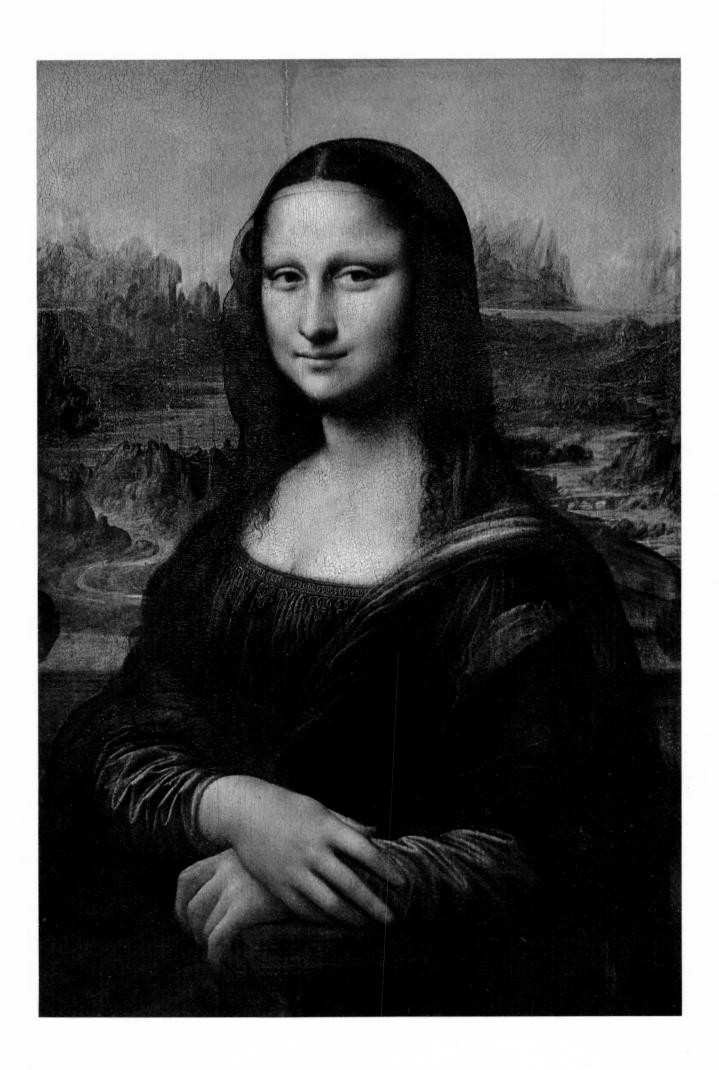

COLORPLATE 35 Painted 1503-7

MONA LISA, detail

Oil on panel

Louvre, Paris

Leonardo's aesthetic was transformed during the years that separate the Mona Lisa from the first portrait that is attributable to him, the Ginevra de' Benci of about 1474 (colorplate 7). To be sure, both women have been posed in a similar manner and both have facial features animated by a crisp sense of personality which is largely communicated by the steady gaze directed at the beholder and by lips that are shaped in response to inner feelings. However, the sullen Ginevra appears indifferent to the beholder's presence, whereas Mona Lisa uses her alluring charm to establish an emotional rapport that is real and mutual.

There are differences in style as well. In the *Ginevra*, Leonardo has emphasized costume, detail, texture, and a linear contour that surrounds the form with a clear and uninterrupted continuity. In addition, he has juxtaposed large areas of densely saturated colors that differentiate and yet unify into a distinct and decorative pattern the dress, shawl, blouse, anatomy, hair, and headpiece. The whole is illuminated by a diffused sunlight that casts delicate shadows on the face and neck. The portrait is still within the Quattrocento tradition that governs the *Cecilia Gallerani* as well (colorplate 30).

In marked contrast to these earlier portraits, color in the *Mona Lisa* has been reduced almost to a monotone, light has become a concentrated and resonant element, and details and lines have been used both sparingly and unobtrusively. Indeed, color, light, details, and line have all been made subservient to the full and monumental volume of the figure. The head in particular, now well structured and fleshy, stands forth emphatically and, together with the landscape, carries the full burden of the painting's expressive content.

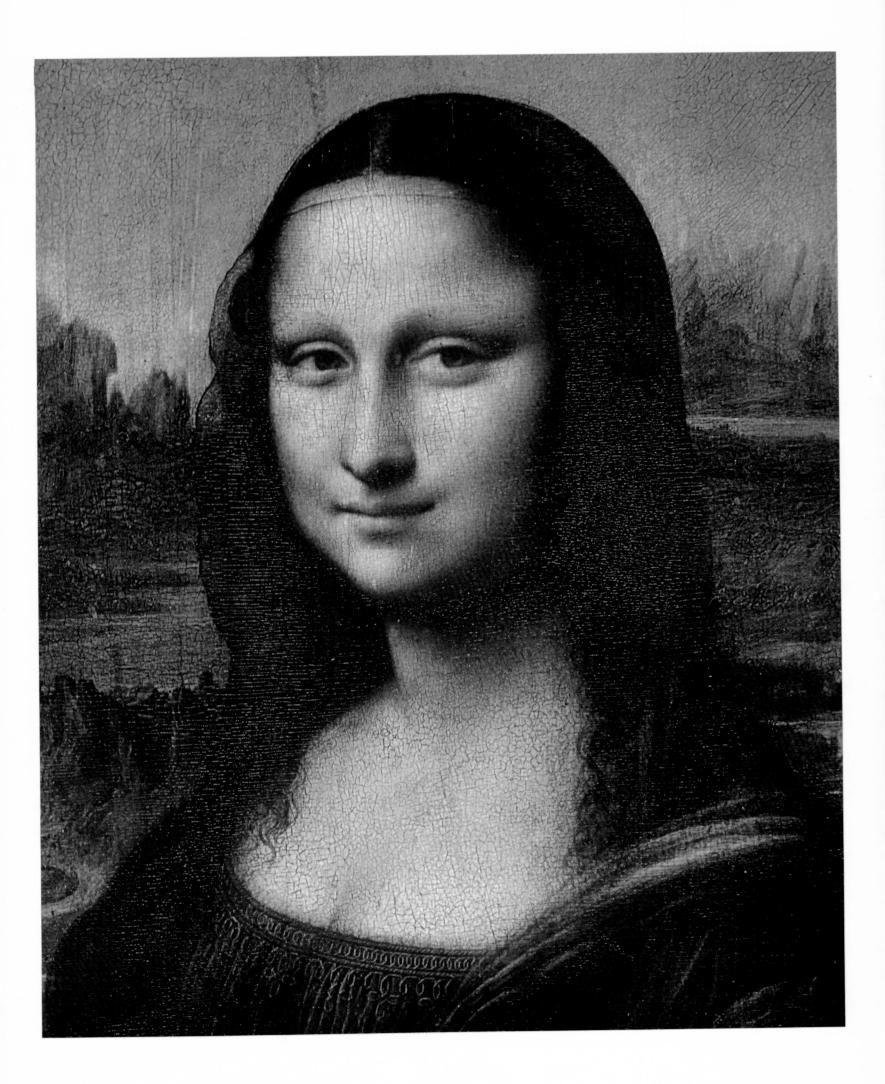

Painted 1503-7

MONA LISA, detail

Oil on panel
Louvre, Paris

In conformity with the portraiture of the late fifteenth century—for example, the Bust of a Woman by Verrocchio (fig. 30)—and with Flemish precedent, Leonardo invariably included the hands of his sitters. They appear in the Cecilia Gallerani, they were seen in the Ginevra de' Benci before they were cut away, and now again they are prominent in the Mona Lisa. Hands in the earlier portraits (colorplate 30; fig. 29) are long and slender, bony and linear. They all have a youthful grace and a tense elegance, as if they were frozen in a moment of acute action. Mona Lisa's plump and stubby hands are in distinct contrast to these. They are conceived as round, regular volumes in space, as is the rest of the body; the strain is gone and what remains is a studied casualness and repose, reflecting the sense of tranquility that governs the figure as a whole. This development in Leonardo's painting is to be expected and conforms to the new conception he had of drawing after his return to Florence in 1500. To the use of parallel hatching that barely described the volume of a figure and indeed ignored the integrity of its contour, he opposes, after 1500 (as Kenneth Clark confirmed), hatched lines that follow the shape of the body and emphasize its three-dimensional volume in space. Leonardo has not left us drawings of hands from the period of the Mona Lisa and so the evolution I have described cannot be demonstrated.

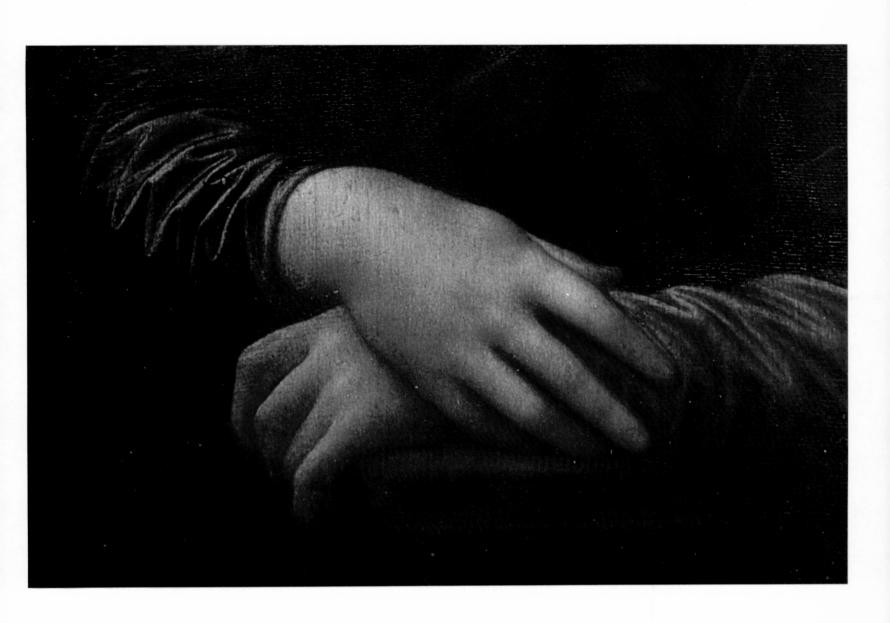

Painted c. 1508-10

VIRGIN AND CHILD WITH ST. ANNE

Oil on panel, 66 $3/8 \times 51 \ 1/4''$ Louvre, Paris

Leonardo returned a number of times to the theme of the Virgin and Child with St. Anne during his mature years. The Burlington House Cartoon (color-plate 32) was the earliest interpretation. In 1501, he devised a second cartoon—now lost—and, it seems, a third—also missing. The third cartoon was described by Vasari in sufficient detail to distinguish it from the other two.

The unfinished painting in the Louvre is Leonardo's fourth and final effort to embody the subject in artistic form, and he began to paint it in approximately 1508. It appears to conform iconographically to the scheme of the second cartoon of 1501. According to the Carmelite monk Fra Pietro da Novellara, who described the cartoon in a letter to Isabella d'Este of Mantua, the Virgin tries to keep Christ away from the lamb, "which signifies the Passion," while St. Anne restrains her daughter from interfering with Christ's destiny. The drama of this cartoon and the melodramatic role of St. Anne that darkens the Burlington House Cartoon are missing in the Louvre painting, for the Virgin, although she reaches down to the Christ Child astride a lamb, neither aids nor deters his willful action, while a physically inert St. Anne "joyfully observes her earthly progeny who have become divine." These are the words Vasari used to characterize St. Anne in the third cartoon, and they apply to the figure in the painting as well. The painting, therefore, would appear to fuse elements from the two previous versions. The complexion of the painting is that of a formal and abstract icon.

The landscape is painted with a lightness of brushwork and a transparency of color that verges on the miraculous. For all its precise and accurate geological character, it reveals Leonardo's temperamental kinship with the strange and suggestive configurations of nature. He translates natural forms inspired by the nearby Dolomites—craggy peaks penetrated by misty vapors—into a cosmic vision suspended in time, untrammeled by man, and unaffected by changes of season. This fosters an impression of otherworldliness as the context in which the figures forecast allegorically the redemptive mission of Christ: "Behold the Lamb of God which taketh away the sins of the world."

The authenticity of the Louvre painting has from time to time been questioned. It is true that the figure of Christ and possibly the head of the Virgin, which I feel has some affinity with the manner of Ambrogio de' Predis, are at variance with the level of quality one usually finds in paintings by Leonardo. Nevertheless, the work as a whole has to be considered his by virtue of the breathtakingly beautiful landscape, the compelling head of St. Anne, and the unique figure composition.

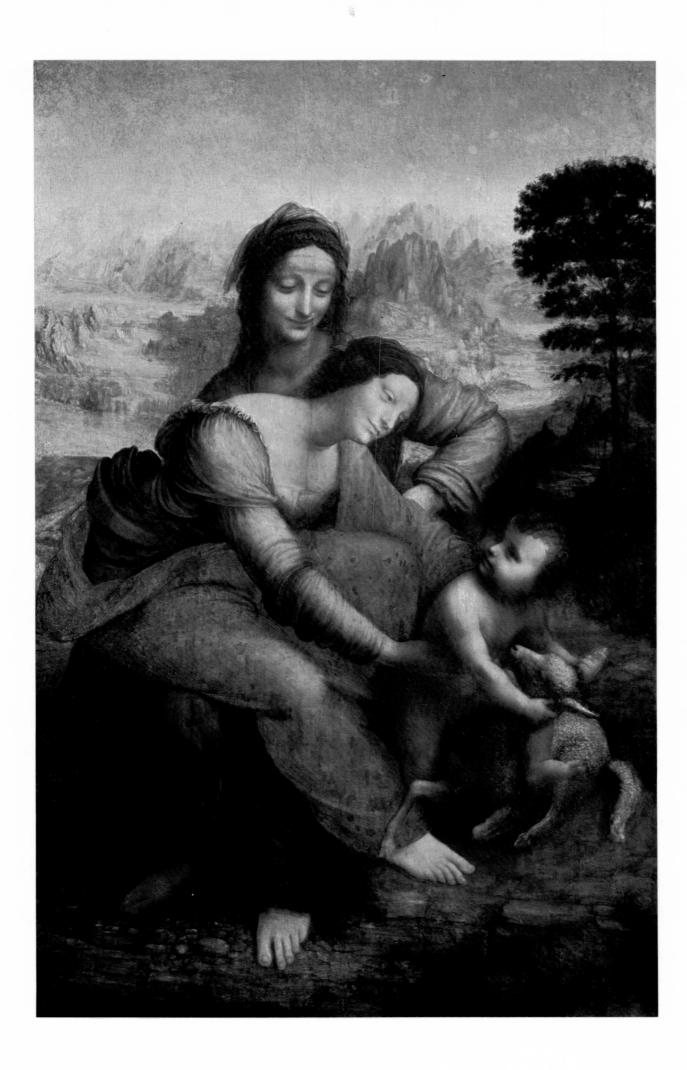

Painted c. 1508-10

VIRGIN AND CHILD WITH ST. ANNE, detail

Oil on panel

Louvre, Paris

Leonardo solved the problem of grouping figures into a compact composition more felicitously in this painting than in the Burlington House Cartoon. His guiding principle was to link the figures by overlapping their limbs and bodies and by interlocking their movements and reciprocal glances. The London cartoon (colorplate 32), for all its beauty and splendor, is marred by superabundance and complexity. The repetition of limbs and twisting bodies impinges too insistently on the beholder's awareness, with a consequent loss of compositional ease and purity. These factors may have prompted Leonardo to proceed by stages to the simplification and directness that characterize the later painting.

The figures in the Louvre panel are more unified than in the cartoon and the communication between them is continuous and reciprocal. They establish parallel formal and psychological rhythms—heightened by the sweep of the Virgin's inclined body and outstretched arms—that descend from a common starting point in St. Anne's head to the Christ Child and lamb and back up again to settle upon the face of the Virgin, who is the focal point of the glances of both St. Anne and Christ. The bent elbow of St. Anne serves further to consolidate and stabilize the composition and to regularize the downward flow of forms. It counterbalances the billowing red and blue drapery of the Virgin's costume and divides the interval between the heads of the women into two equal lengths.

Sigmund Freud, among others, noted the curious fact that St. Anne seems only a little older than her daughter. He viewed this as a reflection of Leonardo's actual experience as an illegitimate child who lived with his father and stepmother and who was probably looked after by a kindly paternal grandmother. His grandmother and his true mother, who later married and lived apart from him, were so mingled in his mind, Freud speculates, that he unconsciously felt himself to have two mothers, one of them merely living further away than the other. In an act of unconscious transference, he gave Christ two mothers also, one in the immediate foreground and the other in the background.

Despite Freud's fascinating hypothesis, I think the answer to the riddle he posed is both simpler and more historically and liturgically based. The last years of the fifteenth century witnessed the rise of a controversy that centered on St. Anne and the question of whether she, as the mother of the Virgin, was not herself immaculately conceived. An affirmative reply was given by Johannes Trithemius in 1494. Leonardo's treatment of St. Anne may already have reflected this controversy in the Burlington House Cartoon, in which St. Anne is represented as a young woman to underscore her spiritual birth and purity. At the same time, he distinguished her from the Virgin in type and slightly in age to make her conform to the logic of their mother-daughter relationship. That Leonardo was consciously concerned with this problem is seen in a drawing of this subject in the Louvre, in which St. Anne is actually represented as an old woman (fig. 76).

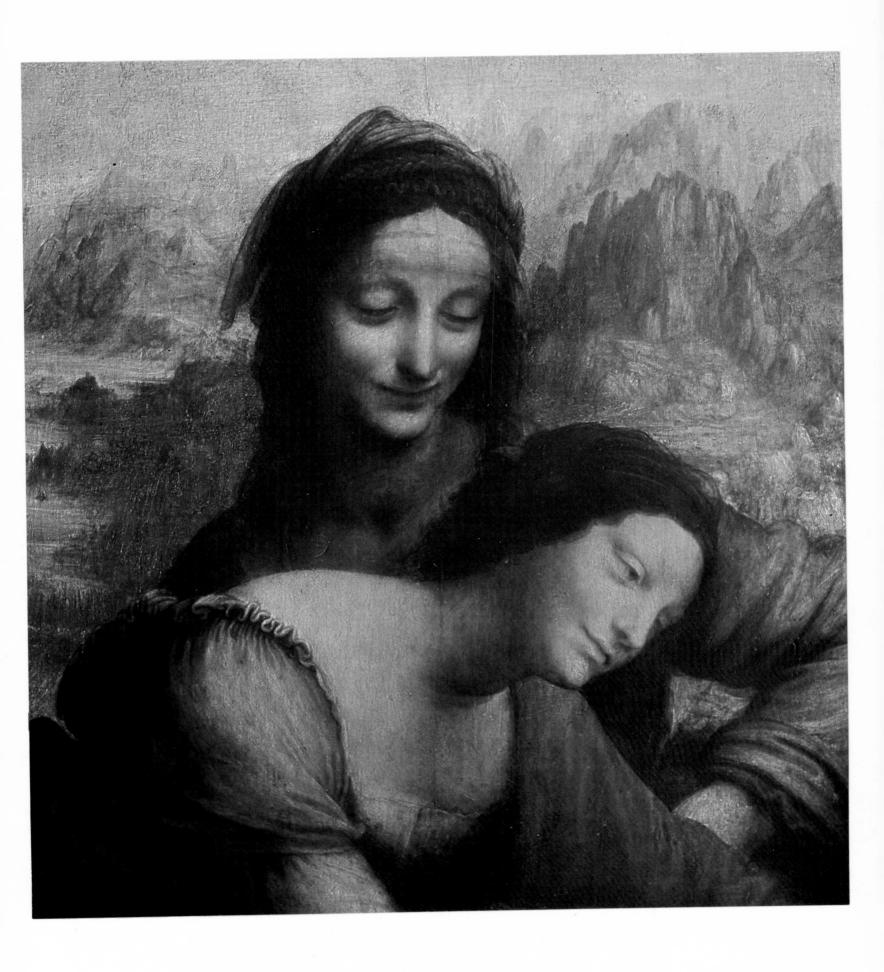

Painted c. 1513-16

ST. JOHN THE BAPTIST

Oil on panel, 27 $I/4 \times 22 I/2''$ Louvre, Paris

This painting, not Leonardo's most beloved or admired work, provokes hostile responses from most who see it. One is rather repelled by the flaccid and sometimes ill-conceived anatomy, by the figure's disturbing and ambiguous smile, and by his strangely androgynous character. For all this, St. John the Baptist is an innovative painting and the most single-minded spiritual essay of Leonardo's career. And if we do not experience the full impact Leonardo strove for, I suspect it is partly due to a paralysis in one arm that he suffered in old age, which probably lowered his skill, and to the intervention of a pupil and even of later restorers. But Leonardo is not blameless. St. John is an effete performance in many ways: the artist has used the pointing finger and the smile too often, and he has failed to adjust these elements, as he had in the two St. Annes, to the deeper religious significance of the figure—with its somber implications of sin, damnation, and redemption.

The painting, nevertheless, has a certain emotional vigor that is unforget-table as it is ineffable. The innovation Leonardo introduced was to focus on the single figure to the exclusion of all else. This contrasts with the St. Jerome, in which the landscape, the familiar lion, and the crucifix—the source of the saint's delirium—are all parts of the total visual pattern. The St. John is an intensely personal statement. It is as if in old age Leonardo had wanted to distill the artistic, expressive, and religious qualities he had developed in his previous works into a new spirituality—a direct and uninhibited revelation of the saint's inner self, and, for the beholder, the essence of a spiritual experience. It is a seminal work, one that will blossom a century later in the paintings of Caravaggio (especially in the treatment of chiaroscuro as a mystical phenomenon) and in the individual saints by Zurbarán.

It has been suggested that the uniform dark background in the St. John is the work of a much later hand and that it conceals a landscape in which Leonardo had experimented with the expansion of spatial and pictorial aspects of the painting. If this is true, it would change the whole conception of the picture and make it a more pedestrian venture, even a failure. However, there is no evidence of the prior existence of a landscape behind the deeply shadowed background, and we must assume that Leonardo had intentionally cast the figure in shadow to increase the saint's sense of isolation from the real world and thereby to enhance his nature as a cosmic being—the prime virtue of the painting.

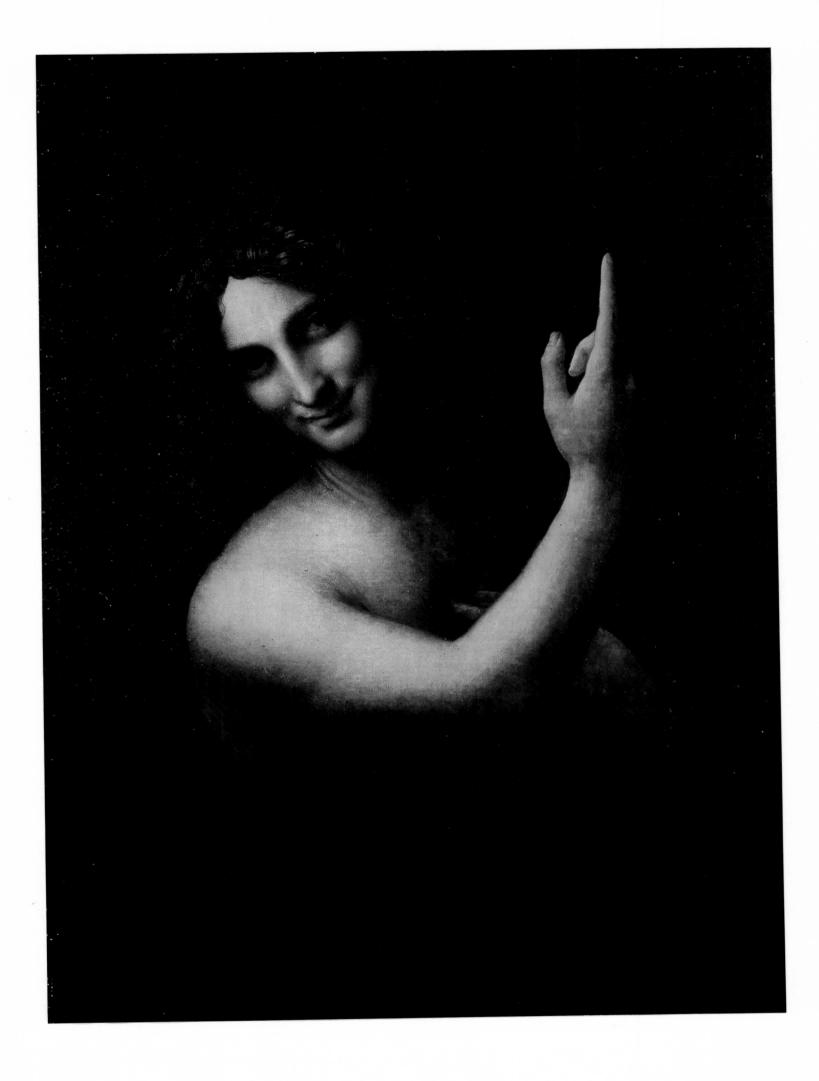

Painted c. 1478

ANNUNCIATION

Tempera on panel, 5 $I/2 \times 23 I/4''$ Louvre, Paris

It is inconceivable that the modest *Annunciation* in the Louvre could ever be considered the work of Leonardo. This attribution, proposed in the late nineteenth century, engendered a storm of controversy that gradually ended with the consensus that the panel was actually painted by Lorenzo di Credi, chief assistant of Verrocchio from about 1478. The controversy is likely to be renewed, because the premise of Leonardo's authorship of the painting was recently put forward again without reservation.

The Louvre painting is in my view a stripped-down variation of the Uffizi Annunciation (colorplate 4) by Credi and his assistants. It is of mediocre quality and I cannot, therefore, join in the praise so often directed at the painting. It has been described as more "coherent" in its details than the Uffizi version, as having an "organic unity of the composition" (no doubt in reference to the arc-like connection between the two figures), as being of "unusual perfection," and as "precise but sensitive." I find it, quite to the contrary, a rather weak artistic achievement. The angel is crudely drawn and ugly, the architecture and landscape are excessively bare and simple, the plants in the garden are indifferently treated, and the configuration of the draperies is dull. In addition, it is hard to believe that the awkward perspective construction could be Leonardo's invention. Take the lectern before the Virgin, for example: it is angled backward so that the orthogonal lines converge incongruously toward a point outside the picture rather than toward one on the horizon, as they should. We may question the attribution of the painting to Leonardo from other technical points of view as well: the medium-tempera-is one that Leonardo had rejected from the start, and the dense preparation of the paint is entirely unlike the thin and light application of pigment he favored.

The Louvre Annunciation thus may be attributed with some certainty to Credi working with assistants. The draperies, for example, have something of the thick and woolly texture of those in the work of Credi (colorplate 41). Moreover, in a number of technical aspects and in the treatment of the landscape the painting is similar to one in the Worcester Art Museum (fig. 43), which has been unanimously accepted as a work of Credi. It even has in common with the Louvre panel the inverted use of perspective, which is now applied to the opening in the ground. However, the figures and the general treatment in the Worcester panel are ungainly and banal, which implies that it was largely executed by Credi's assistants.

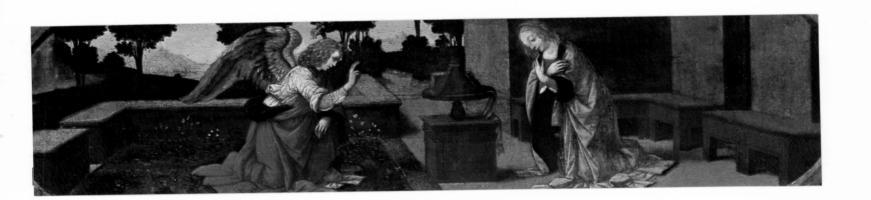

Painted 1475-86

MADONNA DI PIAZZA

Oil on panel, 74 $I/2 \times 75 I/4''$ Cathedral, Pistoia

The commission to paint an altarpiece for the oratory of the Virgine di Piazza in the cathedral of Pistoia was given to Verrocchio by the executors of the will of Bishop Donato de' Medici soon after his death in November 1474. The same document (dated 1485) that includes the name of Verrocchio shows that the execution of the painting was divided into two periods. The first extended from approximately 1475 to 1479, when it "lacked little" to be finished; the second began in 1485, after six years of inactivity brought about by the failure of the Bishop's heirs to continue their payments to the artists.

The painting is not by Verrocchio, but it is sufficiently compatible with his other paintings to be included among the works of his followers. Although there is nothing comparable to such a grouping of figures in Verrocchio's other known work, perhaps the composition can be attributed to him: it is a sacra conversazione in which the Virgin and Child are flanked by saints, John the Baptist and Donato in this instance. On the other hand, Leonardo did once plan a sacra conversazione (he never actually painted it), and for a long time he was thought a viable alternative to Verrocchio as the artist responsible for the Pistoia altarpiece. His name was first associated with this painting in a seventeenth-century history of Pistoia by Michel'Angelo Salvi; since then, efforts have been made to identify the nature and extent of Leonardo's presumed contribution. He has been made responsible for the whole work or for one or another detail (for which, in some instances, evidence was even put forth). For example, there is preserved a sheet of drawings by Leonardo in the Uffizi bearing two cryptic inscriptions that have been considered relevant to the issue. One specifically names the city of Pistoia (. . . e choppa a Pistoia); the other is assumed to refer to this very painting (. . . bre 1478 inchominciai le 2 Vergine Marie). In addition, a drawing of St. John at Windsor Castle has been mentioned that, despite differences, could conceivably have been a preliminary sketch for the figure of St. John in this painting.

Few critics are satisfied with the attribution of the Pistoia altarpiece to Leonardo, since its Leonardesque elements are probably borrowed and therefore tangential to the question of his authorship. On the other hand, the painting's dry and almost mechanical qualities suggest a major contribution by Lorenzo di Credi, even at a moment of particular dependence on Verrocchio and to a lesser extent on Leonardo. The two paintings that we have previously discussed and that are believed to be predellas for this altarpiece are also well within the artistic orbit of Credi. It is true that the differences in quality between the three paintings are considerable: relatively high in the Madonna di Piazza, generally very low in A Miracle of S. Donato of Arezzo and the Tax Collector (fig. 43), and somewhere between the two in the Annunciation (colorplate 40). The natural assumption is that Credi's assistants had varying degrees of control over the

execution of these paintings, especially the two predella panels.

Painted c. 1475-77

MADONNA WITH THE CARNATION (MADONNA WITH THE VASE)

Oil on panel, 24 $I/2 \times I8 I/2''$ Alte Pinakothek, Munich

The so-called Madonna with the Carnation (or Madonna with the Vase) in Munich is one of a group of three paintings that are so alike as to presuppose a common dependence on a single prototype or on each other. The two others are the Madonna di Piazza (colorplate 41) and the Dreyfus Madonna (colorplate 43). If the Madonna di Piazza is largely the work of Credi, then the Munich painting cannot be his, so great are the differences in their styles. In the Madonna di Piazza there is a dry and regular handling of forms and surfaces. The painting's lack of verve and spontaneity is further caused by outlines that are too precise and drapery folds that are stiff and calculated. As a whole, it is not a painting that commands attention. In contrast, the Madonna with the Carnation, although spoiled by time and by the misguided hand of a restorer, still reveals its original strength and presence. It retains a rhythmic intensity and a beauty of detail. These are qualities that point to a superior achievement and, therefore, permit us to speculate on the possibility that Leonardo was in some way or other involved in its design and execution, as has so often been claimed.

When the Madonna with the Carnation was first displayed in 1886 in the Alte Pinakothek, it was assumed to be Leonardo's lost painting of a Madonna that Vasari had seen in the collection of the Medici pope, Clement VII (reigned 1523-34). Clement's painting, according to Vasari, contained a "carafe filled with water and several flowers," as does the Munich panel. Nevertheless, I doubt that the Madonna with the Carnation is Leonardo's despite the carafe and the painting's Leonardesque features: pulsating chiaroscuro, tall, bare mountain peaks enveloped in mist, the Virgin's protruding eyes and braided hair, and the pudgy Christ Child. In my opinion, the painting lacks the sensitive command of the way matter behaves in reality and fails to rise to the great level of technical quality and insight into human feelings that Leonardo was capable of. I am inclined to believe that the artist responsible for the painting, whoever he was, created here a composite of elements drawn from Leonardo-and perhaps also from Verrocchio, since it was probably executed in Verrocchio's studio between 1474 and 1478. Unfortunately, the scant knowledge about that workshop obscures the relationship Leonardo had to his master and they to their assistants, and in the end keeps us from making a more positive statement on this painting.

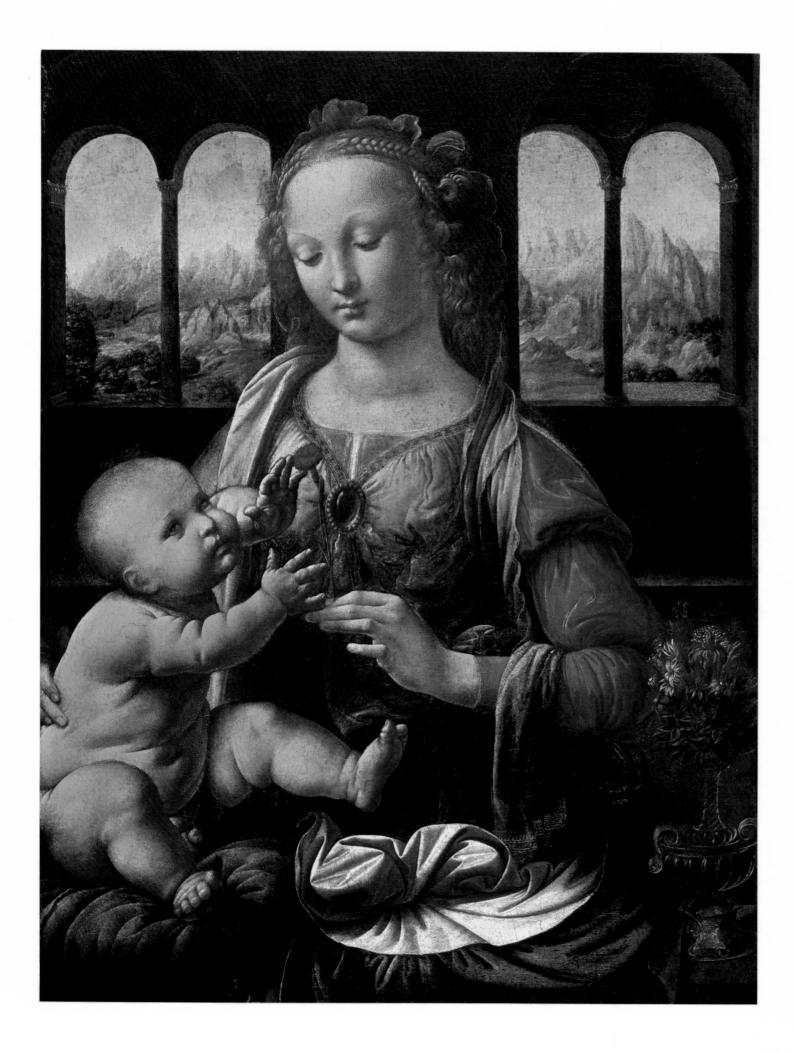

Painted c. 1475-77

DREYFUS MADONNA (MADONNA WITH THE POMEGRANATE)

Oil on panel, 6 $1/4 \times 5''$

National Gallery of Art, Washington, D.C. Kress Collection

In the commentary to the previous colorplate, three paintings were discussed that are intimately related to each other by virtue of the similarity in the treatment of the Virgin. The Dreyfus Madonna is one of these. In contrast to the others, it has a filmy atmosphere that produces softened surfaces and blurred outlines. The figures are not very volumetric and the facial features of the Virgin are miniaturistic. It was, in other words, painted in a style that differs from that of the Madonna di Piazza (colorplate 41) and from the Madonna with the Carnation (colorplate 42). Therefore, we must be dealing with still another artist-obviously not Leonardo, as was once thought. In some ways, the depiction of the Virgin resembles that of the Virgin in the Louvre Annunciation (colorplate 40), although the fact that we are pairing a frontal figure with one in profile makes the comparison difficult and imprecise. Nevertheless, the limpid sweetness of the Dreyfus Madonna, her slightly vacuous expression, and the rather simplified drapery of her garment are not unlike what we find in the Annunciation. I would, therefore, tend to attribute the Washington painting to the assistant who helped Credi with the Annunciation, perhaps still working under his guidance to an extent.

A link between the Dreyfus Madonna and the Madonna with the Carnation is found in an anonymous drawing in Dresden (fig. 44). Of particular interest is the fact that the two children are represented in different postures in the drawing: in one the Christ Child stands, his head reaching above the Virgin's shoulder, as he appears in the Dreyfus Madonna; in the other he sits, and while the figure is not represented in full detail and so is not easily deciphered, he is obviously similar to his counterpart in the Madonna with the Carnation. The figure of the Virgin is also an important link between the drawing and the two paintings, and with the third painting-the Madonna di Piazza-as well. The handling of the drapery that envelops all the figures of the Virgin is the same, especially in the way a jeweled brooch gathers the garment together and creates an array of crinkly folds. Moreover, the Virgins have in common the shape and features of their inclined heads. Despite these connections, however, the role the Dresden drawing had in the formulation of the three paintings remains uncertain. So does the identity of the draftsman, but he could not have been Verrocchio, Leonardo, Credi, or any of the latter's assistants. In its ample conception of form and volume, the style of the Dresden drawing is approximately but not quite like that of the Madonna with the Carnation, and therefore we cannot attribute the drawing to the same artist.

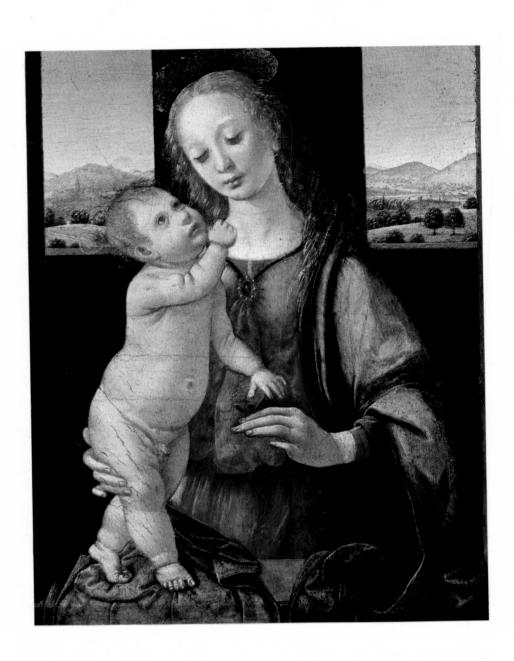

Painted c. 1490

MADONNA LITTA

Tempera on canvas (originally panel), 16 $1/2 \times 13''$ Hermitage, Leningrad

Leonardo's role in painting the *Madonna Litta* has been debated extensively, and opinions range from complete acceptance to total rejection of his authorship. Those who take the negative position, and I number myself among them, point to the slick and too regular modeling of the figures, the resistance the colors offer to atmosphere, and the unsympathetic face of the Christ Child. On the other hand, those who attribute the painting to Leonardo point to an autograph drawing of a female head in the Louvre (fig. 62) that, save for the elaborate headdress, is the twin of the Leningrad Virgin, and to a drawing of an infant in the Uffizi that finds its echo in the Christ Child. They also cite a journal of 1543 by Marcantonio Michiel, who described a painting he had seen in the house of Michele Contarini in Venice: "There is a little painting of little more than one foot in dimensions, of our Virgin, half figure, who nurses the Child, painted by the hand of Leonardo."

Taking this contradictory evidence in hand, Kenneth Clark proposed an ingenious compromise between these extreme positions. In his view, the painting was begun by Leonardo in Florence around 1480 and was finished in 1495 by the Milanese artist Boltraffio, who repainted the entire work. Clark found corroborating evidence for his thesis in a list Leonardo drew up in the early 1480s of works that he may have taken with him to Milan in 1483. The relevant item in the list reads as follows in the original Italian: ". . . una nostra donna; un altra quasi che in profillo." Clark translates this as ". . . Our Lady finished; another almost [finished], who is in profile." He takes the second of these two paintings to be the Madonna Litta, because she is in profile and because it would support his theory that a partially executed painting by Leonardo had been finished by another artist. I believe Clark's translation to be erroneous and, therefore, conclude that the painting Leonardo lists cannot be equated with the Madonna Litta. The word "almost" (quasi che) in Leonardo's text modifies "profile"—not "another," as Clark assumes. Thus, in my opinion the item should read ". . . Our Lady finished; another [painting of Our Lady] almost in profile." The text so interpreted might refer instead to the Benois Madonna (colorplate 8), dating from approximately the same time as Leonardo's list and showing the Virgin "almost in profile." Moreover, some scholars have suggested that the Benois Madonna was finished at a later time, and there is slight evidence that Leonardo had taken it to Milan in 1483, since one finds it quoted in an anonymous Milanese painting of the 1490s (fig. 45). In any event, I feel that the Madonna Litta is a pastiche of motifs taken from Leonardo's work (a rather common practice among his circle of Milanese followers) and that Boltraffio or someone else close to Leonardo was responsible for it. As for the Contarini painting that Michiel described, we need not assume that his taste was sophisticated enough to permit him to distinguish a true painting by Leonardo. He may well have mistaken an imitation for the real thing.

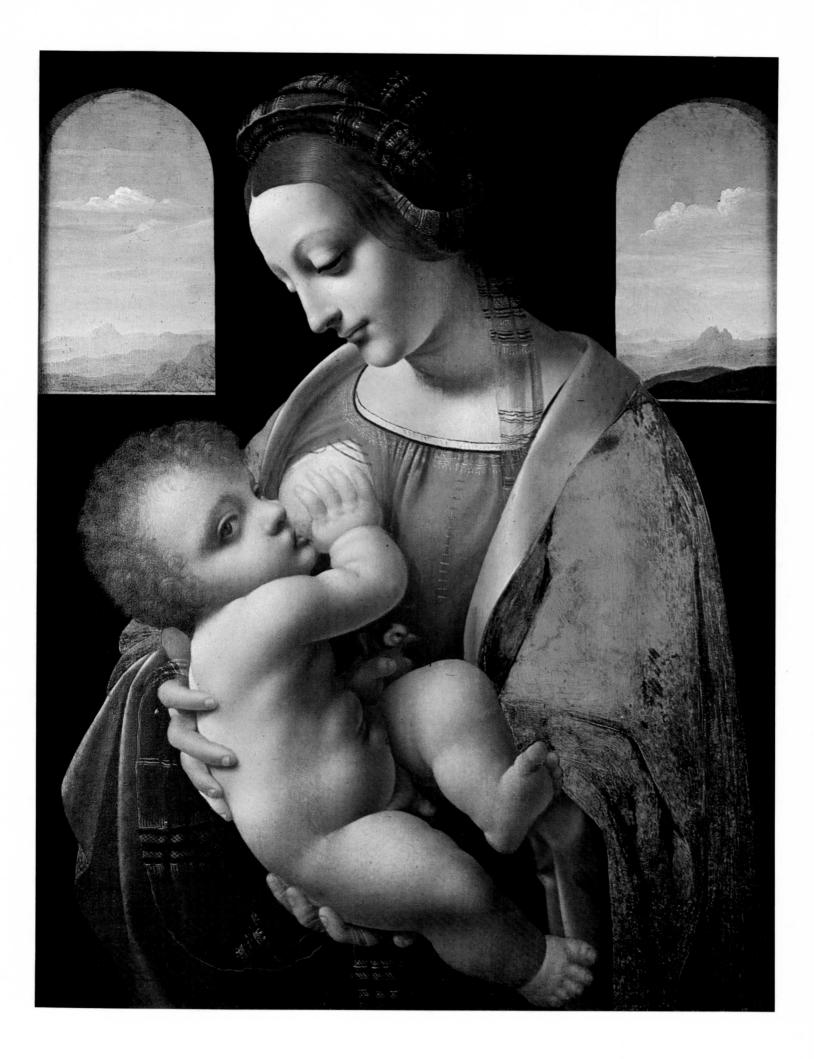

Painted c. 1490

LA BELLE FERRONNIÈRE

Oil on panel, 24 $1/2 \times 17 \ 3/8''$ Louvre, Paris

Recent efforts to reinstate La Belle Ferronnière as the work of Leonardo can only be accounted for by a desire to enlarge his oeuvre, since so few of his paintings have survived. I must confess, however, to being a conservative where attributions to Leonardo are concerned—perhaps mistakenly so, because, as Clark has rightly said, one should not assume that an artist, even one so great as Leonardo, can at all times perform at the highest level. Nevertheless, in order to achieve an accurate understanding of Leonardo's personal style and its evolution, I feel it safer to exercise caution in such matters. In the case of the present portrait, I am ready only to admit that there is something Leonardesque in it: namely, the posture and the directness of the expression on the sitter's face. The woman is posed in the way Ginevra de' Benci and Mona Lisa are (although her head is slightly off axis—a feature not found in the portraits of Leonardo), and she stares outwardly without, however, matching the ambivalent intensity of one or the compelling attraction of the other. Moreover, one hesitates to associate with Leonardo's habitual treatment of drapery the heavy stuff and the careful adagio rhythms of the ribbons and the folds along the sleeve of the garment. The material Leonardo uses is thinner and more pliant while the rhythms of his folds are sprightly and vital. They are treated as forces that rise, fall, zigzag, and interact with spontaneity and energy. Nor can one be convinced of Leonardo's authorship by the static and regular distribution of the chiaroscuro on the sitter's face: it lacks the intricate gradations and the interpenetrations of light that make Leonardo's chiaroscuro pulsate. The identity of the artist who painted this portrait eludes me, but he was surely someone working in Milan in the 1490s and seeking Leonardesque effects.

It has been suggested from time to time that La Belle Ferronnière and the Cecilia Gallerani (colorplate 30) have a common paternity. This contention is unacceptable, even if we propose an artist other than Leonardo, and for some of the same reasons we reject assigning La Belle Ferronnière to Leonardo's oeuvre. The lavish, sharply focused, almost trompe-l'oeil treatment of the dress and ornamentation in La Belle Ferronnière contrasts with the more restrained and modest handling of these hallmarks of wealth and upper-class breeding in the Cecilia Gallerani.

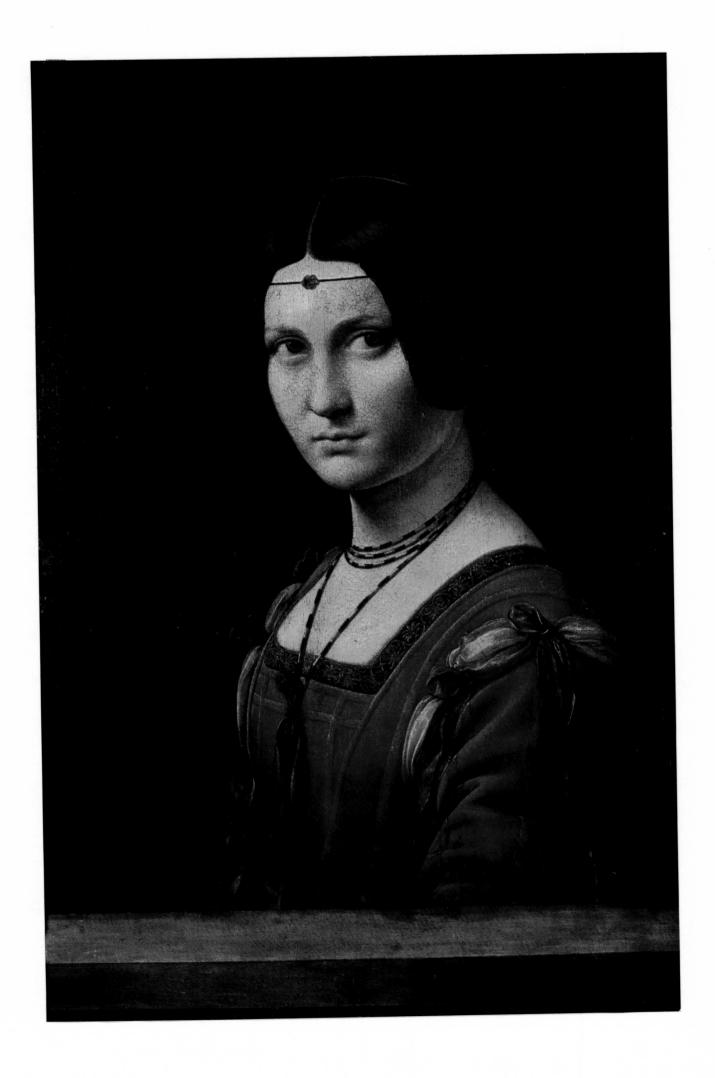

Painted c. 1490

PORTRAIT OF A WOMAN

Oil on panel, 20 1/8 × 13 3/8"

Biblioteca Ambrosiana, Milan

The Portrait of a Woman in the Ambrosiana was once believed to be the invention of Leonardo, but this opinion is no longer current. In all probability, it was painted around 1490 by Ambrogio de' Predis, Leonardo's collaborator on the Madonna of the Rocks; it is a belated effort to revive the profile portrait favored by the generation preceding Leonardo's in Florence and in Milan, despite Leonardo's break with it. The jewelry-bedecked image, even more sumptuous than in La Belle Ferronnière (colorplate 45), is generally in keeping with portraits that are conventionally attributed to Antonio Pollaiuolo. In Pollaiuolo's famous Portrait of a Woman (fig. 46) in the Poldi-Pezzoli Museum in Milan, for example, the sitter is seen in absolute profile so that the viewer is made palpably conscious of the aesthetic and expressive function of line and ornamentation. His is a socially oriented portraiture in which character traits are kept rigorously to a minimum, while beauty of form and decoration are paramount.

By and large, this too is an aspect of the Ambrosiana portrait. Yet for all its compatibility with Pollaiuolo's painting, it lacks the same purity and simplicity of lines and surfaces. The tension between contour as a rhythmic line for its own sake and as a line that traces the natural physiognomy of the profile is gone in the Milan portrait. The primary function of line now is to define the shape of the head. No longer is there the same poised sense of interval and the quivering isolation of exquisite jewelry—the necklace, for example—that enhances the fine and slender shape of the woman's neck in Pollaiuolo's portrait. Forms in the Milan painting are heavy and fleshy, and line and decoration lose much of their autonomy and expressive life by their constant interruption of each other and by their subordination to the reality of the individual portrayed.

Lavish display of jewelry in portraiture was never to Leonardo's taste, even in the aristocratic Cecilia Gallerani (colorplate 30), but line was. We find it in the Ginevra de' Benci (colorplate 7) and still more in the Cecilia Gallerani. In the latter, Leonardo has in his inimitable way expropriated line to his own vision, and he has brought it into an extremely complicated interaction with the twisting pose of the figure. Line is not an enclosing contour that is meant to define the face and torso—volume does that; line has its own life and insinuates itself intricately over the entire figure. Later, in a drawing of Isabella d'Este of 1500 (fig. 64), he is bold enough to experiment with the pure profile portrait, but the emphasis again is on volume and on a more heightened naturalism. This, together with the near frontal arrangement of the body and the complete repudiation of ornamental jewelry, accounts for the sobriety of the portrait. Line here is subdued; it ceases to exist in an aesthetic sense in the Mona Lisa (colorplate 34).

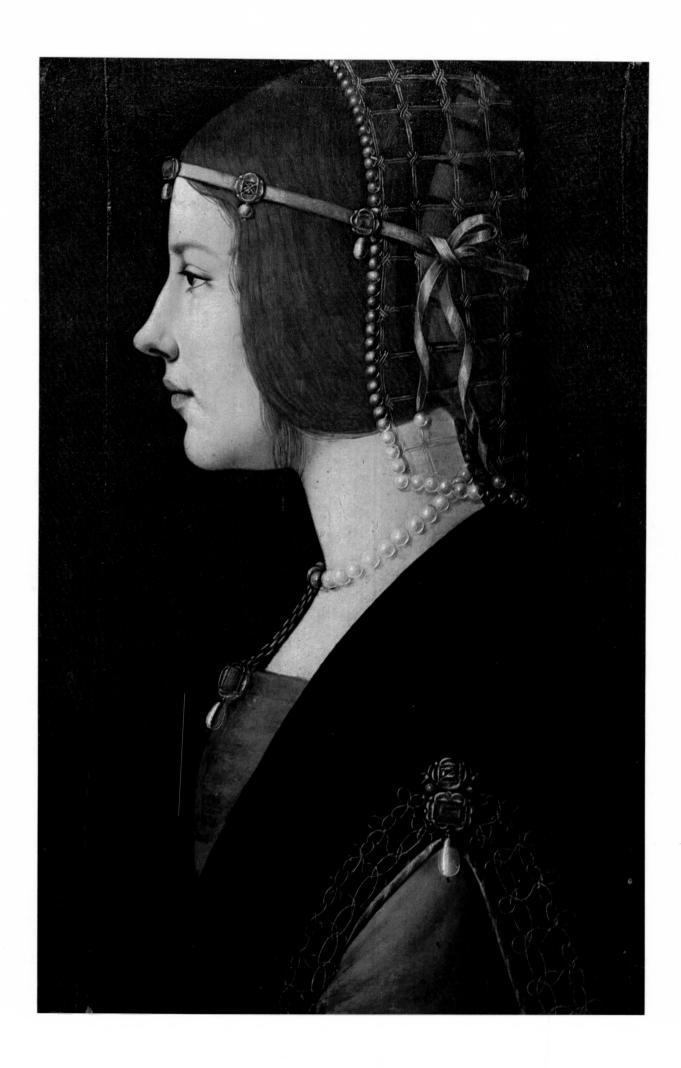

Painted before 1550

BATTLE OF ANGHIARI

Panel

Collection G. Hoffman, Munich

On October 24, 1503, Leonardo was given the key to a room in the Florentine monastery of S. Maria Novella, where he planned the *Battle of Anghiari*, the mural destined for the Hall of the Great Council in the Palazzo Vecchio. Leonardo described the ominous day he began the mural, a year and a half later: "On the 6th of June, 1505, a Friday, at the stroke of the thirteenth hour I began to paint in the palace. And at the moment of laying down the brush the weather changed for the worse, and the bell started to toll, calling men to trial. And the cartoon came loose. The water spilled as a vessel in which it was carried broke. And suddenly the weather worsened still more and great rain poured down until nightfall. And it was as dark as night."

Leonardo had devised a technique whereby he hoped to paint the composition on the dry plaster wall, as he had for the Last Supper, but it proved unsuccessful and he was forced to abandon the painting. The near wreckage was finally destroyed during the remodeling of the Hall by Vasari in 1557. The problem of reconstructing Leonardo's original composition is, therefore, a most difficult one. Neither his description of the way to represent a battle scene nor of the historic Battle of Anghiari itself are useful, and so we must rely on his sketches and on copies by others. The anonymous painting in this colorplate is such a copy; it is believed to derive from Leonardo's unfinished mural because the central figure in the copy wears the red cap Vasari noted in the original. Several reconstructions have been attempted, none conclusive. The oldest assumes that Leonardo intended no more than he painted: the famous Fight for the Standard, seen in this copy. However, it fails to account for his various sketches and for the possibility that the wall was larger (perhaps 24 by 60 feet) than the Standard group alone would occupy. Two other reconstructions have been proposed, one of which, by Neufeld, is reproduced here (fig. 58). A serious objection to this reconstruction is the placement of the Standard group too far back into the middle distance. It would be preferable to locate it closer to the foreground so as to achieve effects of power and monumentality, and in order to stress its symbolic value. The rest might then be disposed in the manner of the Adoration of the Magi (colorplate 10), and not in an extended frieze-like composition, as Wilde suggested, to conform to Leonardo's innate sense of compact design and to a dictum he laid down on another occasion: "You must place the foreground in relation to the eye of the spectator, then arrange figures and buildings in regular diminution over the hills and plains." Therefore, foot soldiers should enlarge the central group laterally and further toward the foreground plane to form a great cone-like composition. Additional infantry and equestrian groups (including the cavalcade on the right in fig. 58) should fill the background, somewhat in the manner of a battle scene by Vasari in his remodeled Hall of the Great Council (fig. 59), but less dense and crowded.

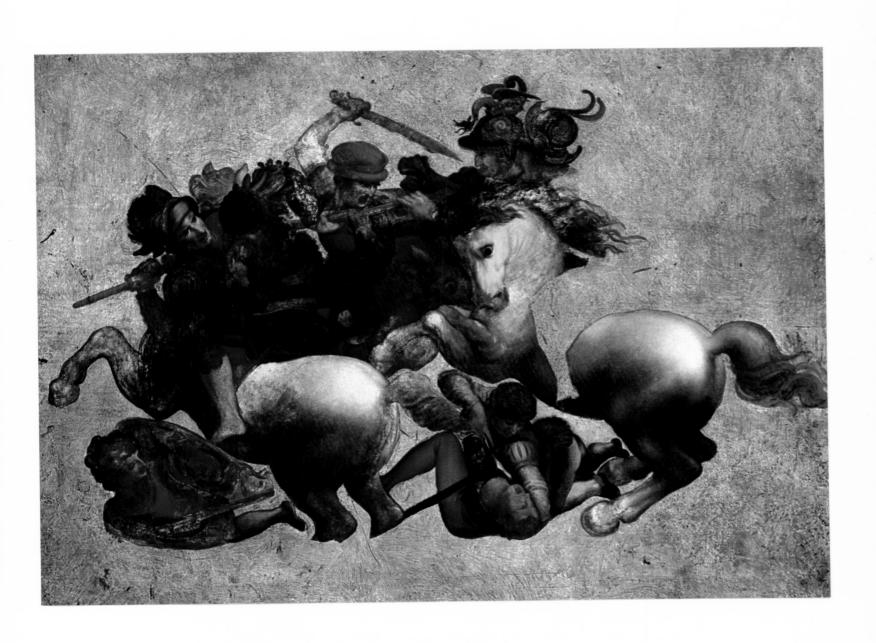

Painted c. 1511-15

BACCHUS

Oil on canvas (originally panel), $693/4 \times 451/4''$ Louvre, Paris

The Bacchus illustrated here was formerly entitled St. John the Baptist in the Desert and was first mentioned with this title by Cassiano dal Pozzo in 1625. He saw the painting in Fontainebleau and described it in these terms: "St. John in the desert. The figure, less than one third lifesize, is a most delicate work, but it does not please much because it does not show any piety and the background is unlikely: the saint is sitting and one can see rocks and an airy green landscape." The painting continued to be called St. John the Baptist in the Desert in a series of catalogues issued by the Louvre between 1642 and 1695, the year the title was changed to Bacchus in a Landscape. Evidently, the lack of "piety" displayed in the painting prompted a mutation of the figure from St. John to Bacchus, which was achieved by the later addition of the panther skin at the waist, the vine wreath on the head, and the transformation of the cross into a thyrsus.

It may seem anticlimactic to conclude this section of colorplates with a painting that, for all its Leonardesque quotations, is a work of inferior quality and would do Leonardo's reputation little good were it proven to be his or even to depend on his design. I include it here because it is invariably mentioned in monographs on Leonardo, whether or not the authors believe it to be his, and because the opinion was expressed recently that the painting, although a workshop piece, was indeed based on an original cartoon by Leonardo. The author of this view (Angela Ottino della Chiesa), sensitive to the anomalous and incongruous character of the landscape, expressed the belief that the "landscape was only vaguely sketched" in the cartoon. I doubt that any part of the picture can be so directly related to Leonardo. The Bacchus is what has been called a "Milanese Leonardo," a pastiche of accumulated details (the face, the pointing finger, even the crossed legs) from the master's paintings and drawings by, in this case, an anonymous follower of Leonardo who assembled them not only in a different background context, but also in a different configuration of the male form.

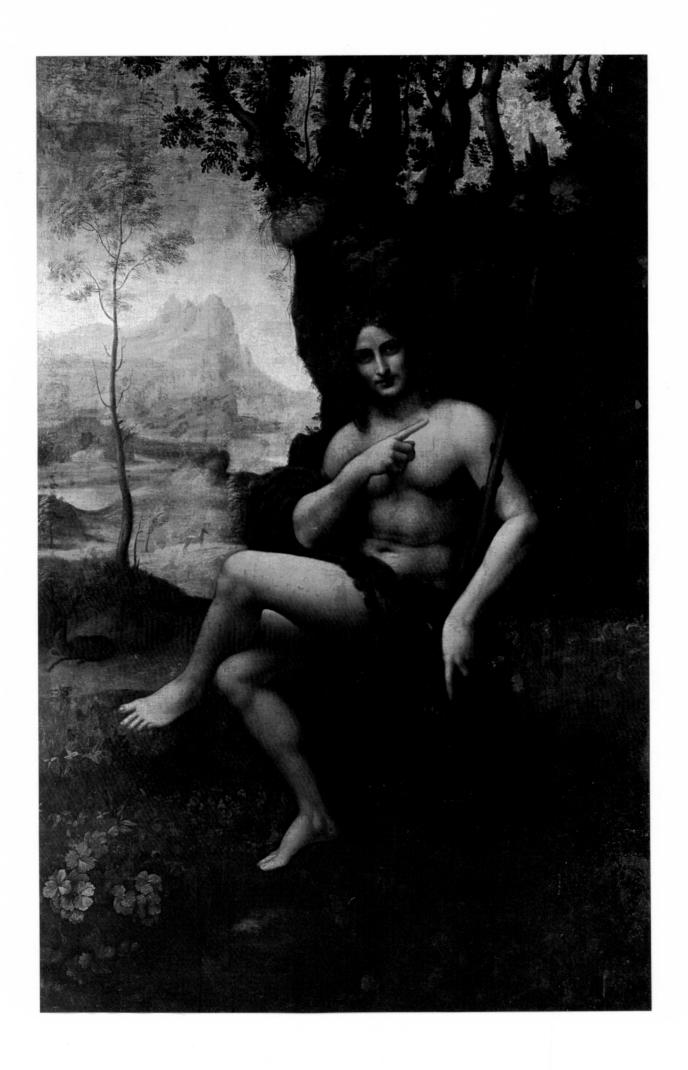

SELECTED BIBLIOGRAPHY

GENERAL WORKS

Berenson, B., The Drawings of the Florentine Painters, 3 vols., 2nd ed., Chicago, 1970.

Chastel, A., The Studios and Styles of the Renaissance: Italy 1460–1500, London, 1966.

Freedberg, S.J., Painting of the High Renaissance in Rome and Florence, 2 vols., Cambridge, Mass., 1961.

———Painting in Italy 1500–1600, London, 1971.

Hartt, F., History of Italian Renaissance Art, New York, 1969. Leonardo's Legacy. An International Symposium, edited by C. D. O'Malley, Berkeley, 1969.

Murray, P., The Architecture of the Italian Renaissance, New York, 1968.

Pater, Walter, The Renaissance, New York, n.d.

Seymour, C., Sculpture in Italy 1400–1500, Baltimore, 1966. The Unknown Leonardo, edited by L. Reti, New York, 1974.

SOURCES

Beltrami, L., Documenti e memorie riguardanti la vita e le opere di Leonardo da Vinci in ordine cronologico, Milan, 1919.

Codice Magliabecchiano, edited by Karl Frey, Berlin, 1892. Giovio, P., Leonardo da Vinci: Vita, published in G. Tiraboschi, Storia della letteratura italiana, VII, Venice, 1796. Reprinted and translated into English in J. P. Richter, The Literary Works of Leonardo da Vinci, 3rd ed., I, New York, 1970.

The Life of Leonardo da Vinci by Giorgio Vasari, translated into English by H. Horne, London, 1903.

Lomazzo, G.P., Trattato dell'arte della pittura, Milan, 1584.

——Idea del tempio della pittura, Milan, 1590.

Pacioli, L., De divina proportione, Venice, 1509.

Pastor, L., Die Reise des Cardinals Luigi d'Aragona . . . beschrieben von Antonio de' Beatis, Freiburg, 1905.

Poggi, G., Leonardo da Vinci: la 'Vita' di Giorgio Vasari, Florence, 1919.

BIOGRAPHIES

Almedingen, E. M., Leonardo da Vinci: a Portrait, London, 1969. Calder, R., Leonardo, London, 1970.

Wallace, R., The World of Leonardo: 1452-1519, New York, 1966.

MONOGRAPHS AND INTERPRETATIONS

Amoretti, C., Memorie storiche su la vita, gli studi e le opere di Leonardo da Vinci, Milan, 1904.

Bodmer, H., Leonardo, des Meisters Gemälde und Zeichnungen, Stuttgart, 1931.

Clark, K., Leonardo da Vinci, Cambridge, 1952.

Eissler, K. R., Leonardo da Vinci: Psychoanalytic Notes on the Enigma, New York, 1961.

Freud, S., Leonardo da Vinci, New York, 1947.

Gantner, J., Leonardos Visionen von der Sintflut und vom Untergang der Welt, Bern, 1958.

Goldscheider, L., Leonardo da Vinci, London, 1959.

Heydenreich, L., Leonardo da Vinci, London and Basel, 1954. Müller-Walde, "Beiträge zur Kenntnis des Leonardo da Vinci," Jahrbuch der Königlichen Preussischen Kunstsammlungen, XVIII-XX, 1897-99.

Müntz, E., Léonard de Vinci. L'Artiste, le Penseur, le Savant, Paris, 1899.

Nicodemi, G., Leonardo da Vinci. Gemälde, Zeichnungen, Studien, Zurich, 1939.

Séailles, G., Léonard de Vinci, l'Artiste et le Savant, Paris, 1892. Seidlitz, W. von, Leonardo da Vinci, der Wendpunkt der Renaissance, 2 vols., Vienna, 1935.

Thiis, J., Leonardo da Vinci: The Florentine Years of Leonardo and Verrocchio, London, 1914.

Uzielli, G., Ricerche intorno a Leonardo da Vinci, Turin, 1896.

PAINTINGS

Baldass, L., "Zu den Gemälden der Ersten Periode des Leonardo da Vinci," Zeitschrift für Kunstwissenschaft, VII, 1953. Castelfranco, G., La pittura di Leonardo, Rome, 1956.

Della Chiesa, A. O., and Pomilio, M., The Complete Paintings of Leonardo da Vinci, New York, 1969.

Heydenreich, L., Leonardo: The Last Supper, New York, 1974. Mariani, V., Le idee di Leonardo sulla pittura, Florence, 1966. Pedretti, C., Leonardo. A Study in Chronology and Style, Berkeley and Los Angeles, 1973.

Ragghianti, C. L., "Inizio di Leonardo," Critica d'arte, I, 1954. Rinaldis, A. de, Storia dell'opera pittorica di Leonardo da Vinci, Bologna, 1926. Shearman, J., "Leonardo's Colour and Chiaroscuro," Zeit-schrift für Kunstgeschichte, XXV, 1962.

Steinberg, Leo, "Leonardo's Last Supper," The Art Quarterly, XXXVI, 1973.

Venturi, A., Leonardo da Vinci Pittore, Bologna, 1920.

SCULPTURES

Brugnoli, M. V., "Documents, Notes, and Hypotheses on Leonardo's Sculpture," *Leonardo da Vinci. Saggi e ricerche*, Rome, 1954.

Malaguzzi-Valeri, F., Leonardo da Vinci e la scultura, Bologna, 1802.

Valentiner, W. R., "Leonardo as Verrocchio's Co-Worker," Art Bulletin, XII, 1930.

DRAWINGS

Clark, K., and Pedretti, C., The Drawings of Leonardo da Vinci... at Windsor Castle, 3 vols., London, 1968.

Cogliati Arano, L., Disegni di Leonardo e della sua cerchia alle Gallerie dell'Accademia, Venice, 1966.

Popham, A. E., The Drawings of Leonardo da Vinci, London, 1949.

Popp, A. E., Leonardo da Vinci: Zeichnungen, Munich, 1928. Venturi, A., I manoscritti e i disegni di Leonardo da Vinci pubblicati dalla Reale Commissione Vinciana, Rome, 1928-52.

ARCHITECTURE

Firpo, L., Leonardo architetto e urbanista, Turin, 1963. Heydenrejch, L., Leonardo architetto, Florence, 1963. ——Die Sakralbau-Studien Leonardo da Vincis, Munich, 1971. Pedretti, C., A Chronology of Leonardo da Vinci's Architectural Studies after 1500, Geneva, 1962.

——Leonardo da Vinci: The Royal Palace at Romorantin, Cambridge, Mass., 1972.

MANUSCRIPTS

Brizio, A. M., Scritti scelti, Turin, 1952.

Calvi, G., I manoscritti di Leonardo da Vinci dal punto di vista cronologico, storico e biografico, Bologna, 1925.

Chastel, A., The Genius of Leonardo da Vinci, New York, 1961. McMahon, A. P., Treatise on Painting by Leonardo da Vinci, Princeton, New Jersey, 1956.

The Notebooks of Leonardo da Vinci, edited by E. MacCurdy, London, 1956.

Pedretti, C., Leonardo da Vinci: On Painting. A Lost Book (Libro A), Berkeley and Los Angeles, 1964.

Richter, J. P., The Literary Works of Leonardo da Vinci, 2 vols., New York, 1970.

SCIENTIFIC WORKS

Cooper, M., The Inventions of Leonardo da Vinci, New York, 1965.
 Hart, I. B., The World of Leonardo da Vinci. Man of Science, Engineer and Dreamer of Flight, London, 1961.

FOLLOWERS

Brinton, S., Leonardo and His Followers, London, 1900. Suida, W., Leonardo und sein Kreis, Munich, 1929. Venturi, A., "Leonardiana," L'Arte, XXV, XVII, XXVIII, 1922, 1924, 1925.

Index

Adoration of the Magi, 16, 29, 86, 94, 104, 106, 108, 112, 116, 126, 134, 170, colorplates 10–13; drawings for, 25, 29, figs. 23, 25

Adoration of the Shepherds, drawings for, 15, 102, figs. 5, 68

Alberti, Leon Battista, 29, 100, 116, 134

Allegorical Subject, fig. 74

anatomical studies, 29, 43, 106, figs. 26, 69

Anghiari, Battle of, see Battle of Anghiari

Anne, Queen of France, 140

Anne, St., see Virgin and Child with St. Anne

Annunciation (Louvre), 15, 158, 162, colorplate 40; (Uffizi), 15, 94, 156, colorplates 4–6

architectural projects, 17, 53, figs. 13, 61

Attavante, Migliore, Baptism of Christ, 80, fig. 53

Bacchus, colorplate 48 Bandello, Matteo, 124 Baptism of Christ, 15, 86, 88, 94, 106, colorplates 1-3 Bartolommeo, Fra, Virgin and Child with St. Anne, 34, 36, fig. 32 Battle of Anghiari, 34, 39, 43, colorplate 47; studies for (Neufeld reconstruction), fig. 58 Beatis, Antonio de', 53, 144 Belle Ferronnière, La, 168, colorplate 45 Bellincioni, Bernardino, 136 Bembo, Bernardo, 90 Benci, Amerigo di Giovanni, 90 Benci, Ginevra de', see Ginevra de' Benci Benois Madonna, 15, 16, 88, 98, 112, 164, colorplates 8, 9; studies for, fig. 34; copy of, fig. Birds in Flight, 25, fig. 19 Boltraffio, Giovanni Antonio, 164 Borgia, Cesare, 21, 34 Botticelli, Sandro, 13, 17, 96, 100; Birth of Venus, 43, fig. 51 Burlington House Cartoon, see Virgin and Child with St. Anne Butinone, 17

Cannon Foundry, fig. 91 Caravaggio, 154 Catapult, by Honnecourt, 23, fig. 17; by Leonardo, fig. 16 Caterina, mother of Leonardo, 13 Cats and Dragons, Studies of, fig. 81 Cavern, A, fig. 89 Cecilia Gallerani (Lady with the Ermine), 21, 39, 42, 146, 148, 166, 168, colorplate 30 Chiana Valley, Aerial View of the, fig. 85 Chiesa, Angela Ottino, 172 Clark, Kenneth, 94, 148, 164, 166 Clement VII, Pope, 160 Confraternity of the Immaculate Conception, 21, 108, 110, 138 Contarini, Michele, 164 Czartoryski, Adam, Prince, 136

Danti, Giovanni Battista, 23
Della Quercia, Jacopo, equestrian statue of Gian Tedesco, 17
Deluge series, drawing from, 48, 57, fig. 57
Desiderio da Settignano, 15, 16, 94, 120; Bust of a Little Boy, 120, fig. 6
Dome Studies for Milan Cathedral, 17, fig. 8
Domed Churches, Plans and Perspective Views of, 17, fig. 9
Donatello, 16, 120; Entombment relief, fig. 7;
Gattamelata, 17; Joshua, statue of, 17
dragons, studies of, 13, figs. 2, 3, 81, 83
drapery, studies of, figs. 77, 79
Dreyfus Madonna, 160, colorplate 43

Embryos, Studies of, 48, fig. 55 Este, Ercole d', 21 Este, Isabella d', 33, 34, 136, 140, 150, 168, fig. 64 Eyck, Jan Van, 39

Fesch, Joseph, Cardinal, 104 Fight for the Standard, 170 Figure in a Masquerade Costume, fig. 65
Flying Machine, 23, fig. 18
Foppa, Vincenzo, 17
Forteguerri Cenotaph, Pistoia, 13
François I, King of France, 13, 53, 140, 144

Gaffurio, Franchino, 138
Ghirlandaio, Domenico, 13, 84, 100; Last Supper, 128, fig. 27
Ginevra de' Benci, 15, 42, 146, 148, 166, 168, colorplate 7; verso of, 90, fig. 28
Gioconda, La, see Mona Lisa
Giorgio, Francesco di, 25
Giorgione, 122
Grotesque Heads, 106, fig. 73

Hall of the Great Council, Florence, 34, 36, fig. 33

Hands, Study of, 88, fig. 29

Head of a Girl, 118, 136, fig. 63

Head of Leda, Studies for the, 48, fig. 52

Head of an Old Man, fig. 72

Head of St. Philip, Study for Last Supper, fig. 71

Head of a Woman, 164, fig. 62

Heads, Grotesque, 106, fig. 73

Honnecourt, Villard d', Catapult, 23, fig. 17

horses, studies of, 17, 42, 102, figs. 11, 12, 47, 48, 68

Imola, Plan of, fig. 84

Jerome, St., 16, 29, colorplates 14, 15; anatomy study for, 29, 154, fig. 26

John the Baptist, St. (Louvre), 43, 48, 53, 144, colorplate 39

John the Baptist in the Desert, St., see Bacchus

Kauffmann, Angelica, 104

Lady with the Ermine, see Cecilia Gallerani

Landscape, 82, fig. 86
Last Supper, 21, 30, 31, 33, 39, 114, 118, 136, 170, colorplates 24–29; copy of composition study for, 128, 130, 132, fig. 80; Ponte Capriasca copy of, 130, 132; study of head of St. Philip for, fig. 71
Leda and the Swan, 42, 43, 94, 114; copy of, 43, fig. 50; studies for, 43, 48, figs. 49, 52
Lens Grinder, 23, 31, fig. 14
Leo X, Pope, 11, 43
Leoni, Pompeo, 57
Liphardt, Ernst de, 92
Lippi, Filippino, 34, 140; Parthenice, 140, fig. 41
Lomazzo, Giampaolo, 11, 13
Louis XII, King of France, 33, 42, 43, 53, 110, 140
Luini, Bernardino, 138

Madonna with the Carnation, 15, 162, colorplate 42 Madonna Litta, colorplate 44 Madonna di Piazza, 156, 160, 162, colorplate 41 Madonna with the Pomegranate, see Dreyfus Madonna Madonna of the Rocks (London National Gallery), 21, 98, 138, 142, colorplates 17, 19, 21; (Louvre), 21, 31, 94, 98, 104, 110, 136, 142, 168, colorplates 16, 18, 20, 22, 23; infra-red photo of, 108, fig. 39 Madonna with the Vase, see Madonna with the Carnation Madonna with the Yarnwinder, 33, 140 Maino, Angelo del, 108; Morbegno altarpiece, fig. 37 Maino, Giacomo del, 108 Male Head Squared for Proportions, 29, fig. 24 Man Wearing a Helmet, fig. 70 Medici, Donato de', 158 Medici, Giuliano de', 43, 53, 144 Medici, Lorenzo de', 11, 17, 33 Melzi, Francesco, 57 Michelangelo, 13; David, 17; Tomb of Pope Julius II, 42

Michiel, Marcantonio, 164

Milan Cathedral, Dome Studies for, 17, fig. 8

Mona Lisa, 39, 42, 90, 166, colorplates 34-36; infra-red photo of, 144, fig. 42

Mountain Peaks, Range of, fig. 88

Neptune Guiding the Seahorses, fig. 82 notebooks, 21-25 Novellara, Pietro da, 33, 34, 140, 150

Oggiono, Marco d', 110

Pacioli, Luca, 17 painters' guild of St. Luke, 15, 80 pattern books for artists, sketches from, 13, figs. Personification of Geometry, 104, fig. 38 Perspective Background for Adoration of the Magi, 25, fig. 23 Perugino, 100 Philip, St., Study of Head for Last Supper, fig. 71 Piero da Vinci, father of Leonardo, 13 Pius IV, Pope, 104 Plan of Imola, fig. 84 Plans and Perspective Views of Domed Churches, 17, fig. 9 plants (drawing), fig. 90 Pollaiuolo, Antonio, 13, 16, 17, 104, 106, 168; Martyrdom of St. Sebastian, 82, fig. 54; Portrait of a Woman, 168, fig. 46 Pollaiuolo, Piero, 104 Ponte Capriasca copy of Last Supper, 130, 132 Portrait of a Musician, colorplate 31 Pozzo, Cassiano del, 110, 144, 172 Predis, Ambrogio de', 17, 21, 108, 110, 114, 118, 138, 150, 168; Studies of Heads, fig. 40 Predis, Evangelista de', 108, 110 Printing Press, 25, fig. 20

Resta, Sebastiano, 140 Robertet, Florimond, 33, 140 Romorantin Castle, Study for, 53, fig. 61 Rossellino, Antonio, 120

Salvi, Michel'Angelo, 158 Sangallo, Aristotile da, Battle of Cascina, fig. 31 Sangallo, Giuliano da, the Younger, Dragons and Other Animals, fig. 3; Turnspit, fig. 22 Savonarola, 33 Self-Portrait, 11, 57, fig. 1 Sforza, Francesco, equestrian statue of, 17, 21, 39, 57, 124; clay model ("colosso"), 17, 21, 33; studies for, 17, figs. 11, 12 Sforza, Lodovico, Duke of Milan, 11, 17, 21, 23, 31, 39, 57, 110, 136, 138 Sforza castle, Sala della Asse decoration, 21 Shackled Prisoner, fig. 66 Sleeve, Study of a, fig. 78 Stage, Rotating, 17, fig. 10 Star of Bethlehem and Other Plants, fig. 90 Storm Breaking over a Valley, fig. 87

Trithemius, Johannes, 152 Trivulzio, Gian Giacomo, equestrian statue of, 42, 57, figs. 47, 48 Turnspit, fig. 21

Vasari, Giorgio, 13, 15–17, 34, 36, 43, 90, 94, 106, 124, 144, 150, 160, 170; Battle of St. Vicenzo, 170, fig. 59
Verrocchio, Andrea del, 13, 15, 17, 84, 88, 98, 120, 148, 156, 158, 160, fig. 30
Virgin and Child with a Cat, fig. 75
Virgin and Child with St. Anne (Burlington House Cartoon), 31, 33, 34, 39, 98, 150, 152, colorplates 32, 33
Virgin and Child with St. Anne (Louvre), 42, 48, 98, 144, colorplates 37, 38; (drawing), 152, fig. 76

War Machine, 23, fig. 15 Water Movements, Studies of, 48, fig. 56

Zurbaran, Francisco de, Hercules Seared by the Poisoned Cloak, 104, 154, fig. 36

PHOTOGRAPHIC CREDITS

(Numbers refer to figures; an asterisk* denotes a colorplate)

The author and publisher wish to thank the libraries, museums, and private collectors for permitting the reproduction of works in their collections. Photographs have been supplied by the owners or custodians of the works of art except for the following, whose courtesy is gratefully acknowledged:

Alinari, Florence (1, 7, 25, 27, 32, 35, 41, 46, 51, 58b, 59, 63, 77, 80); Aubert, Marc, Bayonne (5); Blauel, Joachim, Munich (*42); Canali, Ludovico, Rome (*1, *2, *3, *4, *5, *6, *10, *11, *12, *13, *14, *15, *24, *25, *26, *27, *28, *29, *41); Carrieri, Mario, Milan (*31, *46); A.C. Cooper, Ltd., London (11, 12, 26, 81, 90); Courtauld Institute of Art, London (2, 24, 29, 31, 47, 48, 49, 52, 58c, 61, 65, 66, 67, 68, 69, 71, 72, 73, 82, 83, 84, 88, 89, 91); Éditions Cercle d'Art, Paris (*8, *44); Gabinetto Fotografico, Soprintendenza alle Gallerie, Florence (4, 30, 58a, 75, 86); Laboratoire du Musée du Louvre, Paris (39, 42); Photorama, Le Havre (53); Scala, New York (*18, *20); Schuster, Lucasz, Cracow (*30); Service de Documentation Photographique de la Réunion des Musées Nationaux, Paris (*16, *33, *34, *37, *38, *39, 40, *40, *45, *48, 62, 64, 76); Sotheby & Co., London (3); Webb, John, London (*17, *19, *21, *32, *33).